A View of Greek Art

A View of Greek Art R. Ross Holloway

Brown University Press Providence

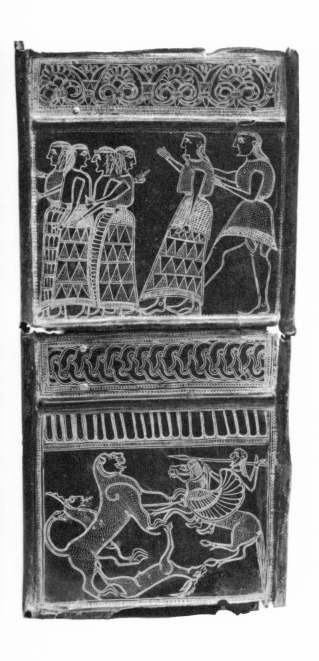

Brown University Press, Providence, Rhode Island 02912
© 1973 by Brown University. All rights reserved
Published 1973
Printed in the United States of America
By Connecticut Printers Inc.
On Mohawk Superfine
Bound by Stanhope Bindery
Designed by Richard Hendel

Library of Congress Cataloging in Publication Data
Holloway, R Ross, 1934–
 A view of Greek art.
 Bibliography: p.
 1. Art, Greek—History. I. Title.
N5630.H64 709'.38 72–187947
ISBN 0–87057–133–8

G.M.A.R.

Romae multis et mihi patronae

Piae aeternae memoriae

Contents

List of Maps and Illustrations

Preface

The first duty of the historian of ancient art has been to ask when and where, to reconstruct the chronology of the monuments and to rediscover the homeland of many works of ancient art scattered throughout the world by the formation and dispersal of ancient and modern collections. Success in these tasks has led to asking by whom, and as a result much of Greek art, at least, has been arranged by schools and attributed to masters known by their own names or by modern conventional designations. It has been less common, however, for the art historian to ask why—why did ancient style develop as it did, and why were monuments created in the form they assumed? This book seeks to answer those questions for Greek art as it existed to honor the immortal gods and to immortalize the accomplishments of men.

This book, therefore, is concerned with the monumental art of ancient Greece. However, it is not a history of Greek monuments (still less, a history of Greek art) but a discussion of essential elements that affected the nature of all Greek creative expression in visual form. I have not considered private monuments of the mature Classical period that perpetuated earlier conventions of expression and style, like the Attic grave stelai of the fourth century B.C. Nor have I considered small-scale decorative art except when it increases our knowledge of major monuments.

The first two chapters define purpose in Archaic sculptural and architectural form. The third discusses narrative decoration and the beginnings of allegory in Archaic art. The subsequent chapters follow the transformations of Archaic assumptions and conventions in later Greek art, with two monuments, the temple of Zeus at Olympia and the Parthenon, receiving particular attention.

I have attempted to avoid archaeological jargon. But in the case of architecture I have found it necessary to use precise technical terms. Extensive use is made of a number of Greek and Latin authors: Homer and Hesiod, the epic poets in whom the traditions of early Greek oral poetry culminated and who probably lived in the eighth century B.C.; Herodotus, the historian of the Persian invasions of 490 and 480 B.C. and of the events leading up to them, who was writing at the end of the fifth century B.C.; Vitruvius, a Roman architect who wrote on the practice and principles of his profession

during the reign of Augustus (27 B.C.–A.D. 14); Pliny the Elder, the Roman encyclopedist who met his death during the eruption of Vesuvius in A.D. 79; and Pausanias, the author of an antiquarian guide to Greece composed in the second century A.D. Notes have been held to a minimum, although an effort has been made to cite publications of recent discoveries that do not appear in standard handbooks. The Bibliographical Note selectively lists handbooks on Greek art. The translations are mine.

●

The sources to which I am indebted for the illustrations reproduced in this book are gratefully acknowledged in the List of Maps and Illustrations. However, for assistance in connection with the illustrations I wish especially to thank Dr. Baldo Conticello, Professor Georges Daux, Professor Nevio Degrassi, Professor George M. A. Hanfmann, Professor Kristian Jeppesen, Professor Gino Felice Lo Porto, Professor Karl Schefold, Professor T. Leslie Shear, Jr., and Professor Vincenzo Tusa.

During the process of composition the manuscript was read, in whole or in part, by four friends who have saved me from numerous errors of fact and pointed out infelicities of expression at several crucial points. In thanking them for their kindness, however, I do not wish to suggest that they necessarily agree with my opinions. They are Brunilde S. Ridgway, Jean Pierre Guépin, Michael C. J. Putnam, and Charles P. Segal. I have also been fortunate in the interest given this book by Miss Gisela M. A. Richter and Professor Wendell V. Clausen. Thanks are due Mr. Douglas Clemensen for the use of his reconstruction drawings and to Miss Linda Miller and Miss Rhea Hurwitz for painstaking photographic work. Photographic costs were defrayed by a grant from Brown University. My largest debt is to John Rowe Workman, who encouraged me to attempt the first of these essays, and to my wife, whose learning is one of my greatest joys.

A View of Greek Art

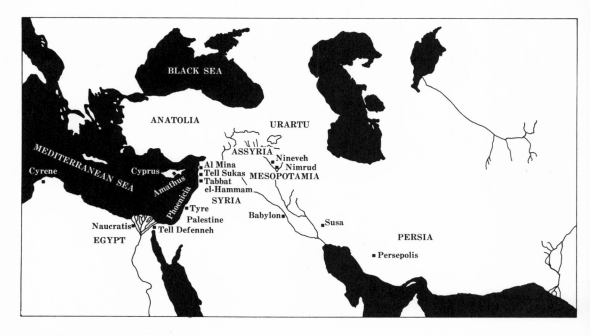

A. Near East and eastern Mediterranean

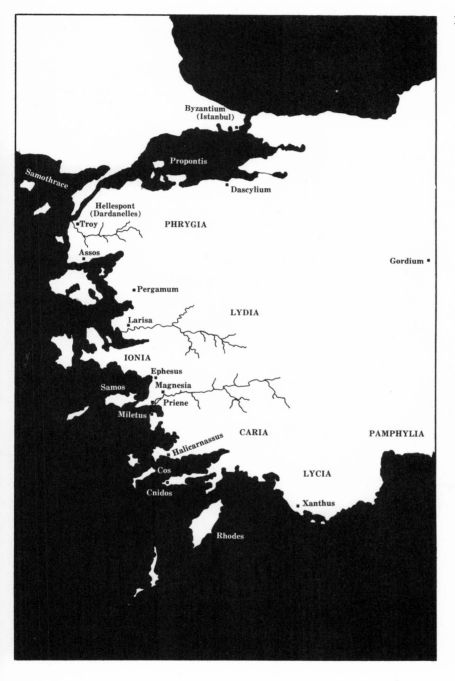

B. Aegean Asia Minor

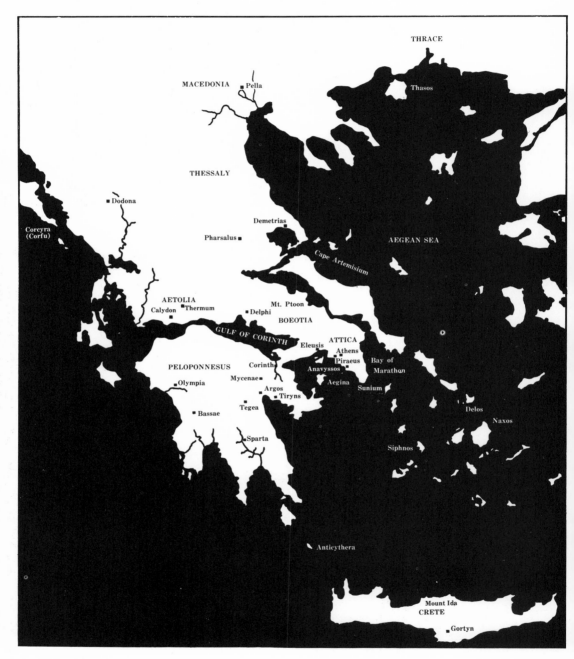

THRACE

MACEDONIA
Thasos
■Pella

THESSALY

Dodona■

Corcyra
(Corfu)

Demetrias■
Pharsalus■

AEGEAN SEA

Cape Artemisium

AETOLIA
Calydon■ ■Thermum

■Delphi Mt. Ptoon■

BOEOTIA

GULF OF CORINTH

ATTICA

Eleusis■

Athens
■ Piraeus

PELOPONNESUS

Corinth■

Bay of
Marathon

Mycenae■

Anavyssos■

Olympia■

Argos■ ■Tiryns

Aegina

Sunium

■Bassae

Tegea■

Delos

Sparta■

Naxos

Siphnos

Anticythera

Mount Ida
CRETE

■Gortyn

C. Greece

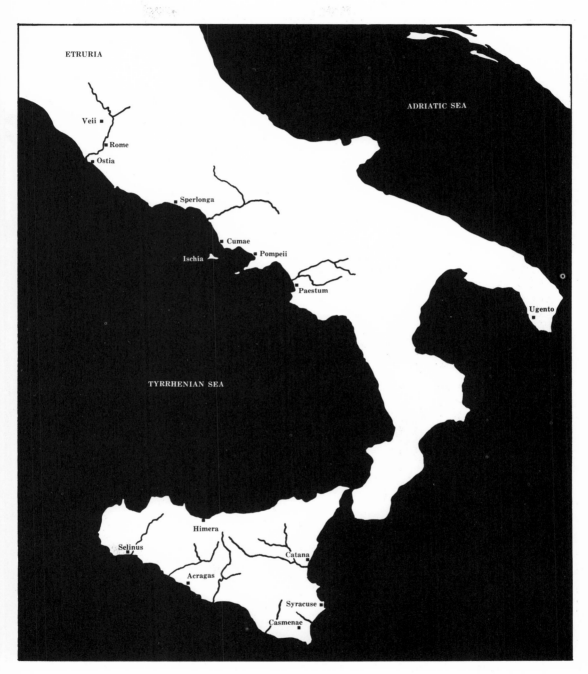

ETRURIA

ADRIATIC SEA

Veii ■

■ Rome

■ Ostia

■ Sperlonga

■ Cumae

Ischia ■ Pompeii

■ Paestum

Ugento ■

TYRRHENIAN SEA

Himera ■

Selinus ■

Catana ■

Acragas ■

Syracuse ■

Casmenae ■

D. Italy and Sicily

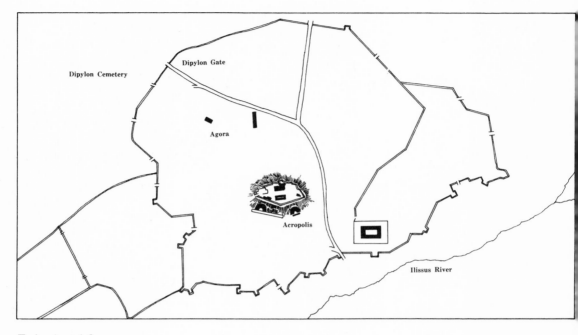

E. Ancient Athens

1. Archaic Sculptural Form

Entering the small museum of the Acropolis, a few steps from the Parthenon, a visitor to Athens leaves the bright architecture of the fifth century B.C. and steps over the threshold into the world of the grandfathers of the Periclean architects and masons. Before him are displayed sculptures and ornaments from Archaic buildings that had disappeared before the Parthenon was built. With them are the statues that constitute the Archaic marble dedications of the Acropolis.[1] It is little short of astonishing that so many pieces of major statuary survive together today so near the sites where they were originally set up. Their preservation is due to the pillaging of the Acropolis by the Persian army that invaded Greece in 480 B.C. and under the orders of Xerxes treated Athens with particular severity to punish the Athenians for their hand in the burning of Sardis in Asia Minor fourteen years before. When the victorious Athenians reoccupied their city a few months later, they carefully gathered together the overturned and desecrated statues and buried them. Most of those buried on the Acropolis were brought to light again only by the excavations of the 1880s. The statues in the Acropolis Museum are no longer mounted on the bases and columns that originally supported them, some well above the ground. On most of them the bright blues and reds that emphasized surface details of drapery have faded, although a few have kept their colors remarkably well.[2]

The earliest of the human figures among these statues is also one of the most memorable (1). Representing a man bringing a calf to the goddess Athena, it is the dedication of one [Rh]ombus and was set up about 560 B.C. The apparent freshness and spontaneity of this statue is, of course, deceptive, for the motive of the calf riding on the shoulders of a worshiper appears earlier in small bronzes. It is the realization of the motive rather than the motive itself that is of interest; close inspection discloses a surprising variation in the treatment of the anatomical elements. Showing through the skillfully suggested transparent jacket worn by the bearer are powerfully molded shoulders and arms. The stomach and legs, however, are light and schematic by comparison. The three parallel lines across the midriff, the buttonlike navel, and the wishbone ridge for a rib arch are very different from the modeling of the upper body. In execution the head is like

1. *Dedication* is used in this work in the sense of an offering to a divinity deposited in the sanctuary of the god. Although there are many kinds of dedications, including such different articles as bronze or terra-cotta figurines and military trophies, the concern of this work is with statuary dedications.
2. For example, the girl known by her inventory number, 675 (see ill. 25).

1. Calf Bearer from Athenian Acropolis

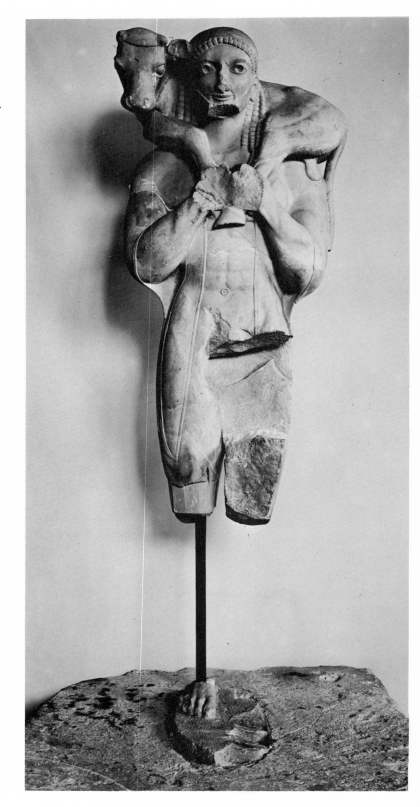

the body. Except for the modeling of the cheeks, it, too, relies on sculptural definition by means of ridges, furrows, and lines. This is noticeable particularly in the sharp eyebrows and the furrow at the side of the nostrils. (The inlaid eyes that once sparkled with colored glass are missing, as is the point of the short beard.)

The modern student of Greek art explains these anomalies as the result of the Greek sculptor's developing, but as yet incomplete, mastery of anatomy. In support of this assertion other figures can be cited in which there are similar discrepancies between linear schematism and plasticity in the lower body, shoulders, and head. Consequently, such a combination of conservative and progressive elements marks a stage in the development of Greek sculpture rather than a concept expressed by the sculptor concerning the nature of his subject. Thus there is no willful distortion, only incomplete knowledge.

This explanation of the progressive and conservative elements that make up the anatomy of the man is, surprisingly enough, unnecessary for the calf, which to a modern eye is far more appealing than the man and gives the statue much of its charm. The calf has this effect not because of sentiments inspired by its imminent sacrifice but because it is executed in a uniformly plastic style. Modeled like the man's shoulders and arms, the calf's whole body is made up of contours of hide stretched over big bones; there is no difference between the modeling of the flank and shoulder or of the neck and shank. Compared with the rigid figure of the bearer, the calf seems far more a creature of flesh and blood.

The Calf Bearer displays in striking form a general problem of interpretation of Archaic Greek monumental sculpture: Why do animals quickly achieve a uniform plasticity that remains foreign to the human figure? Archaic sculptors seem to have endowed even small bronze votive figures of animals with a naturalness that is absent from their human figures. Was the formality and reserve of the latter the unconscious product of gradual but uneven improvement of anatomical representation or the result of a conscious approach taken by the sculptors toward their subjects?

●

The history of monumental art in Archaic Greece begins in the eighth century with great vases used as grave markers. The finest group of these vessels comes from the cemetery at the Dipylon Gate in Athens. The sprawl of modern Athens has been particularly unkind to this most famous of her ancient cemeteries, which was situated along the beginning of the roads to Eleusis and Thebes where they issue together from the city in the valley of the rivulet Eridanos. The area is overshadowed by the black mass of a gas storage tank and the smoke of the industrial workshops of the modern city. Yet the modern surroundings are not inappropriate, for this side of Athens, between the Dipylon and the Agora, was also the ancient industrial quarter. The air was thick with dust when traffic was heavy on the highroad, as countrymen from Colonus, Acharnae, and the areas to the west streamed into the Agora for politics, business, and the celebration of the city festivals.

It was to this audience that the first monumental art of Archaic Greece beckoned for attention. Set on the banks close to the road were the best burial plots, and over the graves of the wealthiest in the eighth century were set up the largest decorated vessels (all over four feet high) that were to be produced in the long and brilliant history of Athenian pottery. They were set into a shallow trench over the grave, and many of them were pierced below to funnel libations of wine to the occupant of the grave. The vessels' decoration and size, however, surpass their function.

A crater in the Metropolitan Museum of Art is typical of these vases, which were produced for only two or three generations during the eighth century (2). Neither the earliest nor the latest piece of the series, it has a stout body, supported by a solid cylindrical base and ending above in a nicely proportioned lip, and two double-arched handles. The virtuosity of the geometric ornamentation counterbalances the message of the representational scenes. On the upper band the dead man lies in state on his bier beneath a checkered canopy. Also under the canopy are two small children; the wife of the dead man, seated at the left with a baby in her arms; and two men on the right, no doubt also members of the family. Birds and two goats are shown below the bier, and the scene is completed by a group of mourners who make their lamentations

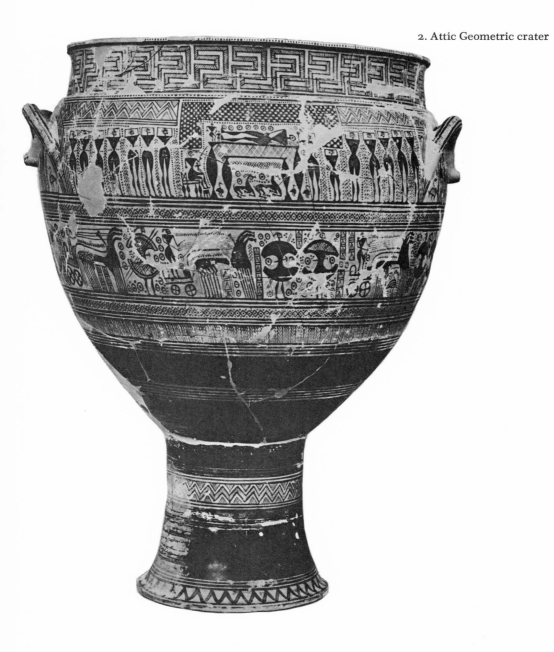

2. Attic Geometric crater

outside the canopy. On the lower band a file of heavily armed soldiers alternates with chariots. These are not serviceable wagons but light, two-wheeled vehicles (their construction is shown diagrammatically and not in perspective) of the kind that had served the Bronze Age warrior but by the end of the Geometric period existed only for sport.

The Athenians who paused to admire these first monuments of Archaic Greece lived in a world that was poor in material surroundings but rich in tradition. Athens can have been little more than a haphazard village. Statuary, if it existed, consisted of crudely shaped wooden images or of figures composed of hollow bronze cylinders. No building aspired to architectural distinction, and only recently had illiterate Greece begun to learn the Phoenician alphabet. So great was the contrast between this simple world and the brilliant material surroundings of the Bronze Age that it is worth recalling what had happened in the Greek world four centuries before.

The Greeks of the Bronze Age had created a world of monarchs and castles. The culture of the Mycenaeans, however, was far from feudal simplicity. In Crete, the island between Greece and Egypt, there existed at the same time a world of palacelike villas and villalike palaces filled with works of art and craftsmanship, all touched with the seemingly spontaneous and perpetual vitality of Minoan art. The Mycenaeans delighted in the island world to the south. They purchased its luxuries, developed more angular versions of its styles, were influenced by its palaces, and conquered the islanders. The Mycenaean princes also built great conical underground tombs (tholoi) for themselves and their burial treasures, and fortified their palaces with walls of stones so large that later ages believed them to be the work of superhuman monsters, the Cyclopes. The Mycenaean states were world powers, whose names appear in the clay-tablet archives of the Hittite kings in Anatolia. From the Orient the Mycenaeans and Minoans learned the arts of financial administration and the use of clay tablets, for which their scribes developed their own syllabic script. This brilliant realm, however, was an unstable superstructure erected over the village economy of Greece, and between 1200 and 1100 B.C. the Mycenaean world vanished. Among the causes of its collapse were the disruption of international trade in the Mediter-

ranean and internecine warfare among the Mycenaean princes.

It was as if the Greeks were reduced to the level of civilization they had known at the beginning of the second millennium, when they first established themselves in the peninsula and come into contact with the refinements of Minoan Crete. This cultural impoverishment applies equally to the Mycenaean stock that settled Ionia, the Athenians who repelled invaders and held tenaciously to their homeland, and the Dorian Greeks who entered the Peloponnesus from north of the Gulf of Corinth. Yet the poverty of Geometric Greece must not be overestimated. Looking through the cases of the small museum that houses the more recent discoveries in the Dipylon Cemetery, one can almost sense the day when the decay of the Mycenaean potter's craft was halted, the technique was regained, and a new geometric style of design was introduced. The importance of this turning point in the history of Attic pottery has often been noted. Its economic importance, which has been less frequently emphasized, lies in an increasing investment of the craftsman's time and an increasing expectation of return for his product. The very rite of cremation that became popular in the Dipylon Cemetery with the first proto-Geometric pottery, possibly in the eleventh century, had economic implications, for in a country that was never heavily forested a pyre was expensive.

The work of the potter and smith points to general activity among the crafts. At the same time the Greeks pressed forward with the overseas colonization initiated in the Late Bronze Age. More than that, over the sea lanes they maintained contact among themselves, as the diffusion of a common proto-Geometric and Geometric style of vase painting shows.

●

Though the material world of the Bronze Age was swept away, the traditions of that age survived because they served a vital purpose in the new Greek world. The Greeks, though dispersed over the Mediterranean, strove to keep their identity, language, and culture. More than clannish exclusiveness was responsible, for the Greeks were determined to remember

3. Pausanias 6. 9. 6–8.

their past, their ancestors, and their gods. Their spiritual unity was promoted through Panhellenic festivals, which brought together the scattered Greeks at various sanctuaries for the solemn rites of the great athletic gatherings. The Greeks also deliberately preserved the stories of gods and men in epic songs, which, culminating in poems of Homer and Hesiod, fixed the personalities of the deities and heroes for all later ages.

It was the good fortune of Greece that part of the Mycenaean heritage was thus transmitted to Classical Greece. But in addition to the Homeric poems and the lesser epics, just enough of the vanished Mycenaean world remained—a bit of Cyclopean wall, a half-ruined tholos, the treasures of a rich grave discovered by chance—to give substance to legends of mighty men of the past and to endow those men, in the superstitious imagination, with superhuman power. Cults were practiced in the entrance ramps (dromoi) of many tholoi, and the power of the revered dead was felt to be at the service of their countrymen.

The tomb was always the center of the hero cult, particularly since the heroes welcomed the more recent dead to their ranks. Among the men raised to this station in later times, however, not all were meritorious citizens. For example, a violent-tempered boxer, Cleomedes of Astypalaea, had the misfortune to kill his last opponent in the Olympic matches and was disqualified. On his return home, his rage turning to madness, he assaulted the main column of a schoolhouse, causing the roof to fall and crush the children. Fleeing from his vengeful fellow citizens, Cleomedes took refuge in a chest in the temple of Athena. For a time all efforts to pry up the lid failed, and when it was finally lifted, the chest was empty. In their perplexity the Astypalaeans consulted the Delphic oracle and were told to honor Cleomedes as a hero.[3]

The same ambivalence is reflected in the Greek attitude toward the legends of Bronze Age heroes, whose lives were considered both examples of vigorous achievement and warnings never to arouse the jealousy of heaven. The tragic aspect of the hero is less important in the context of this book than the positive assertion of the artistic monument, but it was this suspicion of fate's cruelty that aroused the admiration accorded a winner at the Panhellenic games. As a victor, he

alone boasted the permanent and inalienable patent of divine favor. It is no wonder that political careers could be built on the fame of an Olympic crown. An element in the admiration given a victorious athlete was the perennial Greek fascination with male beauty. The Olympic victor Philip of Croton, who accompanied the Spartan adventurer Dorieus to Sicily and died there, received heroic honors from the people of Segesta simply as a result of the impression made by his handsome appearance.[4] The Greek feeling about men so honored is summed up by the seventh-century poet Tyrtaeus, who says of the hero, "Though he may be in his grave, he becomes immortal."[5]

Posthumous adoration on this scale would surely have been welcomed by the Athenian nobles whose graves were marked by vases like the Dipylon crater in the Metropolitan Museum of Art. A hero cult was considered the due of a noble who led a colony or acted as chieftain in a barbarian domain and was buried abroad. For example, when Miltiades, son of Cypselus, died in the Athenian outpost he had organized at the entrance to the Dardanelles around the middle of the sixth century, annual sacrifices accompanied by equestrian and athletic competitions were instituted in his honor.[6] At home the critical atmosphere of Greek society made any such occurrence rare. Yet the Dipylon vases pose the question of the extent to which the concept of the hero is covertly present in the respect paid those graves and is responsible for the first manifestation of monumental art.

The decoration of the crater in the Metropolitan Museum of Art is an example of such heroic overtones in funeral art. Funeral games were the great public manifestation of a hero cult. The entire lower band of the crater is given over to a line of racing chariots alternating with hoplites. Chariot and warrior together would have immediately brought to mind the Bronze Age fighting team of warrior and charioteer, long since superseded by armies of heavily armed infantry and cavalry. This may be all that was intended, with no thought of a race course flanked by soldiers, but simple rows of chariots or horsemen on other Geometric vases certainly portray funeral games. The upper frieze, too, suggests honors due the dead, for the two goats below the bier must be victims for a sacrifice. And the generalized Geometric birds in the

4. Herodotus 5. 47.
5. Fr. 9. 32.
6. Herodotus 6. 38.

field at the right of the bier may be interpreted as cocks; again, a proper sacrifice to the spirits of the underworld.

Support for this idea can be found in vases of a later and more explicit age. One of these (3), the funeral amphora from the Piraeus, Athens's port city, was made a century or more after the Dipylon crater. On its neck is a cock; on its body, two chariots, whose drivers wear the racing charioteer's long chiton. Although the action is hardly rendered with vigor, the two teams are certainly overlapped in a close contest as they approach the turning mark or finishing point. The latter, not visible in illustration 3, is a tomb guarded by a seated lion, a reminder that the later seventh century was already a period of tomb sculpture.

●

This was a new era in monumental art, that of the sculptural predecessors of the Calf Bearer. But to understand this era one must examine the Athenian funeral vases produced between the Dipylon monuments and the Piraeus amphora. The outstanding representative of this group is the great proto-Attic amphora discovered at Eleusis in 1954 (4). Fifty-five inches high and made around 675 B.C., it served for the burial of a ten-year-old boy who was laid to rest beneath the hill of the sanctuary of Demeter. On the vase's neck, Odysseus and two companions run home the brand into the eye of the Cyclops Polyphemus. Below, the hero Perseus, protected by Athena, escapes with Medusa's head but is pursued by the monster's two outraged sisters. In a small band on the shoulder a lion attacks a wild boar.

The Geometric conception of decoration and design has gone. In its place are buoyant, curvilinear patterns—spirals, tendrils, interlaced waves, and loops. In the open spaces of the figured design is a new kind of filling ornamentation. Palmettes, rosettes, stars, swastikas, and diamonds are spread freely with none of the sense of gravity that kept the filling ornament of the Dipylon crater to a vertical axis. Greek vase painting has entered the Orientalizing period, so named because the new forces in Greek art can be traced to the influence of Eastern civilizations. This revolution took place in three quarters of a century and brought into Greek art the

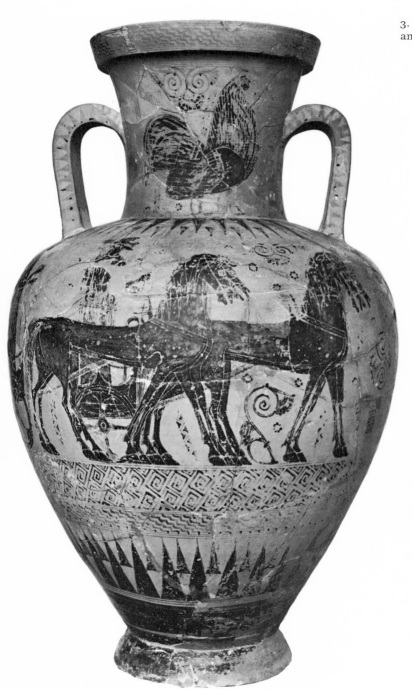

3. Attic black-figured
amphora from the Piraeus

4. Proto-Attic amphora
from Eleusis

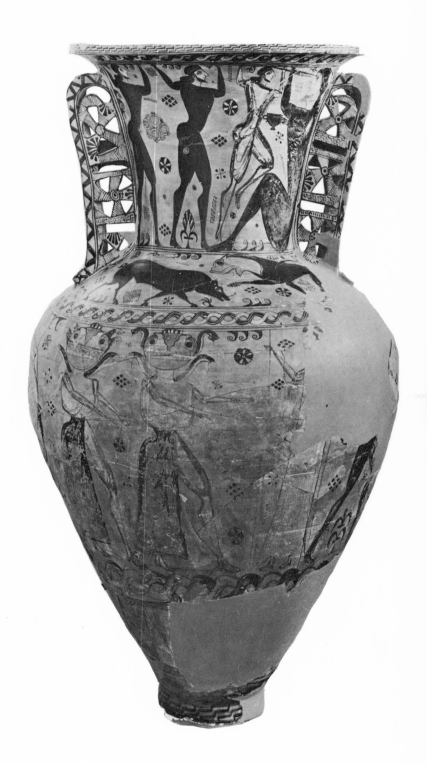

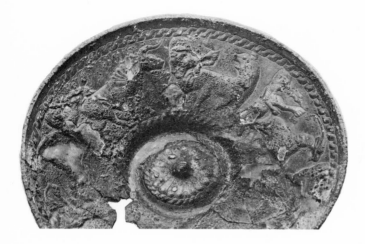

5. Bronze patera from
Dipylon Cemetery

6. Ivory figurine from
Dipylon Cemetery

concepts of plasticity that made possible its future achieve-
ments. But the intellectual importance of this revolution
should not be overestimated, for, like the Phoenician alpha-
bet, it gave a means of expression to the Hellenic mind with-
out influencing its outlook.

The geometric style that was replaced, moreover, was not
simply a refuge of ignorance that the Greek artist was happy
to abandon at the first sight of something better. Indeed, the
human figures on the Eleusis amphora are geometric figures,
hardly more plastic than those drawn a century before. Nor
was it for lack of foreign models that the Athenian craftsmen
of the Geometric Age had persisted in the old ways, for the
excavation of the Dipylon Cemetery has brought to light ob-
jects imported from the Orient or produced in the Greek world
on Oriental models and used as grave goods at Athens as early
as the ninth century. Among them are a shallow bronze ritual
bowl (patera) with a decorative scene of fat, plastically ren-
dered lions, bulls, and goats alternating with human figures
(5); a group of five small ivory goddesses, nude except for a
crown (6); and a series of gold bands, of the type used to bind
the eyes and mouth of a corpse, which are decorated with
naturalistic lines of deer and panthers made by rouletting an
intaglio cylinder over the thin gold strip (7). These subjects,
the ivory, and the intaglio-cylinder technique are Eastern and
prove that acquaintance with Eastern objects did not lead to
automatic imitation by Greek potters. A comparison of the
grazing deer from the neck of a late Geometric jug in the

7. Gold band from Dipylon
Cemetery

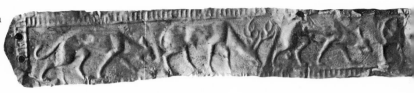

Ashmolean Museum (8) with the deer of the gold bands shows how the plastic type was spurned. But at some point Eastern art passed from the status of a neglected curiosity to that of a source book of representational form.

•

First among the causes of this revolution was the growing volume of imports from the East and Greek experience there. The bronze patera from the ninth-century Dipylon grave, like the bits of Geometric pottery that have come to light as far east as Nineveh, proves that contact with the cities of the Orient had never been broken completely, just as colonization and shipbuilding prove that the Greek cities of the Geometric Age were never abjectly impoverished and isolated. But the Near East was also a troubled and depressed area in the tenth and ninth centuries. It was not until the eighth century that there were again markets in the East for what Greece could offer. In that century the Assyrian monarchs completed their conquest of Mesopotamia, Syria, Palestine, and Egypt; even Greek Cyprus became part of their titular domain. Meanwhile, in Anatolia the Phrygian kingdom guaranteed a measure of peace, and to the east the kings of Urartu, in modern Armenia, seem to have gained control of a corridor to the Black Sea and ports from which the products of their famous smiths and even Iranian goods could be shipped to the west.

These changes brought importance to three routes of communication between east and west. The most northerly was the Black Sea route, the perils and rewards of which are reflected in the story of the Argonauts and the Golden Fleece; in the Greek colonies on the Black Sea coast; and in the trail of bronzes from Urartu, where they originated, to Samos and Olympia, and as far as Greek Ischia, in the Bay of Naples, and Etruria. The Greeks added much during the process of transmission. Illustration 9, for example, shows a cauldron rim

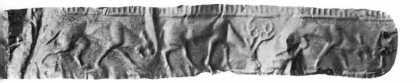

attachment in the form of a griffin's head. Both the idea of the attachment and the griffin's head had Oriental prototypes, but they were combined for the first time, as far as is known, by Ionian Greek craftsmen.

The second route, the caravan trail across Anatolia, connected the Orient and Greece through Phrygia, whose craftsmen developed their own geometric art and a style of animal representation that they shared with the makers of Ionian Geometric pottery. Midas of Phrygia was the first Eastern potentate to make kingly offerings to Apollo at Delphi, and the tombs of his family have now been revealed at Gordium, in the center of the Anatolian plateau.

The third route of contact was also by sea and led to the Syrian ports where Greek trading stations like those of My-

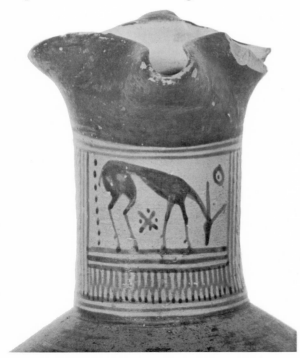

8. Attic late Geometric jug, detail

9. Bronze griffin's-head attachment for cauldron from Olympia

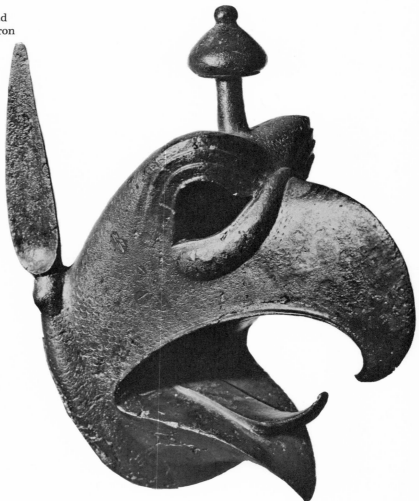

cenaean days were again established at Al Mina, Tell Sukas, and Tabbat el-Hammam. Egypt, of course, does not enter the story until the seventh century, when Assyrian control was overthrown with the help of Greek mercenaries and the grateful rebels modified, if they did not remove, the embargo on foreign trade. Earlier, however, copies and pastiches of Egyptian trinkets were produced on the Syrian coast. In Ezekiel 27:6, 13 it is recorded that in the late eighth century at the Syrian city of Tyre the Greeks traded in slaves and timber. The Greeks also sold their services as mercenaries to pay for the crafts of the East.

10. Bronze votive shield from sacred cave on Mount Ida, graphic restoration

Most imports, whether textiles, jewelry, ivories, or faïence, could affect monumental art only by adaptation. In bronzeworking alone could there be direct imitation in the same medium, and in sheetmetalwork the effect of Oriental models was profound. The bronze shields from the sacred cave on Mount Ida in Crete, which apparently date at least to the early seventh century, are thoroughly Orientalizing in style (10). It would be difficult to claim them all as imports from the East. In fact, it is possible that the Greek metalworker began to use Oriental models for his work long before his colleague the potter.

Nevertheless, the Greek craftsman needed teachers, and the history of ivoryworking shows how he found them. Among the ivories from the excavations of the sanctuary of Hera on Samos, within sight of the mountains of the Anatolian coast, there is a particularly interesting piece, one of the arms of a superbly carved lyre in the form of a kneeling boy (11–13).[7] The boy's features show the striking use of two deep grooves

7. Dieter Ohly, "Zur Rekonstruktion des samischen Geräts mit dem Elfenbeinjüngling," *Mitteilungen des Deutschen Archäologischen Instituts, Athenische Abteilung* 74 (1959): 48–56. A similar reconstruction of a lyre based on an ivory in Berlin has been made by Adolf Greifenhagen in "Ein ostgriechisches Elfenbein," *Jahrbuch der Berliner Museum* 7 (1965): 125–56.

11, 12. Ivory figurine of
youth from Samos

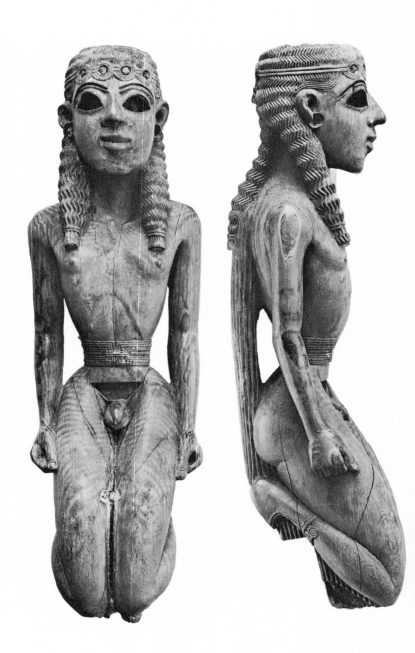

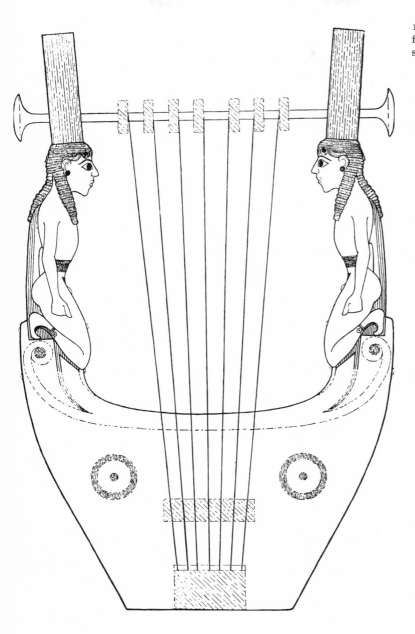

13. Lyre incorporating
figurine of youth, recon-
struction

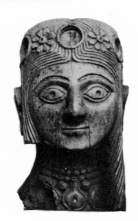

14. Ivory figurine head from Nimrud

for the eyebrows that is characteristic of Near Eastern ivory carvers of the ninth century, whose work is well documented from finds at Nimrud, on the Tigris in Iraq (14). The lyre held upright to be played, as this one seems to have been, is typically Aegean rather than Near Eastern; therefore, the Samos ivory is best explained as an object made in the Aegean by an Oriental craftsman. Similar cases of migrating craftsmen may have influenced early Greek metalwork, and the phenomenon may be compared to the emigration of Greek potters to Etruria in the sixth century. The surprising rapidity with which Ionian ivories lost their Oriental flavor shows how quickly the skills learned from an immigrant master could be put to the service of other tastes by his local pupils.

Only by postulating such a process can one understand the Greek craftsmen's varying degrees of assimilation of new decorative forms and figure styles in the first half of the seventh century. The Eleusis amphora was decorated by an artist who seems to have acquired a bold but undisciplined mastery of the new decorative designs. Yet his figure style was Geometric, and he remained fundamentally a seventh-century primitive.

●

It is almost unbelievable that the Eleusis amphora is only a score of years earlier than the greatest piece of Corinthian vase painting of the seventh century, the proto-Corinthian jug (olpe) called the Chigi Vase, found at Veii in Etruria (15–17). The decoration of this and four or five other vases by the same hand surpasses any contemporary vase decoration in the Greek world. Though only about ten inches high, the Chigi Vase is endowed with a monumental spirit. The drawing, particularly in the overlapping lines of soldiers in the principal band, is a century or more ahead of its time. How its painter had learned figure drawing is difficult to say. His delicate use of incision and miniature style, as well as the plastic lion's-head mouths introduced in his small perfume bottles (aryballoi), the most famous of which is the Macmillan Aryballos in the British Museum, makes it likely that his teacher was a master of the tradition of Oriental ivory carving.

15. Chigi Vase

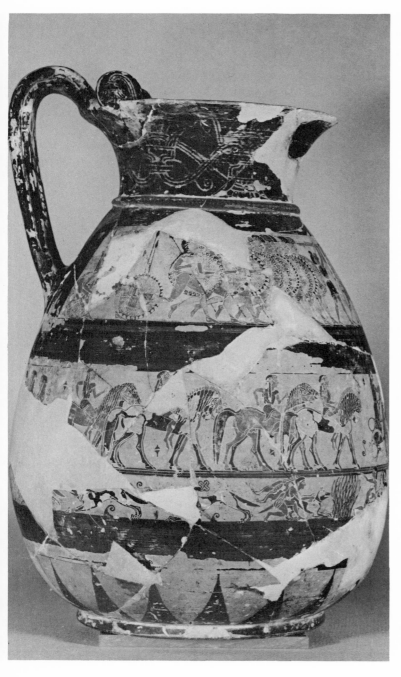

16. Chigi Vase

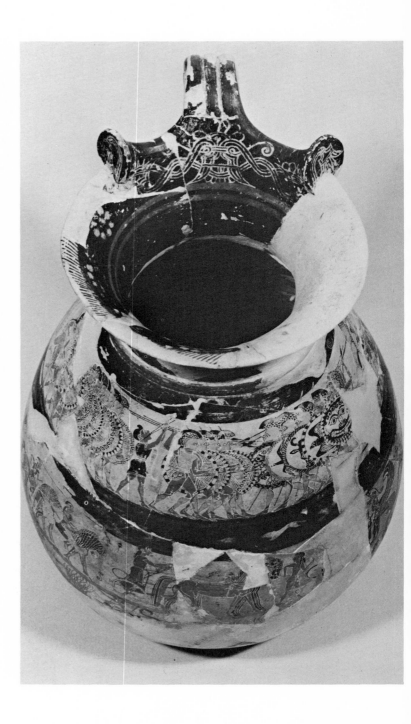

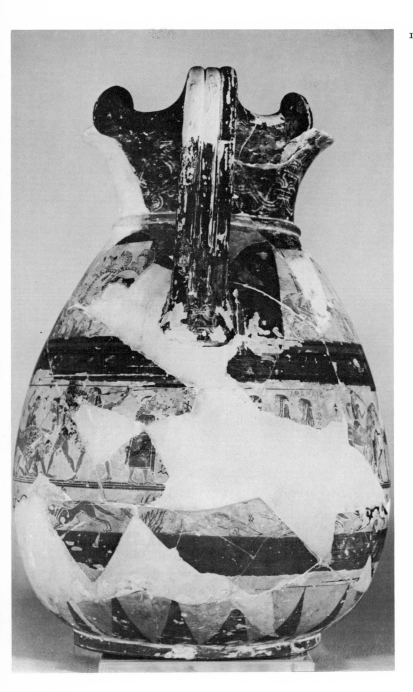

17. Chigi Vase

8. The expressive powers of Geometric vase painting are defended by Sture Brunnsaker in "The Pithecusan Shipwreck," *Opuscula romana* 4 (1962): 165–242.

9. Dinu Adamesteanu, "Contribution of the Archaeological 'Aerofototeca' of the Ministry of Education to the Solution of Problems of Ancient Topography in Italy," *Proceedings of the Tenth Congress of the International Society of Photogrammetry* (Lisbon, 1964), p. 9 (of offprint). Further details of, and corrections to, the plan presented here may be expected from the current excavations at the site by Dr. Giuseppe Voza.

During the centuries of the Geometric Age, the heroic tales set in the Bronze Age were sung and resung, and the expression of the song was refined in a tradition that prepared the way for the glories of Homer. The heroic tradition found no similar visual expression. For all the heroic overtones of the Dipylon vases, identification of epic personalities on Geometric pottery is difficult. The vases were technically superb, and their decoration was impressively designed, but their powers of communication were limited to the most general repetitive suggestion, and expressive power can hardly be said to exist in their figure style.[8] The Geometric style, however, manifests a turn of mind that characterized other activities of the contemporary Greek world, a passion for systematic arrangement. To claim that this quality of the Greek mind is especially evident in the post-Mycenaean period is not to deny the orderly qualities of the Bronze Age. Yet there is a difference between the two periods.

The archives of a Mycenaean palace and the system of its architecture reflect a society marshaled from the viewpoint of the prince and bureaucrat. The nascent city-state of the Geometric and early Orientalizing period was planned in relation to its citizenry. The difference is most evident in the arrangement of the cities of the two periods. While a Bronze Age town was a disorderly agglomeration of houses, a new Greek colony of the early seventh century, like Sicilian Casmenae, established in 643 B.C., was laid out with a completely rectangular street system (18).[9] In comparing Geometric pottery and epic verse, the true comparison is not between the story pattern of one and the ornament of the other but between the hexameter line and the Geometric sequence of ornamentation. At the end of the Geometric period both the pattern of versification that constitutes the hexameter and the pattern of ornament that constitutes Geometric decoration were brought to their highest point of elaboration and refinement.

The debt of subsequent generations of Attic potters to their Geometric predecessors is clear. They, too, made monumentally conceived vases for tombs, of which the Eleusis amphora is only one example. The themes of Geometric art are also the themes of the seventh century, despite all the new fashions and superficial changes of the Orientalizing period. The

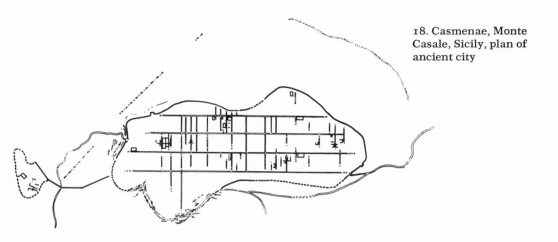

18. Casmenae, Monte Casale, Sicily, plan of ancient city

major decoration of the Eleusis amphora, in which the persistence of Geometric form is apparent, is devoted to the exploits of the heroes Perseus and Odysseus, thus continuing the heroic mood of the Geometric monuments with concrete personalities. Chariots like those of the Dipylon vases are also seen in the chariot race on the Piraeus amphora. So strong are the traditions of Greek art, so familiar the scenes and subjects that appear century after century, that it is easy to forget that a choice was involved in each case. A Chigi Vase shows that a seventh-century painter could make a contemporary battle of infantry lines with no chariots and no cavalry if he chose to do so. But his choice more often fell on the bright world of the heroes. In the Dipylon vases the Geometric period gave Greece the first monuments that, like the epic, expressed a longing to evoke the memory of the mighty past.

●

The eighth and seventh centuries were an age of monumental pottery and of bronze dedications in the form of cauldrons and tripods, but in the early sixth century large-scale sculpture came into its own. The beginning of life-sized and more than life-sized statuary is now dated in about 600 B.C., a generation before the Calf Bearer.[10]

The standing nude male figure known as the kouros (youth) type marks the advent of larger than life-sized sculpture in the Greek world, and the kouros dominated the first

10. Evelyn B. Harrison, *The Athenian Agora,* vol. 9, *Archaic and Archaistic Sculpture* (Princeton, 1965).

11. Rhys Carpenter has described this process in *Greek Sculpture: A Critical Review* (Chicago, 1960), pp. 27–50.

half century of Greek monumental sculpture. Among the earliest kouroi is the superhuman figure from the sanctuary at Sunium in Attica, whose reconstructed height of thirteen feet is probably some inches short of his original stature (19, 20). At the same time were fashioned the colossus of Delos (better known from the drawings of the fifteenth-century traveler Cyriacus of Ancona than from surviving fragments), the two unfinished kouroi in the quarries of Naxos, and the Ram Bearer of Thasos. The kouros type is in no way immature or awkward, even at the beginning of its career. For a student of Classical sculpture, accustomed to representations that are often majestic and at the same time touchingly human, it is an unforgettable shock to enter the first sculpture room of the National Museum in Athens and see the overpowering Sunium kouros. Standing at attention, his military carriage modified only by the advance of the left leg, his rigidity is enhanced by the technical process of his creation, which began with the projection of independent front, rear, and lateral designs in two dimensions on the four principal faces of a marble block.[11] In the resulting figure, which has none of the implicit compromises of naturalistic transitions, the Geometric tradition and the passion for definition in Greek Archaic life are very much in possession of the artist's mind. Deep carving emphasizes the knees and therefore the division of the legs. The V of the hipbones meeting at the pubes has been simplified to a narrow ridge above which fine horizontal grooves delineate the anatomy of the abdomen and a wishbone arch marks the limits of the rib cage; two arches also mark the breast. In the face a too-small mouth and too-large eyes produce the character of the expression. The decorative instinct can be said to have influenced the sculptor only in his treatment of the hair, which rolls easily across the forehead in wide spiral coils and, bound by a fillet that passes through a square knot, falls in evenly arranged locks below the neck onto the back. The ears are marvelous double spirals, but the anatomical rendering of the back seems less successful than that of the front, for the shoulder blade is doubled, the groove of the spinal column is too deep, the lines for the dorsal rib cage are too long, and a long ridge carries the indication of the elbow almost to the wrist.

Closely inspected, the Sunium kouros is a perplexing com-

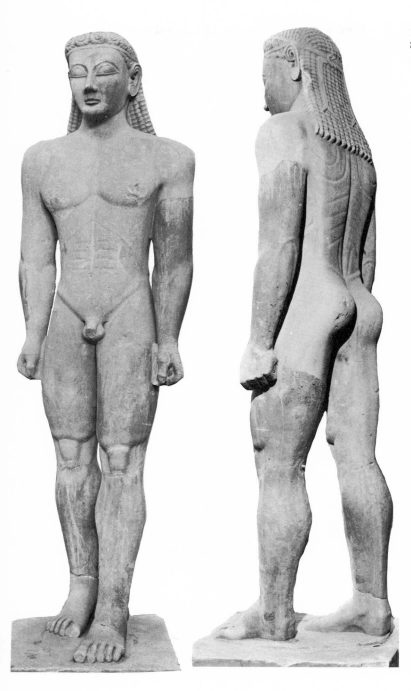

19, 20. Kouros from
Sunium

12. For a general treatment of Greek contacts with Egypt, see M. M. Austin, *Greece and Egypt in the Archaic Age*, Proceedings of the Cambridge Philosophical Society, supp. 2 (1970).

bination of lines and masses confidently presented on a heroic scale. The scale, the pose, and the wiglike hair together suggest a model from Egypt, where two thousand years of striding Pharaohs had taken form in stone before the Sunium kouros was carved. However, the theory that the Greek sculptor's art as it was practiced in the seventh century was indebted to Egyptian instruction cannot be sustained. Egypt was under Assyrian domination for the better part of a century before Greek mercenaries helped the rebel Psammetichos to overthrow the Assyrians and establish the Twenty-sixth Dynasty in the middle of the seventh century. During that time Egypt was a closed world, so that the Egyptian crafts that were known in Greece came through Phoenicia and Syria; most were Syrian or Phoenician reproductions. Even Psammetichos' reliance on Greek soldiers did not automatically open Egypt to the Greeks, for Greek pottery found at Naucratis and Tell Defenneh, two Greek trading stations of the Archaic Age, indicates that commercial relations did not develop for a generation or more. Even then the Greeks were not given freedom to roam and sell at will, but were confined to the trading stations that, like European treaty ports in China, were enclaves populated by foreigners for whom the Egyptians did not conceal their contempt. Besides the Greek traders in wheat, silver, and slaves and the Greek potters, trinket makers, soldiers, and courtesans who were drawn to Naucratis, there were occasional learned visitors like the Athenian statesman Solon, Hecataeus the geographer, and Herodotus himself. But it is unlikely that a Greek sculptor in the seventh century could have journeyed to Egypt and found a sympathetic Egyptian to teach him the trade secrets of quarrying and sculpting. Since there is no evidence that Egyptian sculptors came to Greece, one must look within the traditions of Greek carving and metalwork for the origins of Greek sculpture.[12]

A discovery made in 1955 in an eighth-century tomb in Argos has illuminated the history of Greek sculpture in an extraordinary fashion. The find, a breastplate (21, 22) and helmet, the earliest such panoply known, proves that mannerisms invented in the Geometric Age were carried over into early Greek sculpture. The most distinctive of the motives of the breastplate is the wishbone-shaped groove indicating

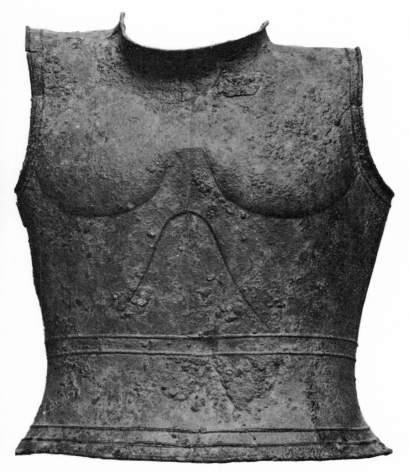

21. Bronze breastplate
from Argos, front

the inside line of the male rib cage. The descendants of these
markings appear in early Greek monumental male figures.
They also appear in small bronzes, for the skills of the arm-
orer, maker of greaves and helmets as well as breastplates,
would have been precisely those needed for the making of
the small tubular bronze statues already known, in all proba-
bility, in the eighth century. A group of such figures was
found at the Cretan sanctuary of Dreros.[13]

●

Nor was the monumental kouros the first Greek venture into
stone sculpture. Thanks to the use in Corinthian pottery of

13. I wish to acknowledge
the value to the develop-
ment of my argument of
the honors paper for .he
B.A. degree written at
Brown University in 1965
by Dr. John Kenfield. The
Argive armor is published
by Paul Courbin in "Une
tombe d'Argos," *Bulletin
de correspondance hel-
lénique* 81 (1957): 322–
86.

22. Bronze breastplate
from Argos, back

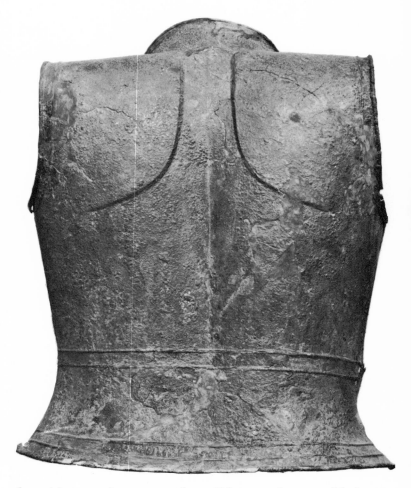

the mid–seventh century of small human faces molded sepa-
rately from the vases and applied to them as plastic decora-
tion, the early U-shaped facial type can be dated in the mid–
seventh century. This type—called Daedalic, although it
seems to have had little to do with the mythical artist—was
superseded in the time of the first kouroi by a longer U-shaped
face. Daedalic heads are found in moderate-sized sculpture
in limestone, and the most famous example is the Auxerre
Kore in the Louvre, so called after its first home in France
(23). This kore (female standing figure) is tight-waisted
like some of the early island kouroi, recalling the Minoan
styles of Bronze Age Crete, which persisted in the island into
the early Archaic Age. The lower body is boardlike, recalling

early wooden sculptures seen by Pausanias in numerous Greek sanctuaries, and the low forehead and face are typically Daedalic. Along with these individual characteristics are Egyptian details—the heavy, wiglike hair and the gesture of the right hand—although this statue was made only a few years after the first Greek mercenaries fought for Psammetichos.

It is safe to say that the Greeks could work stone, at least soft stone, before they could have gone to Egypt. The Egyptian elements in a figure like the Auxerre Kore could easily have been transmitted through the pseudo-Egyptian products of the Phoenician coast. In the case of the early kouroi, it is the monumental scale that seems most insistently to link their origin with Egypt. But the appearance of the kouros coincided with the first Greek stone architecture, and a nation capable of quarrying monolithic column drums like those cut for the temple of Apollo in Syracuse early in the sixth century would not have found quarrying even a marble kouros an insurmountable technical problem. Greek quarry traditions, possibly maintained since Mycenaean times, need not have been dependent on foreign instruction. And even if the Archaic Greeks had had to relearn the technique of quarrying, Egyptians were not their only possible teachers. King Midas of Phrygia, in whose capital at Gordium eighth-century stone sculpture has been excavated,[14] was in contact with the Greeks and sent embassies to Delphi in the late eighth century.

Nevertheless, the subsequent influence of Egypt on the kouros type cannot be discounted, for by the end of the seventh century Greeks were returning from Naucratis with tales of colossal statues and breathtaking temples and with small-scale models of the former. Aside from the novelty of these monuments, the regal Egyptian standing pose—with muscles tensed, head squarely forward, and a piercing gaze—must have fascinated the Greek sculptor because of its success in capturing the superhuman vitality in human form that he himself wished to express.

The inscriptions on the bases of two of the first kouroi dedicated at Delphi identify them as the Argive brothers, the heroes Cleobis and Biton (24). According to Herodotus,

on the occasion of the festival of Hera at Argos it was

14. *American Journal of Archaeology*, vol. 62 (1958), pl. 21, fig. 4.

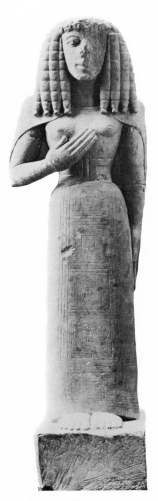

23. **Auxerre Kore**

24. Cleobis and Biton
from Delphi

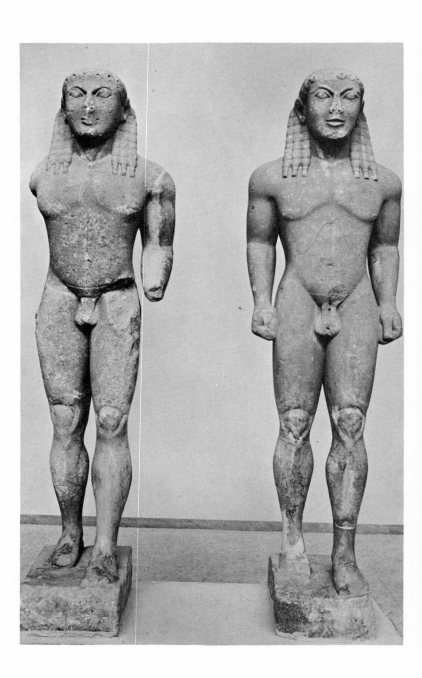

necessary that their mother be transported to the temple by a yoke team. But the oxen did not come in from the fields in time. In view of the lateness of the hour the young men themselves took up the yoke and dragged along the wagon, their mother riding upon it, until they arrived at the temple forty-five stadia away. This deed was viewed by the entire assembly, and there followed the best reward of life, by which the god showed that it is preferable for man to die rather than live. The Argive men stood around and hailed the strength of the youths while the Argive ladies praised the mother for her children. She was carried away in her joy at the deed and the impression it had made, and, standing before the cult statue, she prayed for Cleobis and Biton, her sons who had done her such honor, and asked that the goddess might give them man's greatest blessing. After the prayer they sacrificed and celebrated. Then the youths lay down to rest in the sanctuary and did not arise. Death was their reward. The Argives had statues made of them and dedicated them in Delphi since they had achieved such distinction.[15]

These statues of Cleobis and Biton that were brought to light again when the Delphic sanctuary was excavated are twin kouroi. They are indistinguishable in type from the kouroi that served to represent such divinities as Apollo and Poseidon or victorious athletes, who soon joined the gods and heroes as kouros subjects. The first documented athlete's kouros was that of Arrhachion, thrice an Olympic victor, in 572, 568, and 564 B.C. The older kouroi from the Dipylon Cemetery are among the earliest known.

The standing female type began with figures like the Auxerre Kore that may be earlier than the first kouros. They are often modest and impersonal dedications—like the korai of the Athenian Acropolis (25), whose charm is one of the most pleasant memories of a visit to Athens. Some korai are no more than generically appropriate offerings to the goddess, but like the kouroi, they can also be portraits, as are the korai Ornithe and Philippe, two of a group of six statues on a common plinth that was made by the sculptor Geneleos for the sanctuary of Hera at Samos. (Included in the group are the

15. Herodotus 1.31.

25. Kore (no. 675) from
Athenian Acropolis

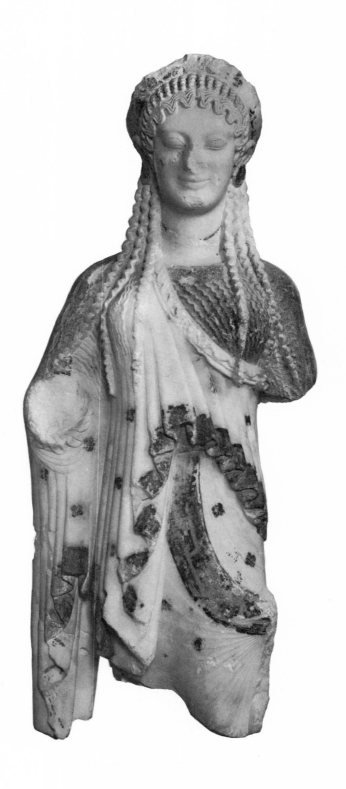

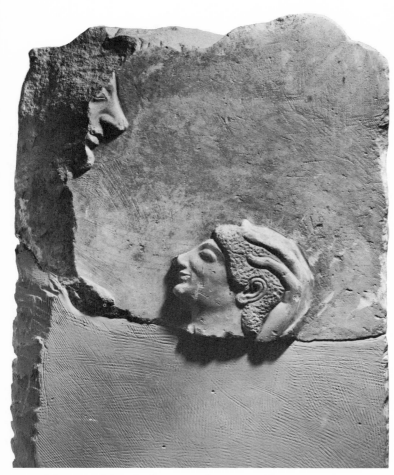

26. Grave stele fragment
from Anavyssos

seated figure of the dedicator, who was a lady named Phileia,
and a reclining gentleman, whose name is only partly pre-
served.)

•

In grave monuments, statues and reliefs of men and women
come into the closest and most poignant relationship with
their subjects. The Archaic grave reliefs carry clear intima-
tions of heroization, and the Attic series is the most impres-
sive of all. Indeed, these stones rank in quality with the finest
Attic sculpture.[16] Women and children rarely appear on the
Archaic Attic grave stelai, but on the exquisite fragment of
a mother and child from Anavyssos (26), in rural Attica, the

16. K. Friis Johansen, *The
Attic Grave-Reliefs of the
Classical Period* (Copen-
hagen, 1951). The inti-
mate connection between
the concept of heroization
and many forms of early
Greek art has been ex-
amined by Karl Schefold
in *Griechische Kunst als
religiöses Phänomen*
(Hamburg, 1959). Ar-
chaic grave reliefs of At-
tica are collected by Gisela
M. A. Richter in *The Ar-
chaic Gravestones of At-
tica* (London, 1961).

27. Grave stele from Attica

hand of the mother against the child's head displays a sympathy that is different in every way from the tenseness of the kouroi and korai. The best preserved relief of a child is the stele erected by one Megacles (possibly of the great Alcmaeonidae family) to his son and daughter that exists today in fragments in the National Museum in Berlin and in the Metropolitan Museum of Art, where a full reconstruction has been made incorporating the lovely sphinx that crowned the shaft (27). The boy and girl stand together, she clothed, as any woman other than a slave girl or prostitute would be and holding a flower; he is nude, with the oil bottle of an athlete suspended from his wrist and holding a pomegranate, a sign of continued existence in the realm of the dead.

There is a strange disproportion between the two figures, for the girl hardly reaches halfway up to her brother's thigh. Rather than an awkward way to show a difference in age, this indicates that the girl is dwarfed by a mighty brother, just as the votaries of other stelai are dwarfed by the hero in whose presence they stand. And the youth's nudity in his sister's presence must also have made their different status clear to ancient viewers, for women did not frequent the palaestra, and boys old enough for gymnastic training did not go about naked even at home.

In reliefs of men simple nudity is often abandoned for the explicit reference of attributes. A stele in the Metropolitan Museum of Art, for example, suggests that its subject is a warrior by the addition of the heroic chariot and men in armor in the panel below the figure. Explicitly athletic are the discus bearer of the National Museum in Athens and the splendidly characterized boxer from the Dipylon Cemetery. And when, as in the case of the painted stele made for one Lysias at the end of the sixth century, the subject is a gentleman wearing his enveloping cloak, he nevertheless carries the wine cup (cantharus) that implies his right to a hero's libation.

Yet simple nudity persisted, for the kouros continued to be the most heroic form of grave memorial. An almost perfect specimen of this type (28, 29), created at the peak of its development in the third quarter of the sixth century, came to light in 1936, together with its plinth and inscription. The inscription of the statue of Croesus from Anavyssos, which

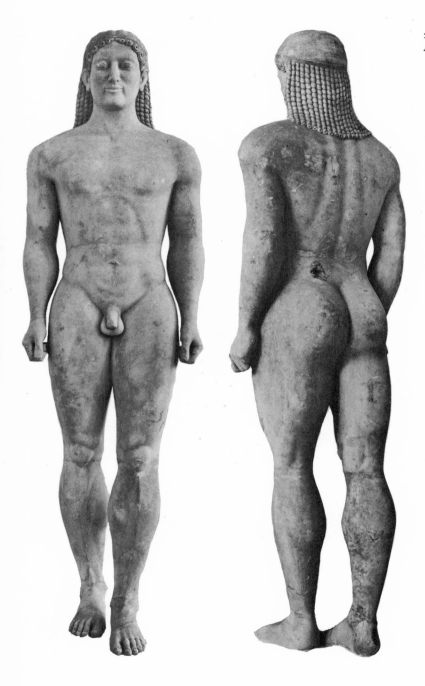

28, 29. Kouros from
Anavyssos

is now displayed in the National Museum in Athens, reads:

> Come stand by this tomb to mourn
> Croesus now dead
> whom fierce Ares struck down
> at the battleline's head.

The heroic portrait above this epitaph stands with all the tense power of its predecessors in the kouros tradition. Like them, it is more powerful than any man could be, with thighs fuller, chest broader, shoulders more powerful, and gaze more confident and triumphant. But, more subtly than his predecessors, the sculptor of the Croesus statue has adjusted the power of his kouros to the human body, so that the fear and pride associated with the hero recede before an ideal reality in stone.

This ability to believe in the product of man's cunning as the embodiment of his dreams is the secret of the wonders of Archaic drawing and sculpture. It explains the marvelous stories that gathered around the masterpieces of the most famous artists, all based on the assumption that, like Pygmalion, they could make statues endowed with life. So too, it explains the unrelenting efforts of the Greek sculptor and painter to make a visually credible image of the world about them and, at the same time, their ability to suggest what is more beautiful, stronger, and more divine than the world of flesh and blood. In short, it explains their ability to make both the calf bearer and his calf.

2. Archaic Architectural Form

Pindar's ode for the victory of Agesias of Syracuse in 468 B.C. begins with these words:

> As if on the handsome porch of a hall we raised golden
> columns like a towering megaron,
> we shall construct [this ode].[1]

Buildings of the size, scale, and refinement that Pindar admired had existed since the seventh century, when monumental architecture had made its appearance in the Greek world almost fully developed. The impression made by the daring early stone temples kept alive the memory of their builders' names and some details of their lives, so that more is known about them than about their contemporaries who practiced any of the other branches of Greek craft and industry.

The first thought of the Greeks was to build for their gods. Piety thus created a fortunate situation for the early architect, because he was called on to build for a kind of worship that had been unknown or architecturally unembellished in the Mycenaean past. There are, however, other religious and architectural links between the Bronze Age and later centuries. Two Archaic temples discovered in Crete at Prinias and Dreros resemble a Mycenaean megaron and shrine room combined; like a megaron, they have a hearth in the center of the room and, like a shrine room, they have a bench at the rear for the votive property of the god.[2] At Eleusis the hall of the mysteries grew up around a Mycenaean podium shrine, a descendant of which always remained the focus of the Eleusinian mysteries. And at Gortyn in Crete a small temple displaying marked Near Eastern architectural influence has been excavated. These buildings are not Classical temples in the usual sense of the term; the forms of the Classical temple were determined by cult practices that developed during the Geometric Age.

In the countryside, amid the ruins of a Mycenaean palace or in the open setting of a shrine that had acquired Panhellenic importance during the epoch of colonization, the gods (except for some underworld divinities and spirits for whom cave sites were traditional places of worship) had to content themselves, as no doubt they had long before, with worship under the open sky. The essential element of the open-air

1. *Olympian Odes* 6. 1–3.
2. For a similar temple at Gortyn, see Giovanni Rizza and Valnea Santa Maria Scrinari, *Il santuario sull'Acropoli di Gortina* (Rome, 1968).

3. The early history of Greek temple building in stone has now been carried back into the first half of the seventh century at the sanctuary of Poseidon at the Isthmus of Corinth by Professor Oscar Broneer, who announced the discovery of stone wall blocks and stone geisa from the early temple of Poseidon at the seventieth general meeting of the Archaeological Institute of America in 1968; see *American Journal of Archaeology* 73 (1969): 232. This evidence is also of great importance for documenting large-scale quarrying operations in Greece during the same period.

shrine was the altar, often nothing more than a mound comprising the cinders of countless sacrificial fires. Although cult statues came to acquire importance, in the beginning they were accessory objects, often merely rude figures of wood, saved from the aesthetic disgust of a later day only by some story of celestial origin. Nor was a temple to house the cult object one of the necessities of the primitive shrine, and although the monumentalized temple later came to dominate the sanctuary, the focus of the cult continued to be the altar, even in sanctuaries where an oracle could be consulted in the temple. This is why the exterior played such an important role in Greek temple design and why the organization of the whole sanctuary cannot be neglected in a discussion of temple development.

Apart from its altar, cult image, and temple, a Greek sanctuary was known by its votive offerings, and its reputation could be judged by their number and opulence. Statues and large metal objects like tripods could stand in the open if well anchored. Small votive gifts could swing from the boughs of trees, as they did in the sanctuary of Zeus at Dodona. But gold and silver, ivory and amber, and even the smaller vessels of bronze needed protection. And so the Greek sanctuary grew by the addition of colonnades (stoas) and treasuries, the former providing the most open, the latter the most trustworthy, repositories. That chaos did not result from the buildings and offerings with which the piety of states and individuals encumbered the sanctuaries was due to the architects of the seventh century, who created the orders of architecture and thereby a means of channeling the potential confusion of independent initiative into a setting of style and taste.[3]

•

The German excavations of the sanctuary of Hera on Samos have made it possible to see how such a seventh-century show place developed. In the eighth century Samos already boasted a temple with a foundation 100 feet long. There is no evidence that the structure, which has been aptly described as barnlike, was architecturally refined. By the mid–seventh century, however, Hera's shrine was already a peripteral building (30). There is no way of determining what resemblance its exterior

30. Second temple of Hera at Samos, ca. 650 B.C.

design bore to the Ionic order, but it was undoubtedly a structure of mud brick and wood, not stone. By the addition of columns to create a peristyle, it was transformed into architecture of a definite style. The very simplicity of this change obscures its importance and brilliance, for an isolated building surrounded by freestanding columns has no prototype in Greece, Egypt, or the Orient. The unknown inventor of the peripteral temple may have been inspired by tales of the columned halls of Egypt or the Orient; indeed, he may have been a traveler who had seen those sights. But unlike the potter or the ivoryworker, who required instruction in figure style and ornament, and unlike the sculptor, whose idea of a statue began with a miniature figure, the builder of the first peripteral temple was an inventive genius. From whatever Greek city it originated, his idea quickly spread throughout the Greek world.

What inspired his achievement, and what was he trying to do? The column was familiar to him from the porch composed of columns between wall ends that was common in the Bronze Age and no doubt through the succeeding centuries. He may also have known buildings with porches at either end. It is not so easy to imagine that the peripteral temple was invented merely by extending such porches around the building, in the manner of the secondary porticoes or rows of shops that the Romans attached to their basilicas, for the transformation of a simple building with porches into a peripteral temple requires a fundamental rethinking of the pitch and system of support of the sloping roof.

The seventh-century architect, however, was probably not unfamiliar with buildings requiring the support of the lateral slope of a roof on a line of columns. At Samos and the Argive sanctuary of Hera there are stoas of the seventh century that existed at the same time as the first peripteral temples at

either site. At both sites the excavators have dated them slightly later than their temples, although the archaeological evidence is too meager to exclude the possibility that the stoas were built first. In any case, the stoa, like the single-room shrine entered through a porch, belongs to the types of utilitarian architecture found in the Mediterranean since the Bronze Age: the megara of the lords of third-millennium Troy fronted on a court surrounded by porticoes, and the megaron at Tiryns, constructed a thousand years later, had the same arrangement. If the inventor of the peripteral temple knew the stoa, his invention consisted in transferring its visual effect to the flanks of the temple.

The peripteral design was never intended to be functional. Although the inner chamber of a Greek temple (cella) was frequently a repository of treasures, and the columns of the porches were not infrequently closed by grilles, only in Temple FS at Selinus did the peristyle have closings between the columns. Moreover, the single peristyle was too shallow to afford protection from the elements or accommodate religious processions.[4] Rather, the peristyle articulated the surface of the temple, giving depth and the changing, enlivening accents of light and shade to a structure that in growing large would have grown ugly, despite attempts at wall decoration. And the repetition of the architectural order in the temple and its stoas gave unity to the sanctuary. Visitors to the newly ennobled sanctuaries of the seventh century, coming from haphazard old towns or monotonously angular new cities, must have felt a surge of pride at what they saw. Even in the Hellenistic Age the temple of Artemis at Ephesus (no larger than its sixth-century predecessor) was included with the Pyramids of Egypt and the walls of Babylon among the wonders of the world.

The ground plans of the mammoth temples of sixth-century Greece were complicated by doubling and tripling the rows of columns of the porches and peristyle to create a forest of columns. At Ephesus, for example, there were 106 columns in the temple of Artemis that was built shortly before the middle of the sixth century with donations from Croesus of Lydia (31, 32). Such multiplication of columns must have been in conscious imitation of the hypostyle halls of the East, and as the Samos temple shows, it began with columns

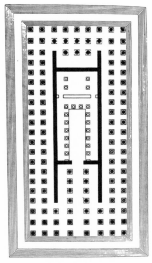

31. Temple of Artemis at Ephesus

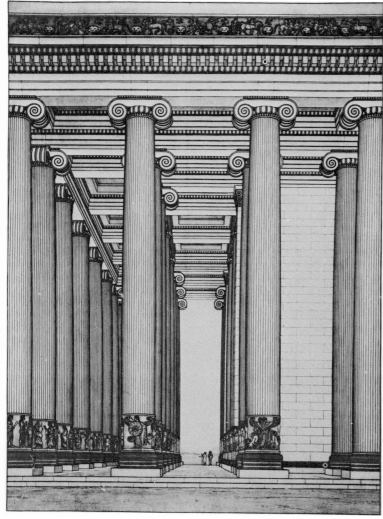

32. Temple of Artemis at
Ephesus

within the wall ends of inner porches, which were the first to
be doubled and then redoubled in the passion for massed col-
umns. Also of Eastern derivation are spectator-level friezes
like those on the lower shafts of the columns at Ephesus,
which are direct imitations of the friezes at the base of the
walls of Oriental palaces. Both these friezes and columnar
multiplication were fashions assumed by a building that was
very different from an Oriental columned hall, for, unlike the
latter, the Greek peripteral temple was designed to be seen and
appreciated from without.

33. Third temple of Hera at Samos, ca. 575 B.C., and adjacent structures

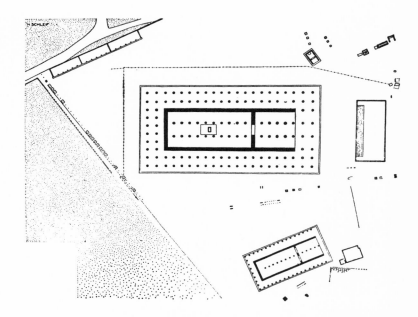

These buildings fulfilled the essential requirement of monumentality in architecture, accomplishing the seemingly impossible with grace and beauty, and it was as engineering feats that the huge Ionian temples acquired much of their reputation in the ancient world. The builders of the temple of Hera on Samos (33) were a father and son, Rhoecus and Theodorus. Herodotus, in the earliest reference to their work, written a little more than a century after the temple was erected, calls Rhoecus the architect. Vitruvius and Pliny, however, ascribe the building to both father and son. This discrepancy is explained by the respective roles of Rhoecus and Theodorous. Diogenes Laertius recounts that when the builders of the temple at Ephesus consulted Theodorus about the engineering problems of building in the Ephesian marshland, he solved them by laying an absorbent mat of charcoal below the foundations. Theodorus was also responsible for a round, umbrellalike hall at Sparta that was much admired for its unusual and daring construction. Apparently, then, Theodorus was principally an engineer and Rhoecus was principally an architectural designer, and they collaborated on the temple of Hera on Samos. As the engineer, Theodorus saw to quarrying, transport, and preparing the foundations, and although the position of the columns might not be his respon-

sibility, their setting up was. As the architectural designer, Rhoecus prepared scale models of individual members and decorative details for the masons to follow. The architectural designer might be more artist than builder, for the architectural design of the Greek temple was always closely allied with the art of the sculptor.

In many ways the early temples betray the inexperience as well as the daring of their engineers. In Rhoecus' temple of Hera at Samos the spacing of the peristyle columns was determined by setting out equal divisions of the interval between the wall ends of the porch for the central columns of the peristyle fronts and then making a second division of the space between these and the edge of the peristyle. The two sets of intercolumniations were not uniform; Rhoecus' reliance on fixed points on the ground demonstrates, among other things, how little the Archaic Greek architect could have used drawings for his work. The gross discrepancies in the interaxial spacings of the peristyles of early temples on the Greek mainland and in Sicily are further reminders of the problems faced by the first Greeks who built in stone on a monumental scale.

Little attention has been given to the importance of stone engineering in creating the stone temples that sprang up within a generation throughout the Greek world. Theodorus was not the only Ionian engineer to undertake commissions in mainland Greece, for Bathycles of Magnesia also worked for the Spartans, building the shrine of Apollo at Amyclae, and in 514 B.C. another Samian, Mandrocles, was the engineer called to construct Darius' pontoon bridge over the Danube. A contemporary inscription also shows the importance both of Ionian engineering and of cooperation between engineer and designer in the construction of Greek temples. The inscription (34) on the top step of the temple of Apollo at Syracuse in Sicily, certainly built before the middle of the sixth century and quite possibly as early as 600 B.C., names the two master builders of the temple and describes their work: "Cleomenes the son of Cnidieides made it for Apollo, and Epicles made the columns, beautiful works."[5]

Cleomenes was not a dedicator. The verb (*epoiese*) makes it clear that he was a maker or builder. He was the engineer, while his associate Epicles was responsible for the detail

5. Restored by Margherita Guarducci, "L'iscrizione dell'Apollonion di Siracusa," *Archeologia classica* 1 (1949): 4–10. The inscription is in *Inscriptiones Graecae*, 14, no. 1. Unpublished excavation evidence is reported to favor dating the temple at the end of the seventh century; see Guarducci citing Giorgio Gullini in *Archeologia classica* 16 (1964): 150.

34. Temple of Apollo at Syracuse, stylobate inscription

6. The question of the influence of the Ionian architects and engineers is discussed in full by R. Ross Holloway in "Architect and Engineer in Archaic Greece," *Harvard Studies in Classical Philology* 73 (1969):281–90.
7. For the Oriental elements recombined in the Ionic order and molding system, see Fritz Krischen, *Weltwunder der Baukunst in Babylonien und Jonien* (Tübingen, 1956), pp. 50 ff. John Boardman maintains that the Ionic order was evolved from prototypes in the minor arts, in "Chian and Early Ionic Architecture," *Antiquaries' Journal* 39 (1959):170–218. The concave Doric molding system derives ultimately from the deep cavetto and simple half round. The deep cavetto seems to be a genuine Egyptian contribution to Greek architectural design, although it is such a simple form that its transmission to Greece need not have depended on any close association between Greeks and Egyptians.

work of the columns. Since Cleomenes' patronymic identifies him as the son of Cnidieides, it may be that the original home of his family was Cnidos in Ionia. The homes of the early Ionian engineers lie almost in sight of one another—Samos, Magnesia (Bathycles' home), and Cnidos—in an area that seems to have been the home of Greek engineering technique; nearby is Miletus, the home of Thales, the early engineering theorist. The commissions won by Bathycles and Theodorus at Sparta and the work of Cleomenes at Syracuse prove that the Ionians carried the techniques of building in stone to the rest of the Greek world, in which the regional styles of building, Doric and Ionic, developed on a common engineering basis but with separate traditions of design that had existed before stone architecture was introduced.[6]

•

The Ionic order clearly reveals its wooden prototype and the Oriental models for its details. The Doric order, however, offers no such clear indication of its origins, although the elements of its decoration appear to be derived from wooden joinery (35).[7] This is particularly true of the butt-blocklike mutules and regulae and the panellike triglyphs. The guttae decorating the underside of the mutules and regulae can be interpreted as wooden pegs or as ornamental bosses like those used to decorate doors and still existing in the House of Loreius Tiburtinus at Pompeii. But such forms, directly translated from wooden building into stone, are not structural but have been added to the Doric temple as decoration.

The triglyph cannot be the decorated beam end of a wooden building turned into stone because the rafters cross the peristyle above the level of the frieze. Moreover, if interpreted as beam ends, the line of triglyphs across the fronts and on the

flanks of the temple would mean that longitudinal and trans- verse beams crossed at the same level, which is impossible. Nor is the frieze band on which the triglyph is placed a struc- tural necessity; Etrusco-Italic temples existed without it. In the Doric as well as the Ionic order the frieze is a decorative band whose role in the harmony of the design is apparent. In the decorative pattern of the Doric order, the vertical grooves of the triglyphs and the flutes of the columns alternate with the dotlike guttae of the regulae and mutules. Enclosing this pattern are the large horizontal elements of the building, the foundation platform, the architrave, and the cornice, the crown of the latter punctuated with spouts or decorated with antefixes aligned with the triglyphs. There is a kinship be- tween this kind of architectural design and the sequence of horizontal decorative bands in Greek Geometric pottery.

The triglyph pattern was not used exclusively for the dec- oration of temple friezes but was considered appropriate to any horizontal architectural band, such as the face of the natural rock podium below the small Archaic shrine in the agora of Corinth. It was a standard decoration for an altar, the basic architectural feature of a Greek sanctuary. Is it more likely, then, that the triglyph frieze was transferred from the temple to the altar or from the altar to the temple? Surely the latter is correct. And if it is, the triglyph frieze may form a connection, however tenuous, between later Greek architec- ture and the Bronze Age; for the similarity between My- cenaen-Minoan dadoes and the triglyph frieze has often been remarked, and bands with decoration like that of the triglyph and metope have a continuous life in Greek pottery through the Mycenaean and Geometric periods.[8]

Whatever the precise origin of the Doric order, it was first worked out by an architectural genius, or geniuses, in the mid–seventh century for buildings made of wood and mud brick with terra-cotta revetments decorating the wooden en- tablature. Two such temples, also decorated with gay scenes

8. See M. L. Bowen, "Some Observations on the Origin of Triglyphs," *Annual of the British School at Athens* 45 (1950): 113– 25.

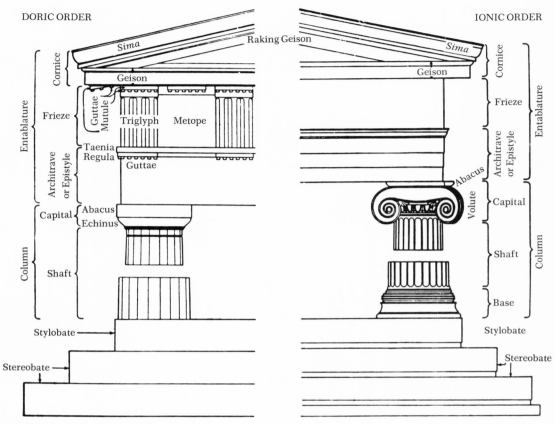

35. Doric and Ionic orders

baked into terra-cotta metopes, at Thermum and Calydon, in Aetolia, show that in the early days building a temple was far beyond the local craft resource of an average Greek city, for the terra-cotta plaques that covered these two temples had been prefabricated in Corinth.[9]

Doric architecture—and western Greek adaptations of it— was to have a longer and richer history than Ionic. After the colossal dipteral temples of the first half of the sixth century, which were the greatest independent work of the Ionian designers and engineers, Ionic failed to advance. The reasons for this were not merely political, in spite of the conquest of Ionia by the Persians in the later 540s. The Ionic style was itself to blame for its failure to develop. For all its beauty and grace, it lacked the clear relation of alternating horizontals, verticals, and points that in the Doric order excited the ingenuity of architects working in mainland Greece and the western Greek world. Not until Pythius built the temple of Athena at Priene in the fourth century was the play of mathematical proportions introduced into Ionic architecture.

The development of the Doric order cannot be understood without some knowledge of its technical problems, especially angle contraction, the reduction of the distance between the final column (or columns) at either end of a row and the neighboring columns. Angle contraction was the result of a design problem in Doric architecture that could never be perfectly solved. Traditionally, a triglyph stood over each column and over the center of each intercolumniation. Arranged in this way, the last triglyph of each face of the frieze would both stand over the center of the corner column and come out to the edge of the frieze only if its width corresponded to the size of the cross-section of the architrave below. In wooden structures with wide intercolumniations, it was possible to keep this relationship and also place a triglyph over the center of each intercolumniation without making the metopes ridiculously narrow, but once stone building was introduced and the columns had to be set closer together, it became impossible to follow the original conventions of the order without losing the metopes altogether. The varieties of Doric design that appeared during the sixth century are largely related to the various ingenious attempts to cope with the corner triglyph problem.

9. For their manufacture at Corinth and shipment to Thermum, see Humfry Payne, *Necrocorinthia* (Oxford, 1931), pp. 248 ff.

If an end triglyph is centered on a column and is thinner than the width of the abacus of the column, there will be a partial metope between the triglyph and the corner of the building. To eliminate this metope either the triglyph must be pushed out to the end of the frieze, causing displacement and irregularities in the arrangement of the other elements of the frieze, or angle contraction must be employed, in which case the corner column (or the corner column and one or more others in the same file) is moved, reducing the length or width of the building.

Angle contraction was the preferred solution to the corner triglyph problem as Greek mainland architects moved toward the development of the temple form that was to dominate the fifth and later centuries. The temple that evolved had a single colonnade—six columns on the fronts and thirteen on the flanks—surrounding a single-cella temple whose front and rear porches (pronaos and opisthodomos) were entered through two columns between the wall ends. Mainland temples tended to adhere to this model, though special requirements led to special ground plans, like that of the temple of Apollo at Corinth, where the need to accommodate two cellae resulted in an elognated peristyle of fifteen columns on the flanks in combination with the standard six on the fronts.

•

In the western Greek world, comprising all Sicily and south Italy as far north as Cumae, the Greek colonists adopted the architecture of Dorian mainland Greece, but their monuments are far from being copies of standard Doric work. Ionic architecture exerted an influence in western Greece through Ionian engineers who worked there, but the concepts of the colonial architects are often startlingly independent.

There are some fixed dates for mainland Doric buildings—among them the Heraeum at Olympia (ca. 600 B.C.) and the temple of Apollo at Corinth (ca. 540 B.C.)—which can be determined from the pottery recovered from their foundation fills. And the sculpture of the "Gorgon" temple (temple of Artemis) on Corfu (36), it is generally agreed, was made between 600 and 580 B.C. But the west has produced no foundation deposits, and the sculptural decoration of its

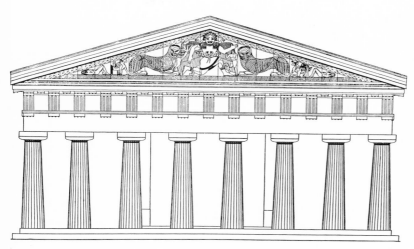

36. Gorgon temple (temple of Artemis) on Corfu

buildings is more difficult to place chronologically. There has therefore been a tendency to judge the western temples by the standards of the mainland, and, in the presence of seeming incongruities of design and detail, to date the western temples on the basis of their latest details according to mainland chronology.

The temple of Apollo at Syracuse, for example, is dated in a well-known English handbook at about 540 B.C., on the basis of its architectural terra cottas. The date of the roof, however, is not necessarily the date of the building, for the terra-cotta roofs of western temples were frequently replaced; for instance, the important anonymous temple at Selinus, known as Temple C, had more than one roof during the sixth century. And while the temple of Apollo at Syracuse has narrow intercolumniations and low columns (37, 38), both symptomatic of early caution in stone construction, a glance at the façades of the Gorgon temple on Corfu of about 580 B.C. and of the temple of Apollo leaves no doubt that the Syracusan temple is earlier. The comparison is valid because Syracuse was linked to Corfu not only by their common origin as Corinthian colonies but also by the main artery of communication with the mother country, which passed from Sicily through Corfu and so to Greece. A more reasonable date for the temple of Apollo (without its existing roof terra cottas) would be in the last quarter of the seventh century.

There is a similar chronological problem for Temple C at

37. Temple of Apollo at
Syracuse

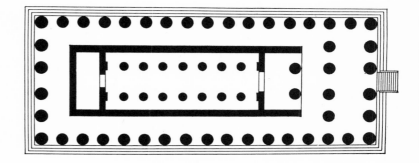

38. Temple of Apollo at
Syracuse

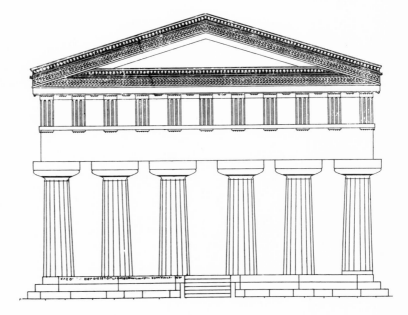

Selinus in western Sicily, the three reconstructed metopes of which are among the chief treasures of the Palermo Museum (39–41). The subjects of these metopes are a divinity in his chariot, Heracles and two mischievous imps called the Cercopes, and Perseus slaying the Gorgon Medusa. The chronological problem of these sculptures is that while the proportions and facial types of the figures are early Archaic, like the sculptures from the Gorgon temple on Corfu and the earliest groups of kouroi, details of drapery, most noticeably in the overlapping pleats of Perseus' tunic, belong to artistic conventions of the late sixth century. Rather than provinciality, such a mixture of styles reflects the Greek practice of

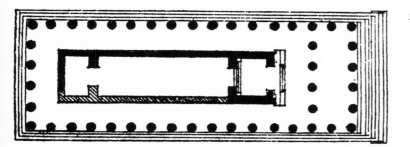

39. Temple C at Selinus

40. Temple C at Selinus

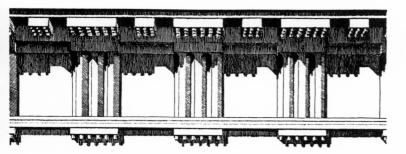

41. Temple C at Selinus, metope

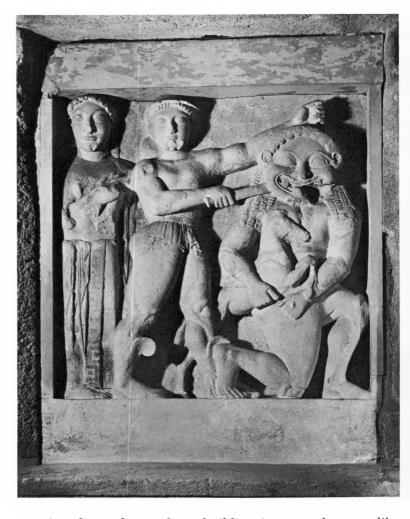

erecting the sculpture for a building in a rough state, like the columns, and finishing it later in place. This practice is documented by the extraordinary early prostyle building in the sanctuary of Hera at the mouth of the river Sele, just north of Paestum in south Italy, where a number of the metopes, after having been blocked out on the ground and hoisted into place unfinished, were never completed (42). Evidently, the Gorgon metope of Temple C at Selinus was finished many years after it was installed—hence the mixture of early and mature Archaic styles.

Although the roof terra cottas of Temple C were renewed in

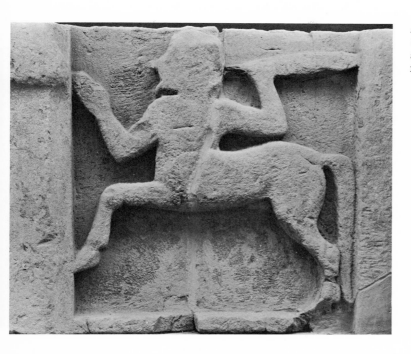

42. Sanctuary of Hera
(early prostyle building)
at mouth of Sele River,
metope

the course of the sixth century, there can be no doubt that the temple was originally constructed at the beginning of the sixth century, when the Gorgon temple on Corfu was built.[10] Comparison of the orders of the two temples shows how much they have in common (36, 40). In both temples the usual simple grooves ornamenting the shafts of Doric columns just below the capital were replaced by wide channels and small bands of beaded ornament, and on the thin band crowning the architrave, usually left unornamented, there was a similar design, a countersunk astragal. Also, in both buildings the peglike guttae suspended from the underside of the overhanging cornice were different from those of conventional Doric. While in the usual arrangement an equal number of rows of guttae was placed over each metope and triglyph of the frieze, on these two temples, as on some other early ones, there were fewer guttae over the metope than over the triglyph.

Similar criteria can be used to date the monumental architecture of another important city of western Greece, Paestum, on the coastal plain south of Salerno between the Alburnian Hills and the Tyrrhenian Sea. The order of the earliest temple at Paestum (43, 44), long known as the Basilica but now

10. See Antonio di Vita, "Per l'architettura e l'urbanistica greca d'età arcaica, la stoa nel *Temenos* del Tempio C e lo sviluppo programmato di Selinunte," *Palladio,* n.s. 18 (1967): 3–61, and R. Ross Holloway, "The Reworking of the Gorgon Metope of Temple C at Selinus," *American Journal of Archaeology* 75 (1971): 435–36. The reroofings of Temple C at Selinus will be discussed in the forthcoming study of Dr. Giovanni Scichilone, to whose kindness I am indebted for permission to mention his most interesting discoveries.

43. First temple of Hera
(Basilica) at Paestum

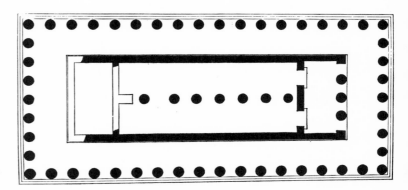

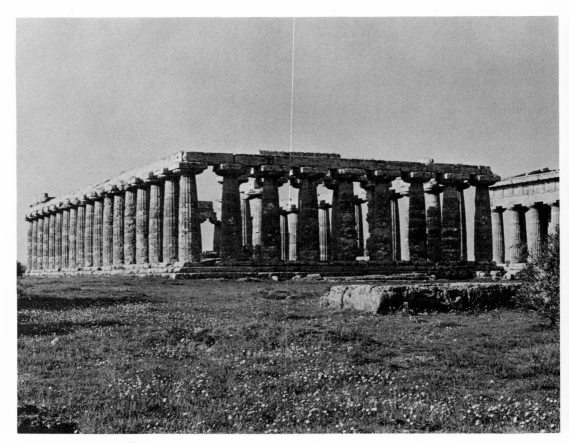

44. First temple of Hera
(Basilica) at Paestum

attributed to the goddess Hera, has points of similarity with the columns of Temple C and the Gorgon temple, but the date of the first temple of Hera at Paestum has generally been fixed by comparison with Temple C and placed far too late. But if Temple C was built in the early sixth century, the first temple of Hera should be placed at least at the beginning of that century. Indeed, there is a good possibility that it is somewhat earlier, because its ground plan has a central row of columns in the cella and an odd number across the façade, a primitive design found in buildings of the seventh century such as the second Heraeum on Samos and the temple at Thermum.

•

In at least three major cities of the rich new Greek world— Syracuse, Selinus, and Paestum—monumental temples were begun by the end of the seventh century or in the years immediately following. Furthermore, these western temples have their own refinements in design: the cella raised above the level of the peristyle, an enclosed room (adytum) replacing the rear porch, and, frequently, a row of columns, as in Temple C, fronting the east and principal porch. At the same time the entablatures remain heavy in proportion to the order, and more use is made of adjustments in the frieze than in the ground plan to solve the problem of the corner triglyph.

Ionian engineers like Cleomenes and possibly Ionian architectural designers asked to build in the Doric style added to western Greek architecture ideas and details familiar in Ionia. Convex Ionic moldings often replaced the largely concave Doric molding system, more abundant floral ornament (like that on the columns of Temple C and the first temple of Hera at Paestum) made its appearance, and the temple façades were given double porches and wide peristyles like those of the Ionian dipteral temples. But these were not the only innovations that took place in western Greece, for there sacred architecture took an additional forward step that carried it into the realm of architectural expressionism.

In Paestum in about 515 B.C. a temple (at one time believed to be a temple of Ceres) was erected north of the first temple of Hera (the Basilica), which had been standing for

almost a century. The new temple (45–48), as the offerings from votive deposits excavated in its neighborhood show, was dedicated not to Hera, the Greek equivalent of the pervasive female divinity of this area of Italy, but to the goddess of wisdom, Athena.

This period of intellectual and spiritual ferment in the Greek cities of south Italy was dominated by the Ionian philosopher, mathematician, and mystic Pythagoras, who settled in Croton some ten years before the temple of Athena was built at Paestum. Pythagoras was one of the gifted thinkers who, believing that they have the key to the secrets of the universe, convince their contemporaries that absolute truth has at last been found. Pythagoras' key to truth consisted in simple harmonic ratios that were evident in the natural phenomenon of sound and could be expressed in mathematical form. In the Pythagorean scheme, ten was the perfect number, while the number four was the creative principle, since the arithmetic progression ending in four is composed of the numbers one, two, three, and four, which, added together, produce the perfect number. The number four, considered as the creative unity of this series, was called the tetractys. Despite the obscurity of early Pythagoreanism, there is little doubt that the essentials of Pythagorean number theory were the work of the founder.

The design of the new temple of Athena at Paestum was entrusted to an architect who seems to have seized the opportunity of making the fundamental, creative ratios of Pythagorean mathematics the controlling modules of his building. The extraordinary temple that resulted measures only 48 by 108 feet on the exterior of the top of its platform, but largely because of the height and breadth of the entablature it achieves an effect of majesty out of proportion to its size. The temple is a union of Doric and Ionic carried out not simply by the use of Ionic columns for the interior porch but also by the substitution of Ionic moldings for the traditional Doric punctuation of the entablature above and below the triglyph and metope frieze. The construction of the frieze was novel, for the triglyphs were made as separate slabs to be fitted into slots between the metopes. Also quite unparalleled in Doric architecture is the underside of the roof overhang, or

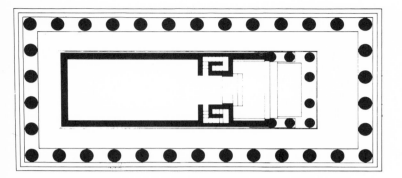

45. Temple of Athena (temple of Ceres) at Paestum

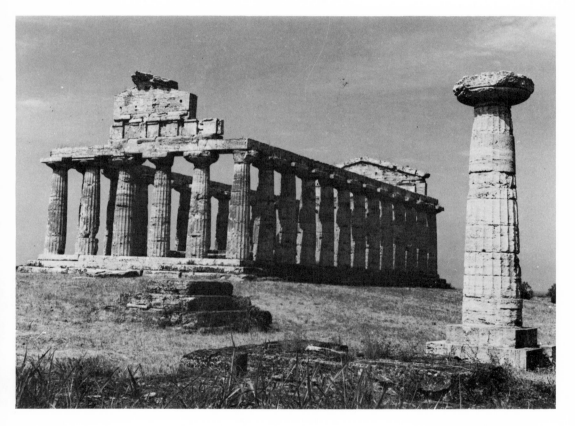

46. Temple of Athena (temple of Ceres) at Paestum

47. Temple of Athena
(temple of Ceres) at
Paestum

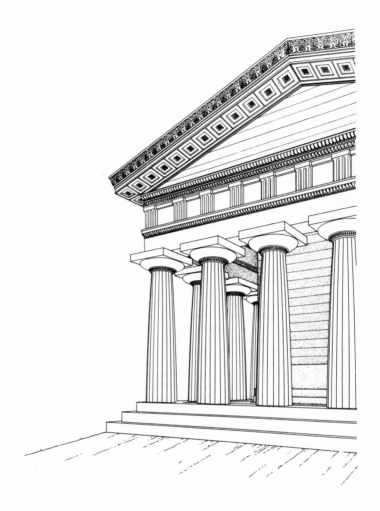

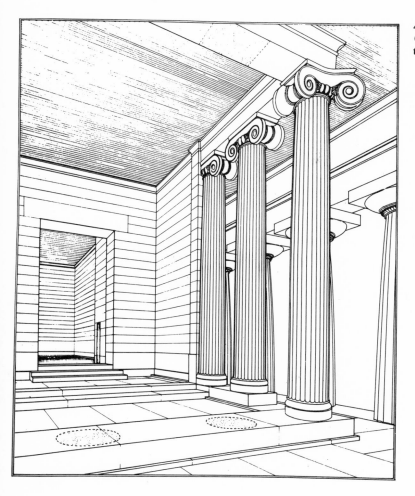

48. Temple of Athena (temple of Ceres) at Paestum, porch

11. R. Ross Holloway, "Architettura sacra e matematica pitagorica a Paestum," *La parola del passato* 106 (1966): 60–64.

geison soffit, which was decorated with coffers in place of the usual Doric mutules and guttae.

The mathematical symbolism of the architecture, however, is to be found in the ground plan of the peristyle, which, including the shared corner columns, has six columns on each front and thirteen on each side. From center to center of the end columns, the fronts measure 40 Doric feet; the sides, 96. Unique in Archaic Doric architecture is the uniformity of the intercolumnar spacing, for the designers of later sixth-century temples, even in western Greece, compensated, at least partially, for the corner triglyph problem by adjusting the ground plan. In the temple of Athena, however, the architect absorbed the entire displacement caused by the corner triglyph problem by widening the end metopes, a solution that must have seemed awkward to his contemporaries.

Principle rather than convenience seems to have inspired this deviation from conventional practice. For the architect of the temple of Athena seems to have designed its ground plan as an embodiment of Pythagorean harmonic ratios. Since he spaced the centers of the columns forming the colonnade uniformly 8 Doric feet apart, the unit of measure (according to ancient architectural practice specified by Vitruvius) may be considered 4 Doric feet, a half intercolumniation. Consisting, therefore, of ten 4-foot modules, each front represents the productive Pythagorean number four multiplied by the perfect number ten. And the sides, each having twenty-four 4-foot modules, represent the product of the productive number four multiplied by twenty-four, the product of the components of the tetractys ($1 \times 2 \times 3 \times 4 = 24$).[11]

The temple of Athena at Paestum lacks only one element: sculpture. But the architects of this period, in perfecting a monumental building that embodied a mathematical philosophy, had created a stage for the permanent display of visions of the heroic and divine world in sculpture.

3. Narration in Archaic Art

If the history of Greek architectural sculpture is considered apart from the rest of Greek art, its development seems direct and simple. In the early Archaic Age temples were decorated with mythical representations chosen for their individual relation to the cult or city rather than for thematic interconnections. Soon the sculptures assumed a programmatic unity, first in the simple juxtaposition of mythical cycles and later by more complicated patterns of reference that in the fifth century verged on allegorical art.

The meaning of allegory in antiquity has been lucidly explained:

> As used by ancient authors, it was always a technical term of rhetoric, and meant two somewhat different things, according to the context. Applied to the creative process of narration, it meant a chain of metaphors by which an abstract intellectual concept could be made accessible to the concrete imagination. Applied to the analytical process of interpretation, it meant the technique of extracting the metaphysical notions implicit in a complex of imagery. These two complementary uses of the word prove that its inventor could distinguish between a mental concept and its verbal expression; and this at once marks the allegory as the product of philosophic reflexion. Allegory stands, as it were, midway between poetry and prose: in its creative aspect it is the poetic rendering of a prosaic idea; in its interpretive aspect it is the prosaic rendering of a poetic image.[1]

In Greek art the concrete subject or scene represented was never entirely submerged in the overtones of symbolism and allegory that may also be present. One of the monuments of the Persian Wars was the Serpent Column bearing the names of the allied Greek cities and topped by a golden tripod (49, 50). It was dedicated to Apollo in the precinct at Delphi and stands today in the hippodrome at Istanbul where Constantine put it in the fourth century A.D. The golden tripod of Apollo set over intertwined serpents is an obvious allegory of the Greek victory over Persia; it calls upon the story of Apollo's victory in the Delphic sanctuary over his adversary Python for the clear allegory of its two symbolic elements, the tripod and the snake. Yet the dedicators of this memorial

1. Roger Hinks, *Myth and Allegory in Ancient Art* (London, 1939), p. 4.

49. Serpent Column from
Delphi

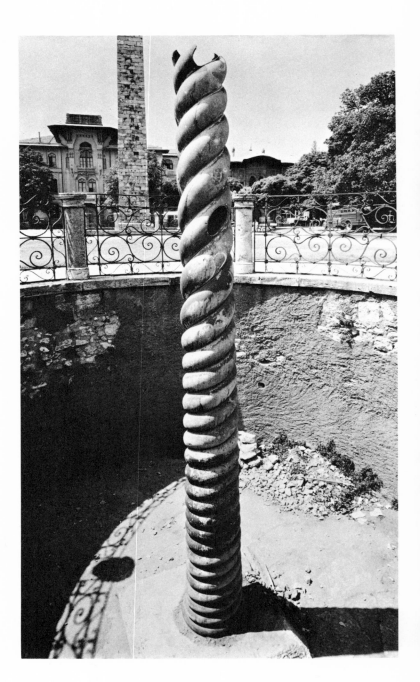

were not solely interested in its allegorical meaning. Indeed, the immediate, concrete object was as important as its symbolism. They had not tired of the wonderful world of plastic creation that their ancestors had discovered little more than two centuries before, and the modern distinction between representation and symbolism in art would never have occurred to them. Art in the Archaic tradition was therefore able simultaneously to elicit an appreciation of both the concrete object and its allegorical meaning—to produce what may be called an *implicit metaphor*.

●

The first narrative monuments that can be interpreted in the light of the implicit metaphor are two objects described by Homer and Hesiod that may never have existed: the shield of Achilles (51) and the shield of Heracles (52). Homer's shield of Achilles, the memorable object wrought by Hephaestus in the eighteenth book of the *Iliad*, is a vast design in a vast poem; it embraces the heavens, the earth, and the sea, and displays moments of hope, fear, joy, and anxiety in the timeless epic world. Hesiod's shield of Heracles, described in a passage over twice the length of its Homeric counterpart, dominates a much shorter poem that is devoted to the battle of Heracles and the giant Cycnus. The decoration of the two shields has much in common, especially in that both contrast the city at peace with the city at war; indeed, it is usually thought that Hesiod's passage was inspired by Homer.

On the center boss of Hesiod's shield were Fear (Phobos) and Strife (Eris) wreathed by snakes. Encircling the boss was a frieze of lions in combat with wild boars. The second frieze was long enough to include two scenes. The first was the battle of Lapiths and centaurs occasioned by the attempt of the latter to carry off the bride of the Lapith king from his wedding feast—a victory of the human (and Hellenic) over the half-human (and barbarian) that was to become a familiar motive in Greek monumental art. Flanking the brawl are the two gods of battle who accompany Heracles into combat, Athena and Ares. The second part of this frieze is a religious dance, in which Apollo performs on the lyre. The third frieze is also divided into two parts: in one, the hero Perseus flees

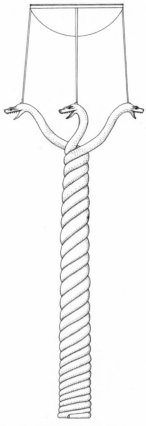

50. Serpent Column from Delphi

51. Homer's shield of
Achilles

52. Hesiod's shield of
Heracles, partial recon-
struction

with the head of the Gorgon Medusa from her pursuing sisters; in the other, a harbor, dolphins, fish, and a fisherman are represented. The two scenes of the fourth frieze are explicitly positioned. Adjacent to the Perseus episode is a battle gorier than any in the *Iliad*, while its opposite, the city with all the activities of agriculture and religious and social life appropriate to a time of peace and plenty, continues the decorating of this frieze apparently adjacent to the harbor scene of the preceding frieze. Finally, at the edge of the shield is the wide ocean, no doubt suggested by the continuous ripple pattern of many Greek artistic borders. The elements of the decoration in the major friezes are clearly arranged to balance a progression of adventures and combats (centaurs and Lapiths, Perseus, and the battle) with a progression of peaceful scenes (the dance, the harbor, and the city at peace).

The scenes of the Homeric shield are arranged on a similar principle. A city at peace balances a city at war, and scenes of agriculture balance a ferocious attack by lions on oxen protected by men and farm dogs. The waves of the ocean again surround the rim. But the description is less regulated by a visualized frame of reference than that of Hesiod's shield, for Homer is not interested in saying explicitly whether a scene is adjacent to the preceding scene, and there is no representation that would serve for a boss. Homer's shield is a more purely literary device. In both poems the arrangement of the scenes forces comparison, choice, and judgment without diminishing the excitement of each picture. The implicit metaphor is that of peace and war, order and confusion. And the metaphor is made universal by placing it in a world setting of night and day, land and ocean.

Here at the beginning of Greek art are descriptions of sequences of scenes that are as close to allegorical art as the Greek artist was to come for several centuries. The designs of the shields of Achilles and Heracles, however, are apparently the product of poetic imagination, only distantly inspired by such artisans' work as the early-seventh-century shields from the sacred cave on Mount Ida and other Cretan sites (10). These Cretan shields are small votive objects from one to two feet in diameter. They have at most two friezes around the central boss, and the figures decorating them are executed in a Levantine style with the usual Egyptian touches.

53. Silver bowl from
Amathus

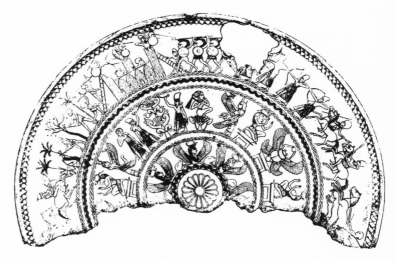

The subjects, arranged around animal-head bosses, are the
struggles of men and beasts, and hieratic animals.

Silver and bronze bowls of the period are also relevant to
the subject of shield design. The earliest piece that is known
is the ninth-century bronze bowl from the Dipylon Cemetery
discussed in chapter 1(5). The most elaborate is a silver
bowl from Amathus in Cyprus (53), which has three friezes
around its interior. The top and longest frieze represents the
siege of a city with domical houses such as are known to have
existed in north Syria. Infantrymen armed like Greek hoplites
take part in the fighting with Syrian archers and cavalry. An
Egyptianizing hieratic frieze follows, and the design is com-
pleted by a frieze of winged sphinxes around the rosette boss
at the bottom of the bowl. Similar objects, probably contempo-
rary with the Amathus bowl, are known from Etruscan tombs
of the seventh century. A comparison of these objects with the
shields described by Homer and Hesiod illustrates both the
intellectual forces that produced early Greek art and the
handicaps overcome by the Greek craftsman to make his work
worthy of its inspiration. However, the smith, the potter, and
the ivoryworker—dependent for instruction on Oriental mod-
els or on Oriental craftsmen who did not share their intellec-
tual stimulation—could make only slow progress in following
the poets.

Evidence that these handicaps have been overcome appears suddenly in the mid–seventh century in the decoration of a proto-Corinthian jug. This jug, the Chigi Vase discussed in chapter 1, is remarkable for its unusual friezes and command of figure style (15–17). The uppermost frieze is a scene of hoplite combat. At the left are two soldiers separated from the main scene, one of them still arming. Together they represent a device to increase the sense of movement and impact in the main action. The moment is critical, for the battle is just being joined between the forces. The army moving from the right advances in two lines, the first poised to hurl its spears, the second still advancing with spears at the ready, and each hoplite bearing a round shield adorned with a tribal device—a lion's head, a swan, a bull's head, an eagle, a swirl pattern, a gorgon's head, or a boar. The army on the left has been taken by surprise, and its second line advances on the double to close up behind the first. The shield devices of the second army are hidden, but to compensate for the absence of the decorative blazons and to balance the visual interest the artist has included a flute player sounding the cadence for his comrades.

The sophistication of this picture is one of the surprises of seventh-century art. Despite the difference in the disposition of the two armies, the mid-point of the frieze occurs where the raised spears intersect and is emphasized by the point of a palmette in the ornament above. The artist has used every tone available to the vase painter—in addition to black, purple, red, and dilute red (the latter giving orange against the cream ground in the figured scenes), he used white and purple on a black ground.

The major part of the middle band shows a line of horsemen following a chariot, whose horses are led by a small boy. The charioteer wears the long robes of a racing driver, and the riders are boys in short chitons. Beyond the riders a group of young men with spears surround a lion that is ravening one of their number. On the same band below the handle is the only mythical component of the decoration, the judgment of Paris. Although the scene is largely destroyed, Alexander (Paris) can be seen, as can the heads of Athena and Aphrodite (whose names, like Alexander's, are inscribed beside them and who are approaching him with Hera). On the

lowest band is another hunting scene in which lithe youths and their dogs stalk rabbits and a vixen through the brush.

This selection of scenes does not fit easily into a narrative program. It can, however, be interpreted as an exposition of the theme of *arete* (moral and physical superiority), especially as it was applied in Dorian Greece to soldiers, athletes, and hunters. It was this tradition of *arete* that Pindar defined so well in his odes for victors at the Panhellenic games. The major emphasis of the Chigi Vase, therefore, is on the soldier, the athlete, and the hunter. But the lion hunt is more an epic than a contemporary comparison, for it is improbable that lions could be seen, much less hunted, in seventh-century Greece. The Chigi Vase scene is remarkably like the lion-hunt inlays on the dagger of the Fourth Shaft Grave at Mycenae, which had been interred with its princely owner almost a thousand years before, and recalls the lion similes in the *Iliad*, as well:

> They were like a pair of lions on the heights of the mountain
> reared by their mother in the thick brush
> who seize cattle and herds of sheep
> ravage the farmsteads of men until they too
> are struck down by the sharp bronze in the hands of men.[2]

The epic hunt connected the world of the seventh century to its unseen, but clearly felt, components: the heroic and the divine. But the scene of the judgment of Paris is hardly an explicit endorsement of the advantages of divine favor. The result of Paris' choice among the goddesses was to be the Trojan War. It is the kind of quizzical reference that Pindar enjoyed making to suggest the instability of human fortune. And by contrasting the two hunting scenes, the epic lion hunt and the contemporary hunt after small game, the artist of the Chigi Vase seems to say, "We are not the men they were. But we contend in the struggle of life, too. And although we dare not say so, we, too, may be touched by the gods."

Although poets were recognized as the teachers of Hellas, painted pottery like the Chigi Vase was important in the Greek world, a world still largely illiterate, without illustrated books, without paintings on the walls of private buildings. The men's evening gathering, the symposium, that institution of such intellectual importance, took place in a room bare

of figured scenes save those on vases—the crater in the center of the party, the amphorae, the water jars, and the wine cups of the guests.

The decoration of vases was usually suited to the purpose for which they were made. Accordingly, on knee covers (*epinetra*) used in carding wool, vanity boxes (pyxides), and, sometimes, water jars (hydriae), it consists of scenes devoted to feminine pursuits, while the decoration of the jugs (*choes*) for children celebrating the festival of the Anthesteria depicts episodes from child life. Pottery made exclusively for the tomb (such as the Attic white-ground lekythoi) has funeral subjects. Specially commissioned vases, like the great funeral loutrophoros of the Penthesilea painter in the National Museum in Athens, also adapt their subject to their use. Dionysus dominates much of the black-figured and early red-figured pottery simply because many of the vases were intended for wine parties. Besides the Dionysiac vases, there is a wide variety of subject matter, with themes drawn from epic and comic sources as well as from daily life. The latter, however, come into prominence only toward the end of the sixth century. The pottery made for symposia before that time seems intended to create an appropriate atmosphere for those social gatherings. It is not always the same atmosphere, for there are scenes in which buffoons appear in padded costumes, as well as scenes of epic formality. But serious or comic, all fit the mood of the symposium. Many were evidently intended to lend an atmosphere of high seriousness to the gathering, and that is especially the effect of many of the late black-figured works from Exekias on, with their majestic processions of chariots, heroic combats, and gatherings of divinities. Although the Chigi Vase ended as an offering in an Etruscan tomb, it was made to inspire the songs of a Greek banquet.

From the point of view of theme and message Greek vase painting of the sixth century never surpassed the level of the Chigi Vase, not even in the most splendid accomplishment of Attic vase painting in the first half of the century, the François Vase. The latter is a black-figured volute crater made by Ergotimus and decorated with over a hundred figures by his associate Cleitias around 570 B.C. (54–56).[3]

Beginning at the top, the François Vase has seven bands, or friezes:

3. Its decoration has been discussed at length by John D. Beazley in *The Development of Attic Black-Figure* (Berkeley, 1951), chap. 3.

54. François Vase

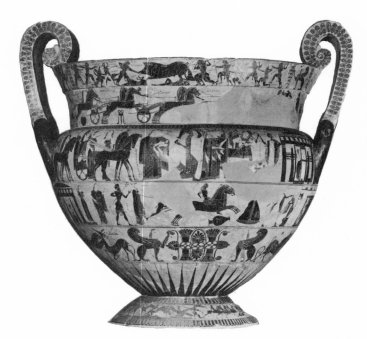

55. François Vase

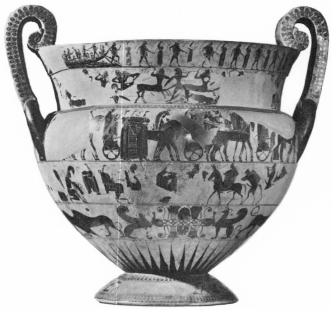

56. François Vase, handle
detail

1. The hunt of the Calydonian boar, with Peleus, Achilles' father, participating (54); and the dance of Theseus and his companions after escaping from the Minotaur (55)
2. The funeral games of Patroclus, Achilles' companion (54); and a battle of Lapiths and centaurs, with Theseus participating (55)
3. The arrival of the gods at the wedding of Achilles' parents, Peleus and Thetis (54, 55)
4. The pursuit of Troilus by Achilles (54), and the return of Hephaestus to Olympus (55)
5. An ornamental frieze (54, 55)
6. A design of rays (54, 55)
7. A battle of Pygmies and cranes (54, 55)

In addition, on each handle exterior are Artemis as Mistress of Animals, above, and Aias bearing Achilles' corpse from the field, below (56); and on the inside of each handle is a Gorgon's-head mask (gorgoneum).

Quite clearly the subject matter of the François Vase is divided between a Theseus cycle (two half friezes) and an Achilles cycle (two half friezes and two handle scenes). The major attention is given to the parents of Achilles, for Peleus not only appears in the colorful and populous Calydonian boar scene, but the only scene occupying a full frieze portrays the arrival of the gods for the wedding of Peleus and Thetis, herself divine but the bride of a mortal.

On the body of the vase the only frieze not directly related to another is the scene of Hephaestus' return to Olympus. (Having been expelled at the instigation of his mother, Hera, Hephaestus took his revenge by leaving an invisible net on Hera's throne that imprisoned her as soon as she was seated, and he refused to release her until, plied with a liberal measure of wine, he yielded to Dionysus and the promise of Aphrodite's hand in marriage.) In the painting Hephaestus comes back to Olympus seated on a donkey and accompanied by Dionysus, who thus gained admission to the divine circle, and a troop of ithyphallic satyrs. The satisfaction of the newcomers is matched by the chagrin of Ares, Aphrodite's lover, who hides behind Hera's throne, and the dismay of Aphrodite on seeing her clubfooted groom arrive. The Greek wedding had its traditional ribald customs, and Cleitias may have in-

tended the Hephaestus episode as a pendant to the wedding scene. Thetis, moreover, had sheltered Hephaestus during his exile, another link between Hephaestus and her wedding. The adventures of the deformed god may also be mirrored in the adventures of the Pygmies (equally deformed to Greek eyes) on the foot of the vase.

The François Vase is an excellent example of implicit metaphor. The scenes from the lives of Theseus and Achilles invite comparison but do not constitute judgment. They are not treated equally; and the pageantry and associations of the individual scenes at each moment vie with the chain of associations that is sustained from frieze to frieze.

One of the most elaborate Archaic decorative schemes, a chest dedicated by the seventh-century Corinthian tyrant Cypselus in the temple of Hera at Olympia, was described in detail by the traveler Pausanias. Cypselus' chest was a kind of museum of Greek heroic mythology, with thirty-five subjects in its decoration, and similar decorative schemes on a large scale were visible at Sparta in the temple of Athena of the Brazen House and nearby at Amyclae on the great throne of Apollo.

On one of the panels of the chest of Cypselus was a completely allegorical scene representing Justice beating down Injustice. Such personifications—Strife, Confusion, and Menace—were included by Homer in the decoration of the shield of Achilles, but Victory was the first such figure to find widespread portrayal. Personification, therefore, either single or combined to make allegory, was known to the Archaic Age, although allegorical groups are not common until the fifth century. The first major instance in sculpture is the group of Lady Peace with the child Wealth executed by the Athenian sculptor Cephisodotus to commemorate a general international peace negotiated in the early fourth century.

The decoration of the chest of Cypselus, however, was hardly designed to illustrate a theme or program. Nor were the similar heroic scenes, preserved on a less ambitious scale, that are particularly well illustrated on the seventh-century bronze shield bands from the excavations at Olympia. These scenes, generally limited to two or three figures, are vividly presented and adaptable to execution in various media. A comparable fragment is a tripod leg now in the Metropolitan

57. Bronze tripod leg, fragment

Museum of Art, on the upper part of which Peleus finds Thetis among her sisters while, below, Bellerophon mounted on the winged Pegasus is in battle with the Chimaera (57).

•

With the possible exception of the reliefs from the small shrine at Prinias in Crete, the terra-cotta metopes from Thermum and Calydon in Aetolia are the earliest surviving scenes with figures that were intended for temple decoration. The series from both buildings are far from complete, but

among the subjects preserved are Orion, Perseus, the daughters of Proetus, and Tereus, Procne, and Philomela.

The remarkable excavations at the sanctuary of Hera beside the mouth of the river Sele near Paestum have brought to light an almost complete set of metopes from an early prostyle building, proving that programmatic arrangement was entering architectural decoration of the early sixth century.[4] This structure was a simple cella entered through a four-column porch. It is 27.3 feet wide and was originally thought to have been 49.5 feet long but is now known to have been somewhat longer. Its construction was so primitive that there was no continuous foundation under the porch, the columns resting on individual piers. The walls are thought to have been of mud brick, but there was a stone wall-crown, and the sculptured frieze that encircled the building was executed in the local friable stone. The building is usually dated about 550 B.C. because the Sileni of the metopes have equine hindquarters, a type unknown in Attic vase painting before the time of Cleitias (ca. 570 B.C.). The building may have been erected in the preceding quarter century, although the character of the pottery fragments recovered from the foundation fill makes it certain that the date cannot be earlier.

There are three groups of metopes at the sanctuary, a Heracles group, an Oresteia group, and a group of other heroic subjects. The Heracles group (on the front or rear of the building) includes the battle with Pholus and other centaurs and (on a long side of the building) the Sileni attacking Hera, the Delphic tripod, the Cercopes, the Erymanthian boar, Antaeus, the Nemean lion, Nessus, Alcyoneus, and either Acheloüs or the Cretan bull. The Oresteia group (on the front or rear) includes the death of Agamemnon, the death of Aegisthus, and Orestes. The other heroic subjects (on a long side) are the death of Patroclus, the death of Troilus, the suicide of Aias, the mourning of Hector, a hero (Odysseus?) on a turtle, Tityus and Leto, Sisyphus, and Castor and Polydeuces with the daughters of Leucippus.

The Sele sanctuary was dedicated to Hera of Argos, and the decorative program is based on Argive themes. Heracles was as much at home in the region of Argos as at Thebes. The Oresteia is one of the most important Argive legends, and Agamemnon's leadership of the Greek host at Troy would

4. The treatment of the Sele metopes presented here depends on the doctoral dissertation of Frances D. Van Keuren, "Tradition and Invention in the Iconographic Program of the Early Archaic Temple in the Hera Sanctuary at Foce del Sele," Brown University, 1972.

5. This is the interpretation of Pierre de La Coste-Messelière, *Au Musée de Delphes* (Paris, 1936), pp. 96 ff.

6. *Archeologia Classica*, vol. 15 (1963), pls. 27, 28; *American Journal of Archaeology*, vol. 67 (1963), pl. 95; and *Archaeological Reports for 1963–64*, fig. 18.

make the association of subjects from the Trojan cycle easy and natural in an Argive setting. Sisyphus lived at Ephyre in the Argolid, and Leucippus was a descendant of Perseus, founder of Mycenae at the head of the Argive Plain. While programmatically chosen for their Argive associations, the iconography of the Sele metopes belongs to the common stock of late-seventh-century decorative scenes and thus demonstrates the international quality of much early Greek monumental architecture. Heracles' encounter with the Nemean lion, for example, belongs to the iconographical type of the hero stabbing a lion, upright on its hind legs, that lunges at him. This iconographical grouping is known in Attic vase painting as early as the late Geometric Age and appears in Peloponnesian bronzework among the shield bands from Olympia.

The "monopteros" at Delphi, a Doric peripteros without walls built in the first half of the sixth century, may have had the first politically motivated program in Greek architectural decoration. This little building carried fourteen sculptured metopes on its exterior frieze. The stone is limestone from Sicyon across the Gulf of Corinth to the south of Delphi, so that the building has been considered a Sicyonian monument. The subjects of the metopes are: Europa and the bull; Phrixus and the ram; the Calydonian boar; the Dioscuri, Orpheus, a fourth figure, and the ship *Argo*; and the Dioscuri, again with the sons of Aphareus and cattle captured in an epic raid. Thessaly and Boeotia (Phrixus and the Argonauts) are important in the program, and many of the subjects are especially appropriate for a Sicyonian dedication: the Dioscuri had a temple at Sicyon, and the lance that killed the Calydonian boar and the oars of the *Argo* were preserved in the city. Moreover, subjects may well have been omitted from the program to conform to known policies of Cleisthenes, tyrant of Sicyon in the first half of the sixth century, for Homeric scenes are absent (Cleisthenes forbade Homeric recitations at Sicyon), as is the great Dorian hero Heracles (Cleisthenes was violently anti-Dorian).[5]

Temple C at Selinus has a huge gorgoneum as a pedimental decoration. That some Sicilian temples boasted double gorgonea in their pediments is suggested by the temple model found in 1961 at Sabuccina near Acragas.[6] A more developed

58. Limestone pedimental sculpture from Athenian Acropolis

form of the same subject is shown by the first pedimental group in stone, from the Gorgon temple on Corfu, built very close to the beginning of the sixth century (36). In the Corfu pediment the Gorgon's full form is represented, and on either side are first her monstrous progeny Chrysaor and Pegasus, then two felines, and finally, in the corners of the pediment, two scenes of combat unrelated to the predominant central figures. In one of these scenes Zeus smites a giant or Titan with his thunderbolt; in the other, a male figure attacks a figure seated on a throne—either Neoptolemus and Priam or Zeus and Kronos. Whichever interpretation is adopted, it is clear that some comparison between the two corner groups was intended.

The remains of a number of pedimental groups remarkable for their vigor and ingenuousness are preserved from buildings that must have been erected on the Athenian Acropolis in the first half of the sixth century, before the time of Pisistratus. Two charming miniature groups show the arrival of Heracles on Olympus and a scene before a fountain. The large-scale groups are again representations of struggles, one group of men against a sea monster and two groups of lions overpowering bulls with sanguinary ferocity (58). This last subject, which has a long history in the Greek world, was introduced originally from the East in the second millennium and reimported in the early Archaic Age. It is found not only at Athens but also at Delphi, on the east pediment of the late-sixth-century temple of Apollo, and appears elsewhere. The

7. A programmatic interpretation is made by Christof Clairmont in *Journal of Hellenic Studies* 79 (1959): 211–12.

8. Evelyn B. Harrison, *The Athenian Agora*, vol. 11, *Archaic and Archaistic Sculpture* (Princeton, 1965), p. 9.

Gorgon, the sphinx, and the lion—these dangerous adversaries of man are all his monumental guardians, and with good reason. The lion-and-bull is a frequent theme of Homeric simile, and though the lion attacks and destroys, he is repulsed or killed by men, just as Perseus killed the Gorgon and Oedipus' wit drove the Sphinx to self-destruction. And so the representation is of a power that is subject to defeat by the greater power of man and is subjected to its place within the divine order represented by the temple. This indeed may be why the scenes chosen to decorate shield bands and temple friezes were vigorous, clear demonstrations of the power of man. Seen in this light, the Sele treasury metopes constitute an implicit metaphor.

The decorative conjunction of stories that were chosen with no concern for thematic unity or relation of characters still gave pleasure in the later sixth century. In fact, the sculptures of one of the most exquisite of Archaic buildings, the Siphnian treasury at Delphi, built about 525 B.C., are without precise thematic interconnection. This tiny marble building, 18 feet by 27 feet, carried a sculptured Ionic frieze around all sides of its exterior and sculpture in its main pediment, as well. The pediment represented the attempt of Heracles to seize the Delphic tripod, a theme certainly at home in the sanctuary. But on the frieze on the west, the side with the principal entrance, was the judgment of Paris; on the south, the rape of the daughters of Leucippus by the Dioscuri; on the east, an epic battle, with divine spectators; and on the north, along the Sacred Way through the sanctuary, the battle between the gods and the giants.[7]

Two buildings erected little more than a quarter century after the Siphnian treasury reflect a new tightness in the planning of architectural sculpture. On the Athenian treasury at Delphi, now dated in the early 490s,[8] there is a simple confrontation of the deeds of Theseus and Heracles. The temple of Aphaea erected on the island of Aegina, in the Saronic Gulf south of Athens, at the beginning of the fifth century had sculptural decorations only in the two pediments, aside from the finials and acroteria. Each pediment was dominated by a figure of the goddess. The two pediments were complementary, their subjects being the two Greek sieges of Troy, the first that of Heracles, the second the Trojan War of the *Iliad*.

9. R. Ross Holloway, "The Crown of Naxos," *American Numismatic Society, Museum Notes* 10 (1962):1–8.

•

At the same time that it was emphasizing thematic clarity, Greek art made its first steps toward wider symbolism than personification. Not surprisingly, the first evidence of this momentous step comes from coinage, for the emblems of Greek states used on coins already show a degree of abstraction. The emblem often was a pun on the city's name, like the type of Phocaea in Ionia, which was a seal (*phoke*), or the cock crowing at daybreak used by the Sicilian city of Himera (*hemera* meaning "day"). However, the combination of symbols to form true allegory also appears in the early fifth century in a commemorative coinage.

The first battle of the Persian Wars was fought in 500 B.C., when the Persians attempted a surprise invasion of the island of Naxos. The attack was repulsed, and evidently to mark this event, the Naxians soon after added a wreath to the bowl of the two-handled vessel of Dionysus, the cantharus, that appeared on their coins as the emblem of the island. Since Naxian warships were also called canthari, the wreath—a symbol of general festivity and victory applicable equally to the island and her warships—makes these commemorative coins examples of the kind of allegory that is present in the Serpent Column at Delphi.[9] Such allegory is an important aspect of Greek monumental art, for the symbol was not invented for the situation but, rather, derived its power from association with the situation. Greek allegory was always to contain the implicit metaphor that is so clearly present in the design of the column at Delphi and in the Naxian coins.

4. Olympia

It is often said that success in the struggle with Persia and Carthage brought to the victorious Greeks an elevation of spirit that manifested itself in the major art of the succeeding generation and continued to inspire the Periclean Age. The dramatic triumphs at Salamis, Himera, and Plataea in 480 and 479 B.C. were events to stir men's hearts and set their minds on the strength of the victors, the might of their heroes, and the intervention of their gods. But, except in Sicily, there was no immediate attempt to capture the exhilaration of these victories in stone or bronze. More forward than the other Greeks, the Sicilians Gelon and Hieron of Syracuse and their brother-in-law Theron (the tyrant of Acragas), in gratitude for the victory over Carthage, built temples near the field of battle at Himera and at Syracuse, and probably planned the great temple of Olympian Zeus at Acragas. Everywhere, however, the sanctuaries of propitious divinities were filled with booty, like the pot-shaped helmet with Hieron's inscription from Olympia, now in the British Museum, that was dedicated from the spoils of a second victory in the west over the Etruscans in 474 B.C. Recent excavations at the same sanctuary have brought to light an astounding collection of captured arms and armor offered as dedications, including a Persian helmet dedicated by the Athenians after the battle of Marathon.

Even in Sicily, however, the architectural monuments do not proclaim the motive for their erection. As in the case of the Naxian coins celebrating the first victory of the Persian Wars, the symbol was not created for the event but gained its particular significance from the event it commemorated. And in Greece the very reticence of the victors is striking. A share of the booty for all the gods—the tripod at Delphi, the monumental statue of Poseidon at the Isthmus of Corinth, and the similar figure of Zeus at Olympia—is all, Herodotus tells us, that was voted after Plataea to commemorate the victory. And in the moment before the battle the Greeks revealed their state of mind by deciding that the blackened remains of the sanctuaries razed by the Persians would be a more eloquent memorial to the war than any lavish rebuilding. Their reticence arose from a feeling that no monument could adequately commemorate the moment of deliverance and triumph.

•

1. For the temple sculptures, see Bernard Ashmole and Nikolaos Yalouris, *Olympia: The Sculpture of the Temple of Zeus* (London, 1967). The program of the sculptures is discussed by R. Ross Holloway in "Panhellenism in the Sculptures of the Zeus Temple at Olympia," *Greek, Roman, and Byzantine Studies* 8 (1967): 93–101.

The most significant monument created in the decades following the Persian victory was the great temple of Zeus at Olympia (59). This building, dedicated before 456 B.C., was the largest temple in any of the Panhellenic sanctuaries of the mainland. It was erected and its famous sculptures were executed when the spiritual impact of victory was felt most strongly.[1] There was probably no time in the history of the Greeks before the rise of Macedon when the Hellenic world could have taken more pride in its achievements and have had more faith in its future. The crucial victories over the Persians at Plataea and Salamis had been followed by two decades of successful warfare and the freeing of the cities of Asia Minor. In Sicily, the Greek cities had just regained independence from the Deinomenid tyranny, and a new era seemed to be coming to the island, while in Magna Graecia, the area of colonial expansion across the Strait of Messina in south Italy, the menace of the Oscan-speaking Italian tribes had not yet been felt. Though the ill-fated Athenian expedition to Egypt had been launched and the first blows between Athens and Sparta exchanged, the time seemed glorious and serene.

The temple of Zeus was erected, under the direction of the architect Libon of Elis, in the hollow of the Alpheus valley where the most revered of the Greek sanctuaries had grown up around the primitive altar of Zeus and a level stretch of ground ideal for a race course. The temple, destined to exert immense architectural influence, continued the tradition of mainland Doric architecture. In Greece its influence was felt almost immediately in the mid-fifth-century temple erected in the sanctuary of Poseidon at the Isthmus of Corinth. In Italy the surrender of western Greek individuality to mainland models is clear in the second temple of Hera at Paestum (60), once known as the temple of Poseidon, which is almost a copy of the temple of Zeus at Olympia. The same tendency is evident to a less dramatic degree at Acragas in the "Concord" temple and at Selinus in Temple ER.

At Olympia the appearance of a new artistic spirit in the Greek world has been sought not so much in the unhurried development of Doric architectural forms as in the sculpture

59. Temple of Zeus at
Olympia

PEDIMENTS

A. East: Pelops and Oenomaus with Zeus
B. West: Theseus, Pirithous, and the centaurs with Apollo

FRIEZE: Labors of Heracles

Over pronaos	Over opisthodomos
a. Boar (Peloponnesus)	g. Lion (Peloponnesus)
b. Mares (Thrace)	h. Hydra (Peloponnesus)
c. Geryon (west)	i. Birds (Peloponnesus)
d. Atlas (west)	j. Bull (Crete)
e. Cerberus	k. Hind (Peloponnesus)
f. Stables (Peloponnesus)	l. Amazon (Asia Minor)

60. Second temple of Hera
(temple of Poseidon) at
Paestum

2. The identity of the Olympia master is much debated. R. Ross Holloway, in "Il maestro di Olimpia: la testimonianza dei documenti," *Colloqui del sodalizio*, 2d ser., 2(1972):46–60, presents evidence for attribution to Ageladas of Argos.

that was made to decorate the temple of Zeus. These figures have been known since antiquity from the long description given by Pausanias. There is strong circumstantial evidence that the master entrusted with their design and execution was Ageladas, the leader of the Argive school of sculpture.[2] Most of the pedimental statues and metope reliefs were unearthed in 1877.

The subjects of the sculptures of the temple of Zeus at Olympia are not programmatic in an allegorical sense; at least the scenes do not seem to have been arranged according to a plan for the exposition of a theme or concept. Probably, like those of the Sele sanctuary, they were planned simply for their geographical associations. The physical scale of the temple would speak for the prospering fortunes of Greece, and the sculptures would welcome all Greeks.

The metopes over the porches inside the peristyle represented the twelve labors of Heracles. The east pediment depicts the preparations for the legendary chariot match in which Pelops won Hippodamia by defeating her father, King Oenomaus (61). At the center of the pediment is Zeus; on one side are the bearded Oenomaus, open cloaked, and his queen; and on the other, the youthful Pelops and Hippodamia. Beyond are their chariots and attendants. The west pediment displays a figure, best identified as Apollo, standing amid the brawl between centaurs and Greeks at the wedding of a Thessalian prince, Pirithous (62).

A visitor who approached the temple from the east saw Pelops and Oenomaus preparing for their encounter. The story did not necessarily discredit Olympia, for, as Pindar told it in the first Olympian ode, Pelops won not by bribing his opponent's charioteer but because of the speed of Poseidon's horses. In the center of the frieze over the inner porch on the east side, and thus in the line of vision of the visitor, were the metopes of Heracles and Geryon and of Heracles and Atlas (63). Both adventures took place in the far western Mediterranean; Pelops came from Asia Minor. Thus the pediment above is balanced geographically in the frieze of the porch.

What became the standard sequence of the twelve labors of Heracles has been recorded with minor variations by two authors of the Roman Empire, Diodorus the Sicilian and Apollodorus the mythographer. But the temple of Zeus at Olympia

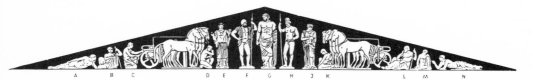

61. Temple of Zeus at Olympia, east pediment, sculpture

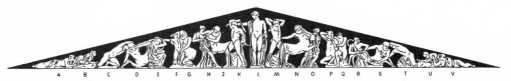

62. Temple of Zeus at Olympia, west pediment, sculpture

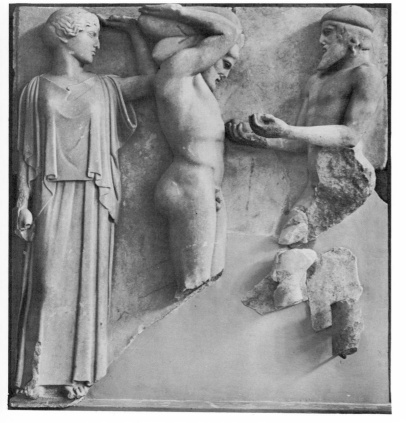

63. Temple of Zeus at Olympia, east porch, metope

departs from the standard, and probably traditional, sequence. Two Peloponnesian labors are prominently displayed at the corners of the east, and principal, frieze: at the north corner is the Elean labor of the Augean stables; at the south corner, the scene of Heracles bringing the boar to surprised King Eurystheus, for whom the labors were undertaken. And the labor involving Geryon precedes rather than follows that involving Atlas, so that a labor set in the western world occupied the center of the frieze over the entrance to the cella. The episode of the horses of Diomedes, also in the east frieze, extends the geographical reference to Thrace, while, at the opposite end of the cella, the west frieze depicts four of the six Peloponnesian labors and those involving the Cretan bull and the Amazon in Asia Minor. Also on the west side, the heroic central figures of the pediment—Theseus and Pirithous—introduce Attica and Thessaly, two important areas of the Greek world in which none of the labors of Heracles had taken place.

That such geographical references could be an important consideration in the planning of the stewards of the sanctuary is obvious; an Athenian visitor to Delphi, like Euripides' servant girls,[3] would have been cheered by the sight of his own goddess Athena in the sculpture of Apollo's temple. And so at Olympia, whether he came from Asia Minor, Thrace, Thessaly, Boeotia (the birthplace of Heracles), Attica, Peloponnesus, Sicily, Crete, or Massilia (Marseilles), he could find in the official program of the temple of Zeus the same welcome association with his homeland that the citizens of the victorious Greek cities found when they read the geographical roll of victors on the coils of the Serpent Column at Delphi. The clear allegory represented by the tripod and Serpent Column is significant in the development of Greek art, but the simple inscription of the victors engraved on its coils achieves its majesty by suggesting the magnitude of the alliance they constituted. The effect may have been uncalculated, for it comes from the traditional economy of Archaic inscriptions, but it reflects the spirit of the age.

In the temple of Zeus at Olympia, as in the Serpent Column, the artistic expression gives form to the official design, and the official program must not be confused with the artistic interpretation involved in its execution. The relation between the two is that of a playwright and an actor. A program names

the characters of the drama and gives their order of appearance. The creation of their personality is the province of the artist. Still further removed from the official plan are the reflections and emotions—many of them responses that could not be expressed—stirred by these sculptures in the ancient visitors to the sanctuary.

The scale and position of the central figures of the pediments, which are nearly ten feet high and rested on a surface more than forty feet above the ground level of the gleaming hall of Father Zeus, assured them prominence and majesty, and the master entrusted with the execution of the sculptures, and his assistants, responded to the challenge of the setting with a uniquely simple and massive style (64).[4] It is a style that stems naturally from Archaic sculpture, despite the Olympia master's revolutionary simplification of the conventional drapery and his equally revolutionary use of drapery to support the composition of the figure. The action and pose of the figures are harmonized, and small details, such as veins, are emphasized, but the general anatomy is derived from the late Archaic athlete figure, and repetitive conventional mannerisms are still employed, as in the peacock-eye loop-ends of heavy locks of hair. The ability to characterize, seen most strikingly in the old man of the east pediment (65), should surprise no one familiar with Archaic works like the cup in the Metropolitan Museum of Art attributed to the Hegesiboulos painter (66).

Another prominent feature of the sculptures of the temple of Zeus is a Classical head type. This type, whose expression of gravity and imperturbability was to dominate the sculpture of the fifth century, came into fashion at about the time of the Persian Wars. The Classical head of the Apollo of the west pediment (67) and those of many of the women in the same pediment (68) are deliberately contrasted with the traditional Archaic facial types of the Heracles figures of the metope series (63) and with the masklike Archaic heads of the centaurs of the west pediment (67, 69).

•

The introduction of "severe" style of the sculptures of the temple of Zeus at Olympia and other contemporary sculpture

4. On the Early Classical period in general, see Brunilde S. Ridgway, *The Severe Style in Greek Sculpture* (Princeton, 1970).

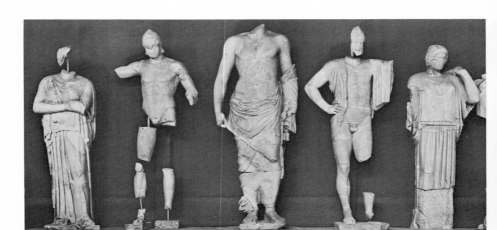

64. Temple of Zeus at
Olympia, east pediment,
central group

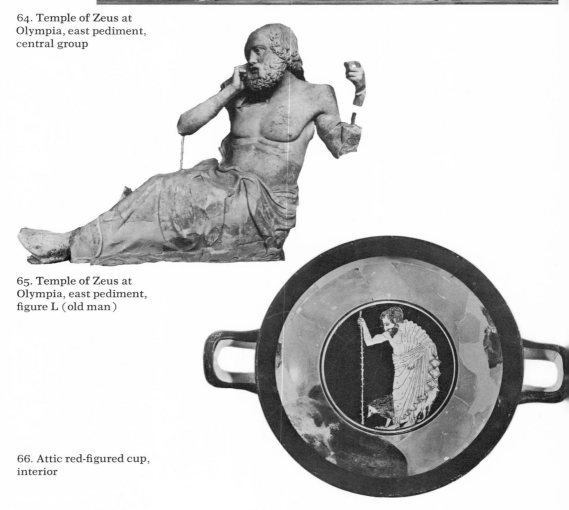

65. Temple of Zeus at
Olympia, east pediment,
figure L (old man)

66. Attic red-figured cup,
interior

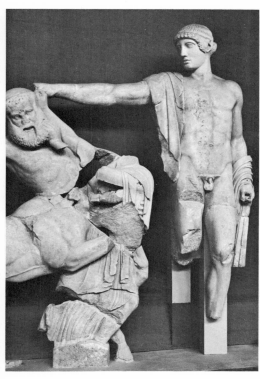

67. Temple of Zeus at Olympia, west pediment, figures L, N, and O (Apollo and centaur attacking Lapith girl)

68. Temple of Zeus at Olympia, west pediment, figure H (Lapith girl)

69. Temple of Zeus at Olympia, west pediment, figures P and Q (Lapith and centaur)

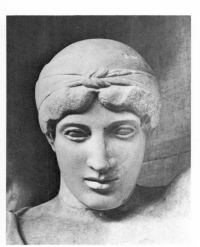

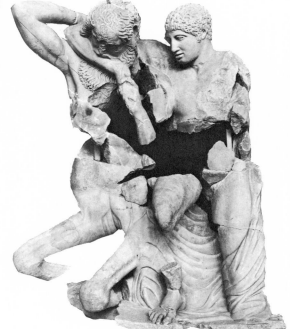

70. Bronze kouros from
the Piraeus

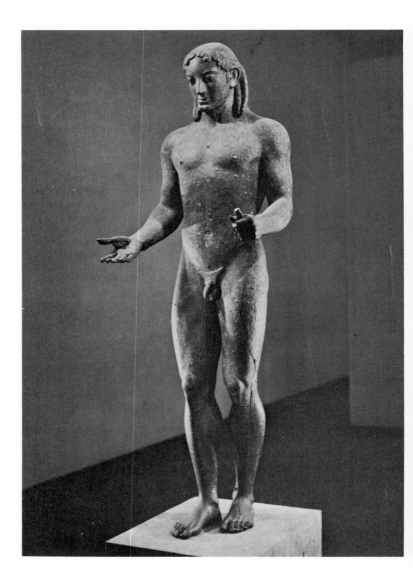

was motivated by two circumstances, one technical, the other
intellectual. The simplification of drapery forms and the pref-
erence for massive anatomical divisions is a reflection of styl-
istic adjustment to the technical problems raised by the intro-
duction of large-scale sculpture in bronze. The character of
early large-scale bronze sculpture was revealed in 1959, when
a late-sixth-century bronze kouros (70), just short of life size
and probably made within a generation of the first experi-

ments in large-scale bronze casting, was found in the Pi-
raeus. The most remarkable aspect of the kouros from the
Piraeus is the way in which the exaggerated transitions be-
tween formal elements of Archaic sculptural form have been
rounded over and smoothed out in the body, face, and hair.
Although large-scale bronze casting was first practiced in
Ionia, where the underlying anatomy of the male nude was
never given the emphasis of mainland sculpture, the anatom-
ical modifications of the kouros from the Piraeus are also a
matter of technical caution, since simple and massive forms
are easier to reproduce in the mold than complex ones. The
fact that complex forms were reproduced in small-scale Ar-
chaic bronzes is irrelevant, because the difficulties of casting
multiply enormously as the size of the casting increases and
the molten metal must be conducted further to fill the mold.
Archaic drapery, in particular, must have posed difficulties
for molding and casting, and the simplification of drapery
forms coincides, in the early fifth century, with the emergence
of bronze as the favored medium for statuary. By the 460s ex-
perience encouraged the bronze worker to attempt more com-
plex molds, particularly for the hair and beards of male
figures, but the character of the "severe" style had already
been established.

The intellectual aspect of the severe style is exemplified by
heads constructed on the basis of a single module re-
peated throughout the features. As in the case of the temple
of Athena at Paestum, in which the regularization of the
ground plan was inspired by Pythagoreanism, the impact of
mathematics on the Greek imagination—and especially of
the Pythagorean demonstration that simple numerical ratios
are present in natural phenomena—is equally apparent in the
modular Classical head.[5]

In the past it seemed appropriate to say that statues in the
severe style, which seem to have put aside the flourishes of
Archaic sculpture for massive simplicity, are the very embodi-
ment of an art of high purpose born of the Persian Wars—a
reformation of the Greek artistic soul and a renunciation of
the past. There may be some truth in this facile historical
analogy, but one should not be satisfied so easily. In its compo-
sition the east pediment of the temple of Zeus (61) may be
compared with the east pediment of the temple of Apollo at

5. The impact of mathe-
matics continues to be
evident in temple design
of the fifth century; see
William B. Dinsmoor, *The
Architecture of Ancient
Greece* (London, 1950),
pp. 152 and 161.

71. Temple of Apollo at
Delphi, east pediment,
sculpture

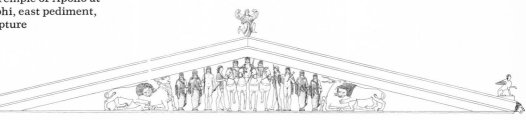

6. Bernard Ashmole has
treated this subject with
great perception in "Some
Nameless Sculptors of the
Fifth Century B.C.," *Proceedings of the British
Academy* 48 (1962):
213–33.

Delphi (71), installed some fifty years earlier. On the Delphic
pediment as reconstructed by the French excavators, Apollo
with his mother and sister ride outward from the gable wall as
passengers in a frontal four-horse chariot. At either side are
symmetrical groups of two youths of the kouros type and two
korai. Beyond them on the left and right are lions attacking a
bull and a stag. The composition is similar to that of the east
pediment of the temple of Zeus at Olympia: the central, out-
ward-facing divinity; the outward-facing groups at either side
(with the possible exception of two of the Delphic kouroi,
who are reconstructed in a profile pose); and, in place of the
chariots, the two lion groups.

Though it is customary to praise the vigor of Early Classical
art, it cannot be said that the Archaic Delphic composition is
less vigorous than the composition at Olympia. In the Olym-
pia sculptures, a sense of imminent action has been sub-
stituted for the formal tension (accentuated by the balanced
grouping of the whole) of the individual Archaic figure and
for the inelasticity of Archaic ornamental drapery. Along
with their new Classical power, in many ways the figures of
the temple of Zeus at Olympia retain the formal tension of
Archaic art. There is no better illustration of the persistence
of Archaic form than the west pediment where the tense fig-
ure of Apollo dominates the struggle that surrounds him
(67).

The ability of the Olympia masters to suggest potential
struggle and future action adds a temporal dimension to the
feeling for comparison and implicit metaphor of the Archaic
Age. The stages of life are carefully portrayed at Olympia,
with youth and age represented and contrasted, especially in
the aging figure of Heracles in the metope series (63).[6] The
relationship between youth and age fascinated the generation
of the Olympia sculptors, and the Brygus painter made his

72. Attic red-figured cup, interior

comment in a different but no less telling way on a cup now in the Louvre. On the interior of the cup he depicted the reverent treatment of old Phoenix, the tutor of Achilles, by the girl Briseis (72); on the exterior, the slaughter of King Priam by Neoptolemus, the son of Achilles.

The quality of reverence in the scene of Briseis and Phoenix is related to another quality of the sculpture of the temple of Zeus at Olympia—tenderness, the emotion expressed toward their masters by the servants on the east pediment. And tenderness is even more evident in the repeated metope scenes of Athena with her struggling, victorious, but often discouraged hero. By portraying emotion and suggesting consequences, the Olympia master and his associates gave artistic greatness to the formal program devised for them to execute. But although it is not fully apparent at Olympia, this achievement, which developed from the potentialities of Archaic art, threatened the very strength of the representational vision shared by the Early Classical and Archaic world.

7. Rhys Carpenter, "Remarks on Familiar Statuary in Rome," *Memoirs of the American Academy in Rome* 18 (1941): 1–17.

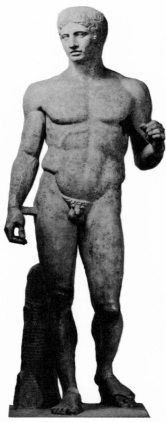

73. Spear Bearer by Polycletus, Roman copy

To suggest meditation or reflection the figures of Early Classical art were made to assume relaxed postures that imply qualities foreign to the concept of superhuman energy that Archaic form had projected so well. The significance of the transformation of the human figure in sculpture that begins with the east pediment of the temple of Zeus at Olympia can be seen in the Spear Bearer (73), the work of the Peloponnesian sculptor Polycletus a quarter century later. Apparently a dedicatory figure, it is thus descended from the early kouroi; but, unlike a kouros, the Spear Bearer has the stance of a relaxed stroller. The Olympia sculptures stand between these extremes, for it was the artistic triumph of their sculptors to have touched the massive, the powerful, and the monumental with a sense of humanity.

The sculptors of the Early Classical period rarely attempted to give such an element of humanity to their individual monumental statues. This is understandable in view of the aspirations and conventions of Greek commemorative sculpture, and it explains why the sculptors were slow to cast off the conventions of Archaic form. However, one of them may have done so in the Apollo Omphalos type. Best represented by the Choiseul-Gouffier Apollo (74), this Apollo is a less daring figure than the Discus Thrower of the Attic master Myron, also preserved in Roman copies (75), which, frozen in motion, seems to make an open break with the past. But Myron relies on numerous Archaic mannerisms of construction and anatomy.[7] The lingering attractiveness of Archaic stylization played an important role in the art of the first half of the fifth century. In vase painting it gave rise to mannerism, which had a sculptural equivalent in such works as the metopes of Temple E at Selinus, executed about 460 B.C. (76).

Five metopes of this temple, which owed not a little of its architectural design to the temple of Zeus at Olympia, exist almost complete, and there are five other marble female heads belonging to metopes that no longer exist. Like the temple at Olympia, this building had twelve metopes divided evenly between the front and rear interior porches; they were executed in limestone, with marble used for inset female heads and exposed extremities. The five complete metopes are remarkably uniform in subject matter, for each depicts a scene of violence between a man and a woman: Heracles subduing the Amazon

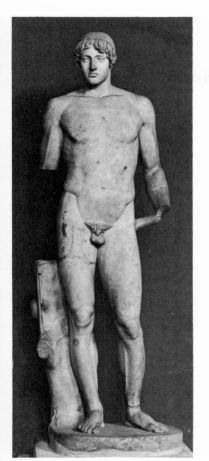

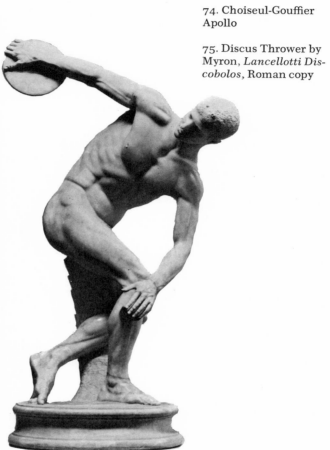

74. Choiseul-Gouffier Apollo

75. Discus Thrower by Myron, *Lancellotti Discobolos,* Roman copy

76. Temple E at Selinus,
metope

8. In respect to the met-
opes of Temple E at
Selinus, I do not follow
Werner Fuchs, "Zu den
Metopen des Heraion von
Selinus," *Mitteilungen des
Deutschen Archäologi-
schen Instituts, Römische
Abteilung* 63 (1956):102–
21.

queen (76), Artemis destroying Actaeon, Athena conquering
a giant, and Zeus, firmly grasping the forearm of Hera, draw-
ing her imperiously toward him. The fifth metope, though
badly damaged, is another scene of struggle between a male
and a female. In addition, at least two of the detached female
heads have the unusual torsion of the Artemis and the Hera,
and seem to have been part of similar compositions. This sug-
gests that at least seven of the twelve metopes represented
scenes of struggle between a man and a woman, sufficient
evidence for a sustained theme of great sophistication. Re-
flected here is a plane of thought, evident in Greek literature
and in Attic vase painting of the early fifth century, that raises
the conflicts of the sexes to a level of divine majesty. In the
major art of the period only Temple E at Selinus makes this
appeal to the creative imagination on a monumental scale.[8]

Two illustrious Greek bronzes, the Delphi Charioteer (77) and the Zeus of Artemisium (78), exemplify the innumerable statues that graced the public places of the Greek city and sanctuary. The charioteer belongs to the life-sized chariot group erected by the Deinomenid prince Polyzalus after his victory at the Pythian Games in 476 or 472 B.C. Within a decade of the victory, statues for Polyzalus' brothers Gelon and Hieron were erected at Olympia. Both commissions and two others from the Deinomenid tyrants were entrusted to members of the renowned school of bronzeworkers of Aegina, and the Delphi Charioteer may also be an Aeginetan work.[9] The dedication, which stood at the head of the Sacred Way before the temple of Apollo, deserves its fame. Resolute and proud in his motionless dignity, the charioteer stands in his car grasping the reins of his team, his head turned very slightly to acknowledge the acclaim of victory. Although isolated instances of such animation are known earlier—for example, in the Rampin Rider—the humanity of this gesture of the head is a break with the traditions of Archaic heroization more telling, perhaps, than the anatomical realism of the charioteer's forearms or the crinkled surface of his robe where it is caught by the shoulder straps of the racing harness. In other ways, however, the composure produced both by harmony and by conscious geometry maintains the traditions of the Archaic monument. The lower robe of the charioteer is fashioned in twenty deep folds divided evenly, five to each quadrant, like the flutes of an Ionic column. The finely incised hair of the charioteer is deliberately unrealistic, but, above all, it is the regularized Early Classical style of the head that conveys a feeling of impersonality. Although the formula of the Early Classical head type was new, the intent in creating it was not: "It is as though its traditional pattern had been revised under a corrective scrutiny to make it conform to some sort of abstract theorem of proportional harmony."[10] For that reason the human qualities of the charioteer do not reduce the intimations of heroic transfiguration in the statue.

The second master bronze of the Early Classical period is the statue of Zeus found in the sea off Cape Artemisium in 1927 (78). It embodies as clearly as any statue that miraculous phenomenon of ancient art, the formal type perpetuated with new vitality. Even in a gallery of prototypes and con-

9. As suggested by Karl Schefold, *The Art of Classical Greece* (New York, 1967), p. 34.
10. Rhys Carpenter, *Greek Sculpture: A Critical Review* (Chicago, 1960), p. 92.

77. Bronze Charioteer
from dedication of Poly-
zalus at Delphi

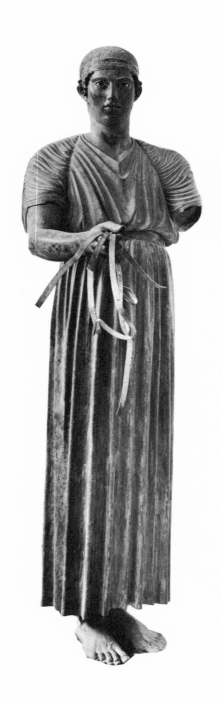

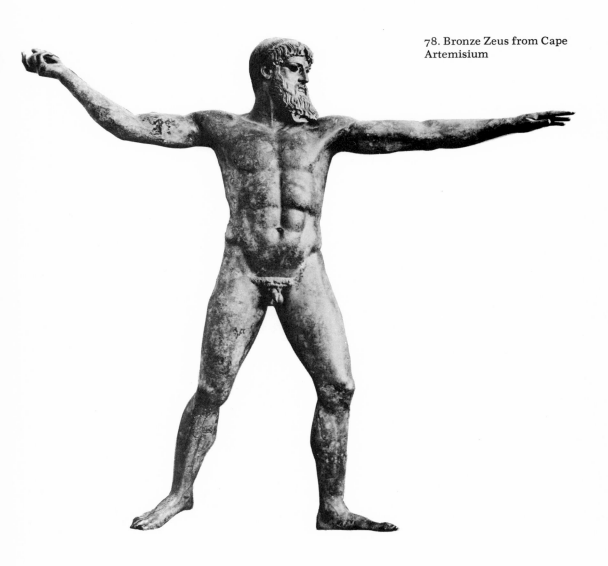

78. Bronze Zeus from Cape
Artemisium

11. For a revised reconstruction of the group, see B. B. Shefton, "Some Iconographic Remarks on the Tyrannicides," *American Journal of Archaeology* 64 (1960): 173–79.

temporary versions of this pose—including the newly discovered bronze statue of a Poseidon from Ugento in south Italy (79)—the Zeus of Artemisium loses none of its majesty. The traditional formula of the striding divinity hurling his weapon is so vitalized by the act of creation that the existence of the prototype is forgotten. The use of the familiar prototype, however, is of prime importance in making each new version a proper reflection of a permanent and divine figure. It could be called the hieratic aspect of a tradition. For the same reason the sculptor of the Zeus was careful to avoid giving the god the free posture of Myron's Discuss Thrower. The chest and stomach, in particular, are presented with a rigidity that lingers from the Archaic Age.

What is lacking in the isolated statuary of the Early Classical Age is the drama that springs to life at Olympia in the sculptures of the temple of Zeus. It is lacking in the tyrannicides monument created for the Athenian Agora shortly after 480 B.C. by the sculptors Critius and Nesiotes, and preserved in Roman copies (80). This monument, which commemorates Harmodius and Aristogiton, who assassinated the ruling tyrant's brother in 514 B.C. and thus initiated the struggles that led to the founding of the Athenian republic, shows the two assassins striding forward side by side with drawn swords.[11] In a sense it is dramatic, for it represents an action and suggests a story. But drama as known in Athenian tragedy—full of the consequences of past events, debate over present action, and future forebodings—does not exist in Greek art before the temple of Zeus at Olympia. And like the success of the Athenian theater, the drama of the temple of Zeus was possible only through the humanization of the participants in the action.

The great temple of Zeus was to wait over a quarter century after its dedication to receive its cult statue from the hand of Phidias. And the creation of the Phidian Zeus leads to the consideration of Phidias and Periclean Athens, where the aspirations of a historical moment were consciously projected in metaphors of the heroic past.

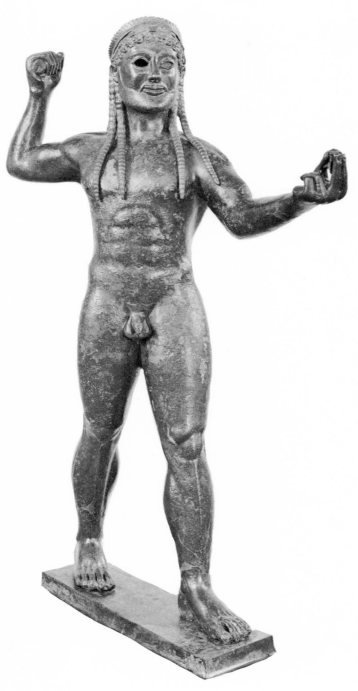

79. Bronze Poseidon from Ugento

80. Aristogiton and Har-
modius by Critius and
Nesiotes, Roman copies

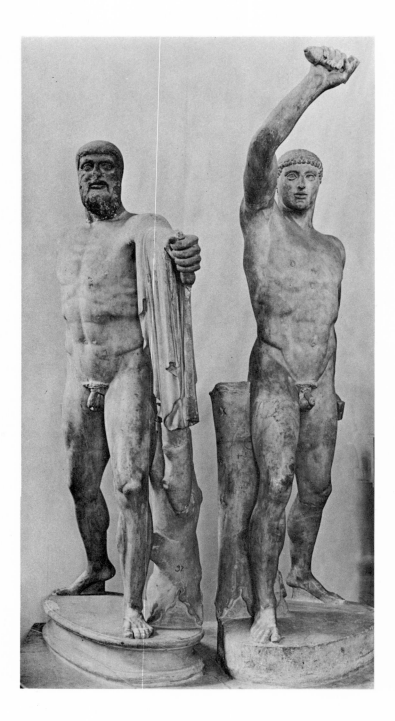

5. The Parthenon

In 479 B.C., on the field of Plataea in the hour before the battle with the Persians was joined, the army of the Greek allies swore this oath:

> I will not value living more than freedom, and I will not desert my officers living or dead, but all the battle dead of the allies I will bury. And if victorious in war over the barbarians, I will not raze to the ground any city of those that have fought for Greece but I will fine all the cities that took the part of the barbarian. And I will not restore in any way the sanctuaries burned and destroyed by the barbarians, but I will leave them as a warning for those to come of the barbarians' impiety.[1]

The oath, first recorded by the fourth-century orator Lycurgus, was attacked by his contemporary, the historian Theopompus, as a patriotic invention. Nevertheless, the clause regarding the sanctuaries accords perfectly with what is known of the Attic sanctuaries after 480 B.C. A generation of Athenians, therefore, grew to manhood knowing only the ruins of what had been the gleaming shrines of their fathers' youth. But by mid-century, time had placed old determinations in new perspective. It is perhaps no coincidence that a formal peace with Persia seems to have been made the year before the Athenians set about rebuilding the shrines that had been neglected for so long.

In 476 B.C. Cimon, the son of Miltiades, recovered the bones of the hero Theseus from their resting place on the island of Scyros, and the Athenians buried the remains of the founder of their polity in a properly dignified *heroon* in the Agora, the Theseum, which was famous for mural paintings by Micon showing the exploits of the hero. Nearly twenty years later, around 460 B.C., Cimon's brother-in-law Peisianax built a stoa on the north side of the Agora (81) that was called the Decorated Stoa (Stoa Poikile) because of the paintings by Micon, Polygnotus, and Panaenus, the brother of Phidias, that embellished it, forming a clearly allegorical program.[2] Balanced against representations of a battle of Greeks and Amazons and the fall of Troy were representations of the battle of Oinoe (an obscure action fought between Athens and Sparta, possibly in the 450s) and the battle of the Athenians and Persians at Marathon. The allegorical equation of

1. Lycurgus *In Leocratem* 81.
2. Lillian Jeffrey, "The Battle of Oinoe in the Stoa Poikile," *Annual of the British School at Athens* 60 (1965):41–57.

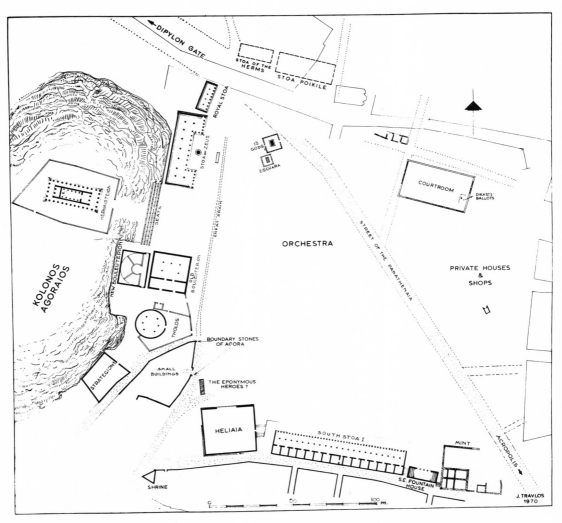

81. Athenian Agora at
end of fifth century B.C.

the Spartans and Persians with the mythical foes of Athens is undisguised. These paintings were probably executed in the 450s, but the murals of the Theseum appear to have been part of its original furnishings when it was built twenty years earlier.[3]

The murals of Micon and Polygnotus evidently covered large wall areas and embraced armies of participants arranged in tiers to suggest depth without perspective. Pausanias described in detail two works of Polygnotus in a hall at Delphi, the Fall of Troy and Odysseus in the Underworld. It is his murals in Athens, however, that gave rise to echoes in Athenian vase painting, the most faithful of which is probably the battle of Greeks and Amazons that decorates a fragmentary crater now in the museum at Bologna. A number of the Amazons are mounted, as were at least some of those in Micon's painting in the Decorated Stoa, according to Aristophanes.[4]

•

The Theseum and the Decorated Stoa, together with other new sanctuaries—even small ones like Themistocles' sanctuary of Artemis Aristoboule, which was recently excavated in the heart of modern Athens[5]—must have made an unbecoming contrast to the mutilated shrines that survived the Persian sack. And the example of Cimon and Peisianax may, more than any other reason, have led to the feeling that the other gods would also welcome new and beautiful homes.

Piety and determination alone, however, even if shared by the whole Athenian state, would hardly have sufficed to complete a fraction of the vast building program that began in Athens just after 450 B.C., and left its mark not only on the city but on the Attic countryside as well. At Sunium the mariner was greeted by the intense white marble of the new temple that still shines like a day beacon on Poseidon's headland. On the east coast of Attica the ancient shrine of Artemis at Brauron was enclosed by a portico and received a new temple. Farther along the coast beyond Marathon, at Rhamnus, the largest of the Attic townships, where the sanctuary of the goddess of Justice (Nemesis) was given equal attention, the cult statue was by Phidias or his associate, Agorac-

3. See Karl Schefold, *The Art of Classical Greece* (New York, 1967), pp. 63–70, for this material and a suggestive treatment of the possible influence of mural painting on contemporary sculptural compositions.

4. *Lysistrata* 677–78.

5. J. Threpsiades and Eugene Vanderpool, "Themistokles' Sanctuary of Artemis Aristoboule," *Archaiologikon Deltion* 19 (1964): 26–36.

6. Reexamination of fragments in the Rhamnous Museum and in the National Museum in Athens has now permitted a reconstruction of the statue by Georgios Despinis, Ἡ Νέμεσις τοῦ Ἀγορακρίτου [The Nemesis of Agoracritus], (Athens, 1971), summary by Karl Schefold in *Antike Kunst* 14 (1971): 130–31.
7. *Clouds* 275–313; *History of the Peloponnesian War* I. 10.

ritus (part of the head is preserved in the British Museum).[6] And in inland Attica a temple to Ares and Athena was built at Acharnae while at Eleusis the hall of the mysteries may have been rebuilt in an enlarged form.

In Athens the temple of Hephaestus on the hillock beside the Agora is the best-preserved temple of the Classical period. Below it rose the Stoa of Zeus and a long stoa that closed off the south side of the public square. Smaller temples, like the little Ionic building that stood on the Ilissus until the end of the eighteenth century and the Eleusinion on the north slope of the Acropolis, are representative of the numerous other projects undertaken at this time.

The Athenians were far from unconscious of the effect they were creating by making a city with buildings that rivaled even the Panhellenic sanctuaries. In Aristophanes' *Clouds* the entering chorus sings of the landscape of Attica glistening with monuments that would catch the eye of the clouds approaching from the southwest; and Thucydides remarks that if the future were to judge the powers of his day from the appearance of their cities, Athens would seem far more powerful than she actually was.[7]

The Periclean building program was financed not by the internal resources of Athens but by contributions from much of the Greek world. The ability of a single state to make use of other cities' money in this way was a consequence of the financing of the naval league formed to continue the war against Persia in 478 B.C. From the beginning the league, which had its headquarters at Delos, was commanded, and its treasury administered, by the Athenians. By mid-century the greater number of the Athenians' partners in the alliance were meeting their obligations through an annual assessment of money, which they paid in place of the original contribution of ships and crews to the service of the league fleet. The league was in fact an Athenian empire, and although the enthusiasm of many states for this system of defense cooled as the Persian threat diminished, unwilling states found it impossible to extricate themselves from its bonds. In 465 B.C. Thasos revolted and became the first of a long series of disaffected states to be kept in the league by force. Rebellious states found their assessments increased and saw land confiscated within their territories turned over to colonists, in-

variably Athenians. The allies generally had to accommodate themselves to Athenian judicial, as well as economic, regulation.

With the passing of the years the treasury of the league began to show a substantial surplus, and in 454 B.C., under the pretext of security precautions, the Athenians announced the removal of the treasury from Delos to Athens. Thereafter, not only was the Athenian fleet maintained, and its citizen oarsmen paid, by the league but the Delian fund was applied directly to the Periclean building program. There was, perhaps, some slight justification for using these funds to ennoble Athens, for the work was undertaken to replace buildings damaged or destroyed by the Persians in Attica. But it was paid for by a transparent raid on a federal treasury by its ostensible stewards. Pericles, who had been the leading figure in Athenian politics for less than a decade when the treasury was brought to Athens, was an antagonist of the former ruling group that included Cimon and Peisianax. But it would have been very difficult to oppose a program that promised employment for so many men during the long intervals when the Mediterranean farmer was inactive and the sea was unsafe for shipping. The opponents of Pericles had to attack him indirectly by charging Phidias and other intimates of the great man with peculation and offensive behavior toward the gods. The peculation proceedings generally failed; the appeals to superstition were more effective.

•

In the meantime, the monuments for which all later ages have acclaimed fifth-century Athens were planned and built, among them those on the Acropolis (82–84).[8] In 448 B.C. the first marble was quarried for the Periclean temples, and the first gangs of carters, masons, carpenters, and laborers assembled to begin work on the Parthenon, other Acropolis projects, and the Hephaesteum. Most of the material was Athenian, as were the workmen. But Athens alone could not have provided sculptors even for the Parthenon, not to speak of the other projects under way. And so sculptors from all corners of the Greek world, especially from the Athenian empire, were drawn to Athens. Some of them achieved independent

8. Rhys Carpenter's *The Architects of the Parthenon* (Harmondsworth, Baltimore, and Victoria, 1970) appeared after the completion of this chapter. His arguments for a partially completed Parthenon project immediately antedating the Periclean building are, in the main, persuasive. The chronology of this phase of the Parthenon and Carpenter's attribution of it to the initiative of Cimon, however, are more debatable.

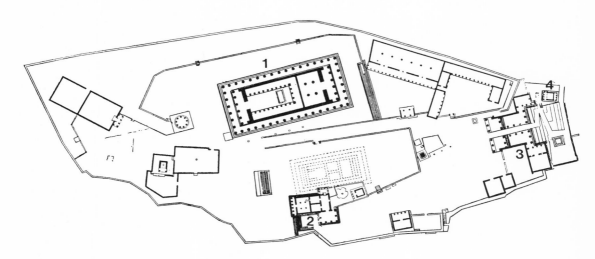

82. Athenian Acropolis,
showing Parthenon (1),
Erechtheum (2), Propy-
laea (3), and temple of
Athena Victory (4)

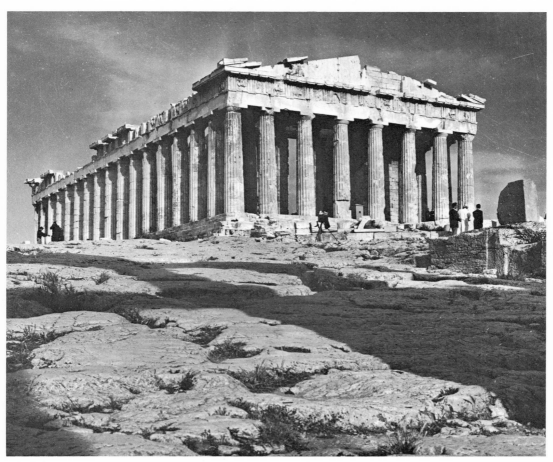

83. Parthenon

84. Parthenon

9. *Pericles* 13. 6.
10. With the exception of the conservative centauromachy metopes, which Carpenter in *Architects of the Parthenon* shows were prepared for his "Cimonian" phase of the temple.

success but are nonetheless recorded as members of the Phidian circle: Paeonius from Mende in Thrace, Agoracritus the Parian, Cresilas from Cydonia in Crete, and Styppax the Cyprian.

Plutarch says that Phidias was the general director of the program, and barring the discovery of significant new inscriptions, that is probably all that will ever be known of the organization of the work.[9] However, building accounts survive for the Erechtheum, the neighbor of the Parthenon on the north side of the Acropolis, during the last years of its construction in the final decade of the fifth century. And similar accounts, although in a very fragmentary state, exist for the construction of the Parthenon. In them there are no entries for the payment of individual sculptors, but there is a detailed record with entries showing purchases of stone and timber, and of gold and ivory for the cult statue, as well as sales of such surplus material as scaffolding timber and equipment. Such accounts exist also for the Propylaea, the gate building of the Acropolis.

The Parthenon accounts show that the temple was completed in 438 B.C., ten years after it was begun, save for the cult statue and the pedimental sculptures, which were added during the next five years. During the first ten years of the project an army of sculptors must have been required to execute the 92 metopes of the exterior frieze and the 524-footlong Ionic frieze that ran around the inside of the colonnade at the top of the cella wall. The composition of these friezes must have been the work of the master designer, especially the Ionic frieze, of which one section on the north side continues for 60 feet with 50 overlapped horsemen. But although the execution was his only in the most general sense because of the number of sculptors participating in the work, the Parthenon sculpture has the marvelous uniformity of style and outlook of the sculpture of other Greek temples, notably that of Zeus at Olympia.[10] Because of the many young men who must have served their sculptural apprenticeship on the Parthenon, its influence was to be unbounded.

●

The Parthenon has attracted admiration as much for the per-

fection of its masonry, the beauty of its detail work (including the traces of polychrome decoration), and the sophistication of its architectural refinements as for its sculpture. The slight upward curve of the stepped podium that is carried through the columns into the entablature, the slight inward inclination of the columns, and the precision of the stonework are examples of the highest achievements of ancient masons and designers. The sculpture, however, is the key to the meaning of the building in the eyes of its creators.

Pausanias, who wrote a detailed description of the temple of Zeus at Olympia, is unfortunately much briefer in his treatment of the Parthenon. He does, however, mention the subjects of the two pediments: on the west, the contest between Athena and Poseidon for the patronship of Attica; on the east, the birth of Athena. Were it not for Pausanias it is doubtful whether the subject of the east pediment could be identified, because the central group of figures was missing even before the disastrous gunpowder explosion of 1687. Fortunately for the study of the Parthenon, some years before the explosion a French artist, probably Jacques Carrey, in the entourage of the ambassador to the Sublime Porte made drawings of the building and its remaining sculpture. These drawings, now in the Bibliothèque Nationale, Paris, show the east pediment already in a ruinous state. However, the knowledge of the pediment group provided by the Carrey drawings and the structural evidence of the cuttings on the pediment floor has led to the identification of possible reproductions of the group, notably the decoration of a Roman well curbing now in the Archaeological Museum in Madrid (85). From such evidence it is possible to arrive at a reconstruction of the pediment, although there is still some disagreement as to the scale and relationship of the central group—Zeus, Athena, and Hephaestus. They were probably flanked by a Hera and a Poseidon, of which fragments survive, but there is no certain evidence as to the next three figures to the south and the three or four successive figures to the north just before the corner groups.

These uncertainties do not, however, diminish the value of Evelyn B. Harrison's recent study of the east pediment (86).[11] Miss Harrison has her own carefully reasoned candidates for the missing intermediate figures on each side of the

11. "Athena and Athens in the East Pediment of the Parthenon," *American Journal of Archaeology* 71 (1967): 27–58.

85. Roman well curbing

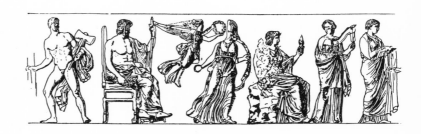

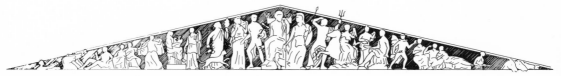

86. Parthenon, east pediment, sculpture

pediment. But it is not necessary to accept or reject any one of these in order to appreciate her major discovery about the plan of the pediment composition, which depends on her identification of the figures of the corner groups, now for the most part preserved in the British Museum. On the south, after the rising chariot of the sun (Helios), the lounging male figure long called Theseus or Dionysus must be recognized as Heracles, the deified hero reposing as he is often pictured on Attic red-figured vases of the later fifth century (87). The pair of female divinities seated next to him are reasonably identified as Demeter and her daughter Persephone. The running girl who follows may be identified as Artemis herself on the basis of a newly discovered relief with a similar figure from the sanctuary of the goddess at Brauron. Still closer to the center are the figures of Hera and Hephaestus.

In the north corner is the descending chariot of the moon (Selene). Next come the three majestic seated female figures long known as the Three Fates (88). Two of the figures should be Aphrodite and her mother Dione; Miss Harrison suggests that the third is Hestia, goddess of the hearth. And beyond the conjectural divinities of the lacuna there is the central group of Poseidon, Athena, and Zeus.

The groups of the east pediment, Miss Harrison contends, compose a sacred landscape. While the divinities in the south-

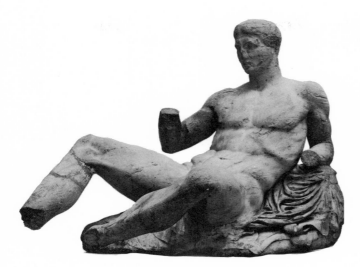

87. Parthenon, east pediment, figure D (Heracles)

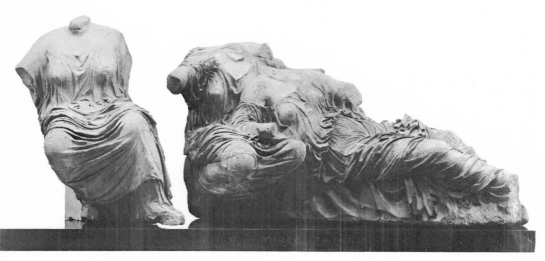

88. Parthenon, east pediment, figures K, L, and M (Hestia, Dione, and Aphrodite)

12. See Giovanni Becatti, "Postille partenoniche: I frontoni," *Archeologia classica* 17 (1965):54 ff.
13. *Parthenonstudien* (Augsburg and Vienna, 1928).

ern half of the pediment are known to have had major sanctuaries south of the Acropolis along the Ilissus valley, those in the northern wing of the pediment (including Hephaestus in the center) are known to have had major sanctuaries north of the Acropolis. The east pediment, therefore, is a vision of the Attic landscape in terms of its divine inhabitants at the dramatic moment of Athena's birth from the head of Zeus. This vision unites a moment from the past with a topographical reference to the contemporary world, the same union that is found in the program of the sculptures of the temple of Zeus at Olympia. This vision is not an innovation but the development of a familiar scheme. Nevertheless, Miss Harrison's discoveries are fundamentally important for the interpretation of the larger program of sculptural decoration of which this pediment is a part.

The west pediment presents no such problems of reconstruction (89). In the center of the scene Poseidon and Athena produced their magical portents in the presence of the startled horses of two chariot teams and an assembly of figures at either side. As in the east pediment, the scene was one of excitement and surprise. The witnesses of the divine competition, which must have been a race between the two divinities to produce the first portent, were unquestionably the heroic Athenians of bygone times, the clans of Cecrops and Erechtheus.[12]

The implications of the pediments were carried further by the sculpture of the metopes on the exterior of the temple. Below the east pediment were scenes from the battle of the gods to keep the earth monsters, or giants, from invading Olympus. Below the west pediment, a battle of Greeks and Amazons almost certainly recalled the invasion of Attica by the Asiatic warrior women that was repulsed at the foot of the Acropolis by Theseus. Despite the wretched state of preservation of the Parthenon metopes, reduced to battered stumps and shadows as much by the malice of the Christian Athenians as by the neglect of the Turks, their subjects were recovered by the painstaking work of Guido Praschniker.[13] The north and south friezes, however, where the effects of the explosion of 1687 were felt most seriously, present great difficulties. Much of the north side has disappeared. From what is left at the two ends of the series, its metopes seem to

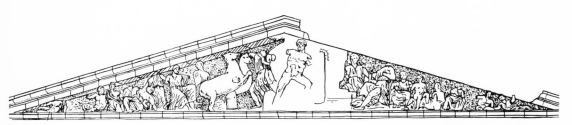

89. Parthenon, west pediment before 1687, after drawings by Jacques Carrey

have consisted of scenes of the fall of Troy, with assembled divinities at the west end. The Carrey drawings include sketches of metopes from the south side; a dozen of these metopes, part of a centaur battle, survive in the British Museum, together with fragments of others (90). The Carrey drawings show two groups of centaurs and their opponents separated by an enigmatic set of metopes with varied arrangements of male and female figures. Rather than spectators at a single centauromachy, they may be participants in other mythological episodes. In that case, however, there must have been two separate contests between men and centaurs; perhaps Theseus battled the Thessalian centaurs at one end of the frieze, and Heracles, King Dexamenes, and his men fought the centaur Eurytion and his kin at the other.

Some of the thematic connections that existed between the elements of the program emerge from the fragmentary evidence. The divine world of the pediments is also Attica, for on the east the animated geography of the scene ties it to the Acropolis and to Athens. And on the west the divine contest takes place on the Acropolis itself, where the resulting prodigies, Athena's olive and the mark of Poseidon's trident, can still be seen. Beneath the transfigured world of Attica is a world of struggle and defense in which the gods meet their antagonists, the monstrous giants; Theseus defends Attica; and Greeks overcome centaurs and Trojans. Each scene has precedents in Greek architectural sculpture. The theme—the protection of the Hellenic world from what is subhuman and monstrous, and from the Asiatic Trojan empire—is also a fit mission for Athens and the divine world surrounding her, as it is pictured on the pediments.

But another theme, that of alliance, runs through these sculptures. Theseus subdues the Amazons because under his leadership Attica has been united. The gods who battle the giants form an alliance that can be victorious only through

90. Parthenon, exterior
frieze, south side, metope

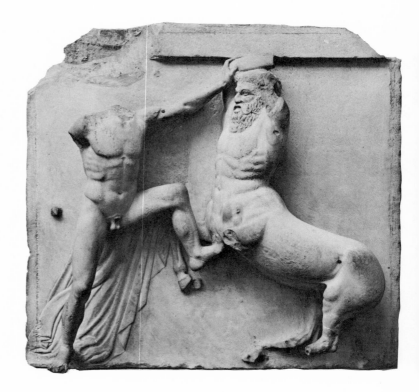

the assistance of the hero Heracles. Theseus battling centaurs
comes into the fray as the ally of Pirithous, and Heracles, if
he is represented in the corresponding centauromachy, is the
ally of Dexamenes. An Athenian would remember that on the
occasion of Theseus' ill-considered attempt on Persephone,
Heracles was the ally of the Attic King and delivered him from
the underworld. The most impressive of all the alliances rep-
resented by the exterior Parthenon sculpture is the victory of
the united Greeks over the Asiatic kingdom of Troy.

•

Two questions arise from reading the message of the exterior
of the Parthenon in this way. First, what is the relation of the
interior decorations of the building to this theme? Second,
what grounds are there for believing that such a program
would be viewed by the ancients for its contemporary signif-
icance?

Since the first modern travelers visited the Athenian Acropolis, the Ionic frieze that crowns the exterior of the cella wall inside the colonnade of the Parthenon has been regarded as a vision of a religious procession of the fifth century, idealized perhaps, but nonetheless human. Alone among Greek temples, the Parthenon seemed to have included a civic festival in its sculptural decoration; and this elevation of man to the company of gods and heroes has long served as a major example of the confident humanism of Periclean Athens.

James Stuart, the eighteenth-century investigator of Athenian monuments, was apparently the first to identify the frieze as the Panathenaic procession, the annual ceremony in which a new robe (peplos) was brought to Athena on the Acropolis by the citizens of Athens, accompanied, in the days of their greatness, by delegations of their allies, subjects, and colonists. Stuart's identification of the frieze as a depiction of that procession has been widely accepted since the last century. The procession is visualized as beginning at the southwest corner of the cella, proceeding along the north and south sides of the building, and converging on the east front. There, in the presence of the Olympian divinities, a priest and priestess present the folded peplos of Athena.

However, if the frieze was intended to represent the Panathenaic procession, its designers deliberately omitted three elements known from literary evidence to have been part of the procession in the fifth century: the Panathenaic ship, on the yardarm of which the peplos was displayed in the procession; the honored maidens who carried sacred baskets in the procession (kanephoroi); and the Athenian citizen infantry who marched in the procession. Moreover, another element has been curiously altered: the women who carried water jars in the procession (*hydrophoroi*) have been replaced by young men.

Stuart's identification can be defended only by what may be called the episodic theory. According to this theory, the frieze is not a comprehensive picture of the procession but a selection of scenes chosen from various points along the course of the parade, with one scene fading into the next and important elements of the ceremony omitted.[14] But this conception of the frieze is a distortion of the unity of time and space that characterizes Classical Greek art. There was a kind

14. The best statement of the episodic theory is put forward by Philip Fehl in "Rocks on the Parthenon Frieze," *Journal of the Warburg and Courtauld Institutes* 24 (1961): 1–44.

91. Parthenon, Ionic frieze, east side, slab 5, figures 28–37 (presentation of peplos and seated divinities)

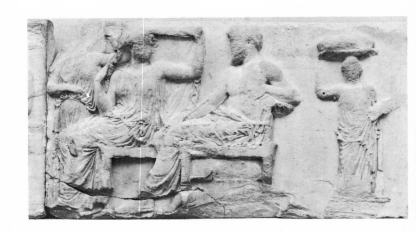

15. Γλαυκῶπις—ʽΟ ʼΑρχαῖος Ναὸς καὶ τὸ Θέμα τῆς Ζωφόρου τοῦ Παρθενῶνος [Glaukopis—the Archaic naos and the theme of the Parthenon frieze], Archeologike Ephemeris, vol. for 1961 (1964), pp. 61–158.

of continuous narration in the mid–fifth century—for example, a series of pictures placed around the body of a vase to show consecutive episodes of a hero's adventures—but the art of that century was also characterized by respect for the limits of human vision, by a remarkable unity of action, and by emphasis, with labels if necessary, on all the essential elements of a story. Between the clear scenic definition of Classical Greek art and the fluid viewpoint and incomplete action that the episodic theory finds in the Parthenon frieze, there is a world of difference.

An important recent study of the Parthenon frieze, by Chrysoula Kardara, makes the case for interpreting the entire frieze as a scene of the heroic past, not the human present.[15] A basic observation supporting this thesis is that the two figures engaged in handling the peplos in the center of the east frieze are to be seated on stools being brought to them by two attendants and will thus take their place with the gods of the frieze (91); they clearly belong to the divine world. Miss Kardara suggests that the scene shows the royal boy Erechtheus-Erichthonius with his mother Ge (Earth) and King Cecrops in the act of presenting the peplos of the first Panathenaic festival. It is for Erechtheus-Erichthonius and Ge that the two daughters of Cecrops are bringing stools. Beyond the divinities seated to left and right stand the other kings for whom the Attic tribes were named (92). With them are the original stewards (hieropoioi) of the festival. The entire scene thus belongs to the age when gods and heroes

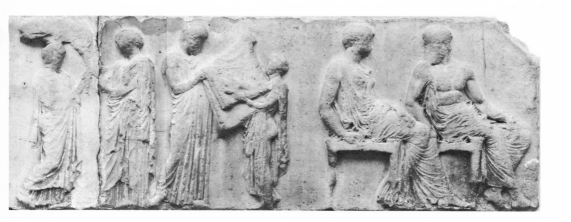

mingled in the world, and the difficult problem of a divine audience in the midst of a human festival is avoided.

On the three remaining faces of the frieze Miss Kardara sees two processions, that on the south for Ge and that on the north for Athena. Midway along each of the long sides, according to Miss Kardara, the scene shifts, and the groups of chariots and horsemen that follow do not belong to the procession but are scenes from the equestrian contests of the first Panathenaea. Here it is more difficult to follow this interpretation with confidence, especially because the interpretation of the chariots and horsemen, by introducing once more an element of the episodic fallacy, removes them from the place and time of the entire procession. However, Miss Kardara herself stresses the necessary connection of the entire frieze with the gods and heroes of the east side and, quite rightly, maintains that the entire composition belongs to the same sphere of the heroic and divine. It is only the precise character of the connection that must be further defined.

The procession that meets the kingly heroes of Attica on the east frieze is composed of seven groups of subjects: women, sacrificial animals and their attendants, youths with hydriae, musicians, mature men, chariots, and horsemen. All of these subjects had previously been represented among the Archaic dedications on the Acropolis, and the Parthenon frieze is, in fact, a restoration of dedications of the Archaic Acropolis.

Before they were defaced by the Persians in 480 B.C., such

92. Parthenon, Ionic frieze, east side, slab 4, figures 20–24 (patron heroes of Attic tribes and seated divinity)

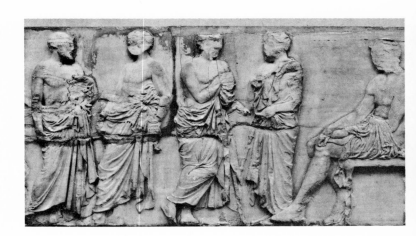

statues and the many small votive gifts accompanying them stood on the Acropolis as a permanent reminder of acts of piety. The most numerous statues were the standing figures of girls, which, bearing a token offering—an unguent bottle, an owl, or a pomegranate—were evidently generically suitable dedications for Athena. Otherwise, the reasons for the dedication of these korai are often obscure, although some of them may have been set up in connection with the Panathenaea; a number of other Archaic dedications were certainly connected with the festival, among them the offerings of the stewards of the festival and those of the winners of Panathenaic musical competitions. However, among the other Archaic monuments on the Acropolis were state monuments and dedications from overseas Athenian colonists. An equestrian dedication was made by one Diphilus on the occasion of his passing from one property class to another, and the base of a kore bears the dedication of a fisherman named Isolochus to thank Poseidon-on-the-Acropolis for a good catch.

In 448, when the first stones of the Periclean Parthenon were dressed and laid, many Athenians, like Sophocles, could remember the Acropolis as it was before the Persians came, and more than a few of them had witnessed the burial of the disfigured Archaic votives by the pious victors of Salamis. In a sense the entire Parthenon was a restoration on the same site of its unfinished predecessor, left in ruins, along with the other shrines destroyed by the Persians, as a reminder of

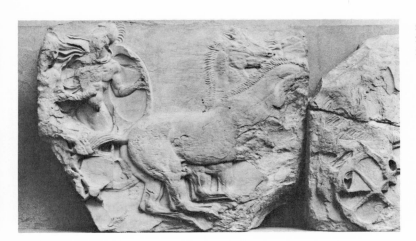

93. Parthenon, Ionic frieze, south side, slab 30, figures 73–76 (*apobatai*)

barbarian impiety. But when, thirty years later, the oath of Plataea was set aside and the Parthenon begun, what more fitting tribute to the memory of the heroes of Marathon and Salamis than that their dedications and the dedications of their fathers and grandfathers, which had suffered at the hands of the Persians, should be remembered in the decoration of the temple? The restoration was not a literal restoration of Archaic statuary but a composition of the figure types of the Archaic dedications.[16]

Two elements of the frieze seem to link it explicitly with the Panathenaic festival. The first element is the folded cloth in the center of the east frieze, which, there is no reason to doubt, is the peplos of Athena (91). But the peplos renewed each year by the dedication of the new garment displayed in the Panathenaic procession was also a votive, perhaps the most important votive placed in the procession of the goddess. These peploi, too, had perished in 480 B.C., and they, too, were part of the memory of the Archaic Acropolis. The second element, on the north and south faces of the frieze, is the depiction of armored contestants (*apobatai*) in a race that, at one point at least, required the participants to leap from a moving chariot (93). This race, founded by Erechtheus, was part of the Panathenaic games and was run in the market place. But the *apobatai* of the frieze need not be interpreted literally as charioteers in an athletic event suddenly found in the midst of the Panathenaic procession. They may well be recollections of the dedications, among the Archaic monu-

16. This interpretation is argued in detail by R. Ross Holloway in "The Archaic Acropolis and the Parthenon Frieze," *Art Bulletin* 48 (1966):223–26.

94. Parthenon, Ionic frieze, east side, slab 8, figures 57–61 (girls with sacrificial vessels)

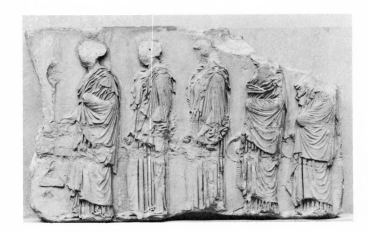

ments of the Acropolis, of earlier victors in the race. Consequently, neither the presence of the *apobatai* nor of the company of horsemen who follow them in the frieze support the episodic theory. These horsemen and athletes do not interrupt the literal record of a procession but are part of a vision of what is generically and eternally appropriate.

On the Ionic frieze of the Parthenon (94), one can almost see the Archaic korai in their new dress and form. Behind them come the sacrificial animals and their handlers, recalling Archaic dedications such as the statue of the Calf Bearer. Beyond the youths with water jars on their shoulders, the musicians come forward like the Panathenaic victors in the musical competitions who left memorials on the Acropolis. They are followed by mature men in whom may be seen the counterparts of the draped male figures, standing or seated, among the Archaic dedications. Last come the chariots, horses, and horsemen (95), all matching types found among the Archaic sculptures of the Acropolis. Among the riders of the north frieze there are six who wear long-sleeved chitons, unusual dress for Athenians, even for young bloods who affected barbarian costume when they rode. These chiton-clad riders are strikingly reminiscent of a rider in Persian dress that had once stood on the Archaic Acropolis.

In the frieze this equestrian group, which with spirit and majesty occupies half its length, is given the preponderance of numbers, if not the honor of position. The horse—created by Poseidon and associated with Athena and Erech-

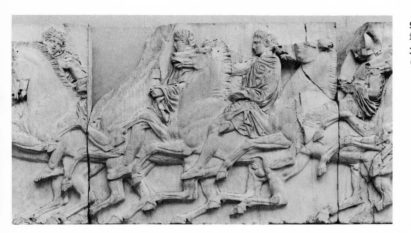

95. Parthenon, Ionic frieze, north side, slabs 36–38, figures 112–16 (horsemen)

theus-Erichthonius, the first horse tamer and chariot builder —carries unmistakable connotations of heroization.[17] Thus the Parthenon horsemen are not only the appropriate escort of Athena but symbols as well of the heroic overtones of the frieze.

The interior of the Parthenon was dominated by the gigantic gold and ivory cult statue of Athena that Pausanias described when he saw it, long after the original gold drapery had been stripped and renewed. An idea of the majesty of the Phidian goddess can be recaptured only with difficulty from small or even from life-size copies, among them one in the Louvre, one from Pergamum, and two, recently discovered, from Gortyn in Crete and Bitola in Yugoslavia.[18] The goddess held a statue of Victory in her outstretched hand, and at her feet a snake curled, possibly a reference to the mythical Athenian king Erechtheus-Erichthonius, who sometimes took the form of a snake. On her sandals and shield were reliefs identified by Pliny the Elder: on the sandals, a centauromachy; on the shield, representations—on the exterior and interior, respectively—of a battle of Greeks and Amazons and a battle of gods and giants. On the base of the cult statue was a frieze showing the birth of Pandora.

Each part of the decoration of the cult statue recalls an element of the program of the architectural sculpture of the building. Athena is the goddess born on the east pediment. She in turn, with Hephaestus, created Pandora, who, as the mother of Pyrrha and Deucalion, was the mythical mother of

17. Ludolf Malten, "Das Pferd in Totenglauben," *Jahrbuch des Deutschen Archäologischen Instituts* 29 (1914): 179–255.
18. The copy from Bitola is illustrated in *Bulletin de correspondance hellénique* 90 (1966): 62–63, fig. 15; that from Gortyn is published in *Bollettino d'arte* 36 (1951): 356, fig. 44.

mankind. The snake Erechtheus-Erichthonius echoes the role of the ancient Attic heroes in the architectural sculpture. The battles of the metopes are also repeated: gods and giants, Greeks and Amazons, and centaurs and Greeks. Only the Trojan War seems to be missing; however, in their compressed descriptions Pausanias and Pliny may well have omitted a repetition of the Trojan scenes in the decoration of the cult statue.

•

The decoration of the interior of the Parthenon thus echoes the theme identified in the exterior decoration: Athens-alliance-victory. That the contemporary allusions of this theme figured in the planning of the Parthenon program and were appreciated by the audience for which it was intended is indicated by the deliberate patriotic juxtaposition of mythical and contemporary foes of Athens in the paintings of Polygnotus, Micon, and Panaenus in the Decorated Stoa, which was built more than a decade before the Parthenon was begun. In those paintings the repulse of the Persians at Marathon and of the Spartans at Oinoe was placed on a plane with Theseus' Amazon victory and the Trojan War. Indeed, in decorating the Periclean monuments of the Agora no opportunity was neglected to glorify Theseus, and through him Athens. He and Heracles were the subjects of the sculpture of the temple of Hephaestus on the hillock west of the Agora. The paintings in the Theseum proper also depicted the repulse of the Amazons and a centaur battle. The pairing, in the Decorated Stoa, of the paintings of epic scenes with those of recent battles is an unmistakable guide to the associations that an Athenian would have felt implicit in the paintings and sculpture of the Theseum, the Hephaesteum, and, most of all, the Parthenon. Just as the divine world of the Parthenon pediments is related to Attic geography, so the program of the building is tied to the theme of alliance and victory. The less disgruntled of the Athenian allies, perhaps, took some pride in that message.

6. Late Phidian Expressionism

The eloquence of the Parthenon sculpture depended on the sympathetic eye of a world that had not lost the ability of the Archaic Age to accept the suggestions of an implicit metaphor without doubting that a plastic image could represent divine and heroic reality. The vitality of the individual episodes that decorated the Parthenon was, therefore, as essential to its effect as the continuity of the implications that were its message. But the Parthenon is the monument of an intellectual situation that could not endure. Indeed, it has been said of Greek thought before Socrates that "one of the most important aspects of the philosophical development of the period lies in the gradual emergence of a distinction between the ideas of corporeal and spiritual. At the beginning there is no awareness of such a distinction, and only in the middle of the fifth century does it begin to emerge with clarity."[1] The attempt of Archaic Greek sculpture to achieve forms that would express the virtues and strengths of transfigured humanity was a hopeless pursuit in an age in which virtues and divinities had become abstract ideas. For the assumptions of anthropomorphic theology were already under criticism at the beginning of the fifth century in the poems of the Ionic skeptic Xenophanes of Colophon. And in the Periclean circle there were two natural philosophers whose criticism was devastating for the old order, Protagoras of Abdera and Anaxagoras of Clazomenae. Both fought the cause of epistemological skepticism with famous dicta on the inaccuracy and inadequacy of the senses that made them the object of persecution by outraged conservatism. (Anaxagoras may have been attacked in the courts as early as the 450s and Protagoras possibly later, though the evidence is unclear.) In the theater Euripides' plays, notably *Hippolytus* and *The Trojan Women*, brought skepticism to the stage. Irrevocable damage was being done to the old intellectual order by the sophistic movement, which made the reflective artist less and less confident that his creations opened an unobstructed view into the realm of heroes and gods.

In addition to the uncertainties raised by this attack on the intellectual basis of representational form, sculpture was still facing a problem inherited from the preceding generation, that of harmonizing the divine personality with the appearance of motion or repose as these states had come to be por-

1. W. C. K. Guthrie, *Greek Philosophy: The Hub and the Spokes* (Cambridge, 1953), p. 7.

trayed in the Early Classical period. The solution of Phidias and his contemporaries was to return to the idealized humanity of the Early Classical facial type. This stifled portraiture in Greece for another half century, in the course of which secondary devices were invented to carry the emotional content of the artistic representation.

•

Illustrations 96 and 97 present, side by side, Roman copies of two works of the fifth century, the portrait of Pericles by Cresilas and the head of an Amazon, possibly from an original by Polycletus. The remarkable similarity of the heads of these two very different subjects—a mythical warrior maiden and a contemporary Athenian statesman—shows how hard the later fifth century strove to preserve abstract nobility in facial expression. Nevertheless, skill in draftsmanship and the sure hand of the sculptor, when governed by the curiosity and sharp eye of the Greek, could break such conventions, and rare instances of portraiture or caricature occur even before the fifth century. One of these, on a cup in the Metropolitan Museum of Art attributed to the Hegesiboulos painter, is the figure of a hook-nosed old man out for a stroll with his dog (66). And in the fifth century there are portraits of contemporary statesmen, besides that of Pericles, that suggest the potential genius that would one day turn Greek art from the general toward the personal and unique and, at the same time, reveal the limitations of the traditional Hellenic world that stunted such growth for so long.

Cresilas' portrait of Pericles is not dated precisely, but there is no reason to assume that it was made during the statesman's lifetime. Indeed, a portrait of a living man—except for a dedication, for which an athletic victor was among the traditionally sanctioned subjects—was still deemed so grievous an insult to the eternal gods that the charge that portraits of Pericles and Phidias lurked among the figures depicted on the shield of the gold and ivory Parthenos was used against Phidias in the courts. The very abstraction of Cresilas' portrait of Pericles suggests that it is a posthumous heroizing tribute to the Athenian leader. Similar posthumous heroizing portraits are that of Miltiades for the Athenian Marathon

memorial at Delphi by Phidias; that of the disgraced Spartan general Pausanias, erected at his tomb under orders from the Delphic oracle; and that of the Syracusan tyrant Gelon at Olympia.[2]

A Roman herm copy of a portrait of Themistocles was a revelation when it came to light at Ostia in 1939 because it is a realistic portrait in the style of the second quarter of the fifth century (98). A refugee in the Persian Empire during his later years, Themistocles was governor of Magnesia on the Maeander until his death in 460 B.C., so that if the portrait was made during his lifetime, it was undoubtedly executed there. The subject of another portrait, a diademed bronze head in the museum at Cyrene (99), has been identified as Arcesilas IV, the last Battiad king who reigned at Cyrene until the overthrow of the dynasty in the 430s. If it is correctly identified, it is the only realistic portrait unquestionably made during the subject's lifetime that has survived from the fifth century. But the subject of this distinguished sculpture was not an ordinary man but a Greco-African king.

Painters, as well as sculptors, seem to have adhered to the convention of abstract nobility in facial expression. Pliny the Elder said that "Polygnotus . . . made many innovations in painting; it was he who first represented the mouth open, so that the teeth show, and varied the face from Archaic rigidity that existed before him."[3] But Polygnotus' facial variety may have been no greater than that of the sculptures of the temple of Zeus at Olympia, among which are figures with open mouths, like the Greek youth recoiling with shock as a centaur bites his arm (69). Figures answering to Pliny's description of Polygnotan innovations have been noted in mid-fifth-century painting, particularly in the work of the Niobid painter. However, it seems unlikely that even the painters' desire for variety, their ability to characterize, and their interest in caricature led to anything like real portraiture.

The conventions of Athenian art in respect to portraiture were those of Greek art as a whole. These conventions are evident in the athletic figures of the Peloponnesian contemporary of Phidias, Polycletus, whose interest in an anatomically developed figure of standardized proportions and convincingly balanced pose produced a series of figures that were to serve as prototypes for a thousand years of sculpture. The

2. Several copies of the Pausanias portrait have been recognized by Hans P. L'Orange in *Mélanges Charles Picard* (Paris, 1949), 2:668ff. For Greek portraits in general, see Gisela M. A. Richter, *The Portraits of the Greeks* (London, 1965).

3. *Natural History* 35. 58.

96. Portrait head of Pericles by Cresilas, Roman copy

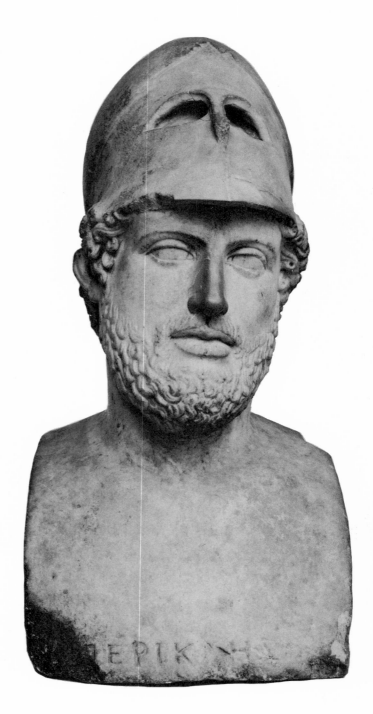

97. Head from Amazon
attributed to Polycletus,
Roman copy

98. Portrait of Themisto-
cles, Roman copy

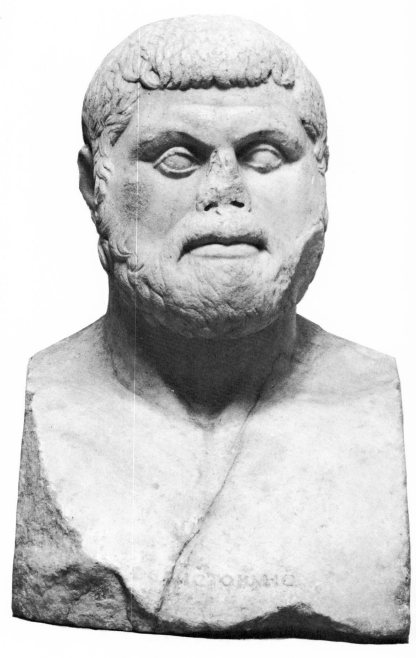

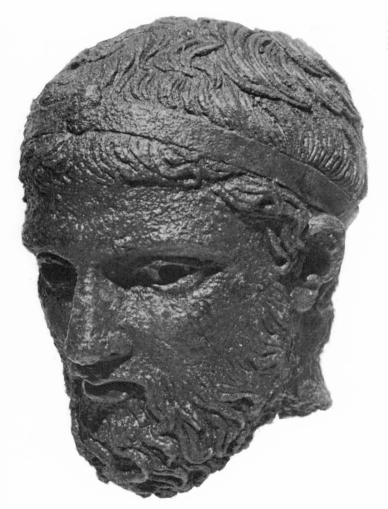

99. Bronze portrait head, possibly of Arcesilas IV, from Cyrene

100. Attic funeral relief

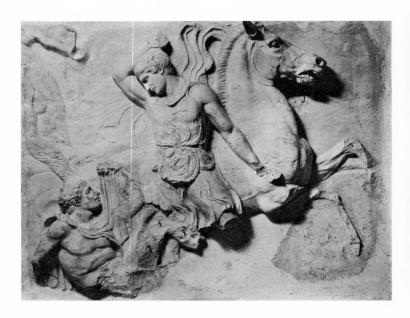

most famous is the Spear Bearer (73), which, like the Discus Thrower of Myron, had lost its identity by the time of the Roman Empire, a victim of the impersonality that characterizes the work of Phidian sculptors who stayed within the conventions of their time. It was a favorite academic model for Roman sculptors, and many of their copies survive.

The generalized humanity of Phidian sculpture led to an increasing preference for symbolic values over personality or immediate drama. The large and justly famous relief in the Villa Albani in Rome is a major piece of Periclean sculpture, perhaps made to adorn the monument of the war dead of one of the Athenian tribes (100). One is tempted to identify the victor standing over his fallen adversary as a horseman, because of the mighty steed that rears in the background of the relief, but neither of the unmounted combatants is necessarily a cavalryman. The horse is present for his symbolic value, to provide the same heroic connotations that the horses of the Parthenon frieze were intended to evoke. And the relief needs its symbolic horse, for the figures of the warriors in themselves were insufficient to suggest the quality of the heroic that the Archaic world had been able to make apparent in a single motionless kouros.

●

4. See chapter 7, in which this development is discussed further in connection with the art of the fourth century.

Preoccupied with an effort to create a sense of animation and emotion around the tranquil sculptural figure, the late-fifth-century sculptor became a conscious expressionist, like contemporary architects, in whose work the familiar orders became the servants of an architecture of brilliant effects and surprises. There is no better example of Late Phidian expressionism than the Aphrodite discovered in the Athenian Agora in 1959 (101), which seems more fit to adorn an Italian baroque tomb than a Classical Greek city. The rotation of the massive torso sends long waves and ridges through the goddess's light gown, agitating the drapery far more than the slow spiral motion of the body warrants. Indeed, the most effective means devised by the sculptor to animate his figure is the wave of heavy overdrapery that runs together as it rises and comes to a crest over Aphrodite's left arm. The same technique of emphasizing relief by light and shadow is also developed in contemporary painting.[4]

The windblown ripples and ridges of Late Phidian drapery were best fitted to a figure in motion, particularly to a winged Victory. Such a figure, dating from the 420s, was executed at Olympia by the sculptor Paeonius and survives, posed as if alighting from her dazzling flight on the top of a high stele (102). The Victory of Paeonius illustrates the success of Late Phidian art, given a situation in which illusionist effects could be employed, in continuing to satisfy the Archaic aspiration for divine beings in stone.

The devices of expressionistic sculpture—whether the spirited horse, agitated drapery, or off-balance pose—all characterize the Phidian style as it developed on the Parthenon. However, the conscious application of these devices in an intensified and artificial fashion resulted in a trend among the members of the Phidian school toward purely decorative art and toward archaism.

Symptomatic of this trend are the friezes of the Erechtheum and of the balustrade of the small temple of Athena Victory, perched atop the age-old bastion beside the entrance to the Athenian Acropolis. The latter frieze was on the exterior of the parapet surrounding the precinct of the temple, where it could be admired by visitors climbing slowly up the path-

101. Aphrodite from
Athenian Agora

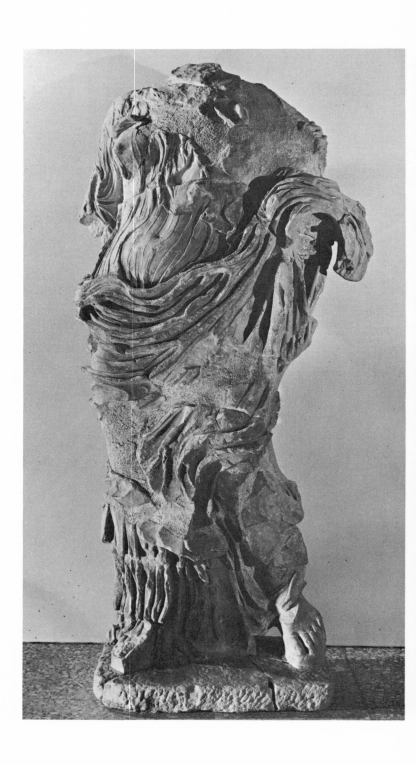

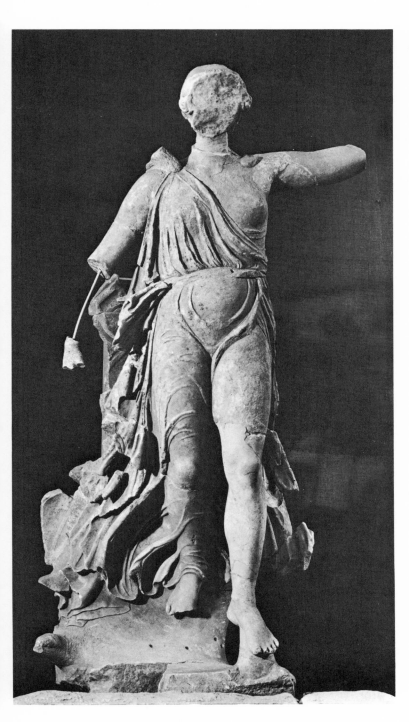

102. Victory by Paeonius
from Olympia

5. This was demonstrated by Homer Thompson, "The Altar of Pity in the Athenian Agora," *Hesperia* 21 (1952): 47–82; see also Evelyn B. Harrison, "Hesperides and Heroes: A Note on the Three-figure Reliefs," *Hesperia* 33 (1964): 76–82.

way toward the high place of the gods. Its subjects are Victories, some engaged in the serious works of sacrifice, others occupied with incidental activities, like one of the most charming of them, who seems to be tying her sandal (103). There is no real drama, but excitement is generated by the emotive power of the flow of the drapery. Reduced to its essentials, the work of the Phidian expressionists is much like the simple decorative schemes of their Archaic predecessors. But there is a vast difference between the two, for the Phidian sculptors have brought into prominence the grace and endless variety of the transient and human.

Even when not so decorative as the parapet frieze of the temple of Athena Victory, architectural sculpture created after the Parthenon often reverted to the ambiguity of implicit metaphor as it was employed in the Archaic Age. One group, known only in Roman copies and consisting of four reliefs, has been restored as the exterior decoration of the Altar of the Twelve Gods at Athens.[5] On the altar two reliefs flank each of the two entranceways into the altar enclosure. Their subjects, however, are not gods but heroes: Heracles in the garden of the Hesperides, Heracles rescuing Theseus from Hades, Orpheus and Eurydice (104), and, finally, Medea and the daughters of Pelias. A tone of warning and apprehension surrounds the subjects: Heracles may be a blissful hero in the magic garden of the Hesperides, but he will leave behind a victim of an impossible love; Theseus is rescued from Hades, but his companion Pirithous is doomed to remain; there is a version of the Orpheus story in which he succeeds in leading Eurydice home from the dead, but the version in which the fatal backward glance occurs seems to be implied here; the daughters of Pelias hope that the bath they are preparing will rejuvenate their father, but Medea has tricked them, and he will boil to death. The four reliefs are stately and evocative. It is far from certain, however, that they contain a programmatic message. Probably the observer was meant to find his own interpretive metaphors.

Another symptom of the state of fifth-century art is the archaistic sculpture of the Phidian school, which reproduced mannerisms of the past for a conscious effect. Two Roman copies with identifying inscriptions and a number of related copies reproduce a pillar surmounted by the head of the god

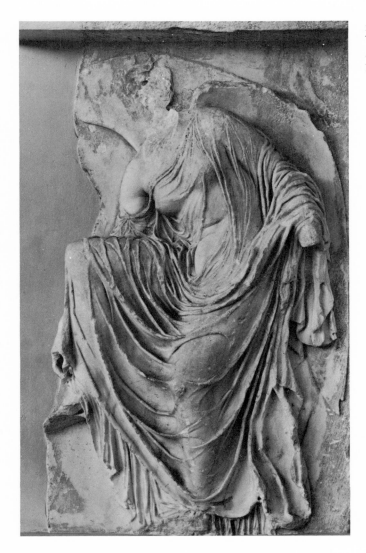

103. Temple of Athena
Victory on Athenian
Acropolis, Victory from
parapet frieze

104. Roman copy of relief attributed to Altar of the Twelve Gods in Athens

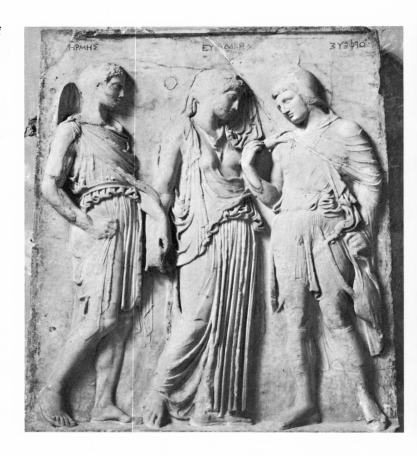

Hermes (105), probably the Hermes Propylaeus by Alcamenes that stood at the entrance to the Acropolis. This herm is a bearded Classical head topped with a corona of Archaic curls to convey a sense of divinity and dignity.

•

Thanks to the pride of the cities of Sicily and south Italy in the artistic quality of their coinage, the artistic trends and discoveries of the later fifth century are recorded with especial brilliance in an unlikely medium, coin engraving. The engravers employed by these cities were so famous that their names were ostentatiously displayed on the dies. Few examples of medallic art or of Phidian expressionism in any medium equal the full-face Apollo head executed by Hera-

clides for the city of Catana (106). And the coins of Euaene-
tus (107, 108) reveal fifth-century achievements in linear
perspective better than any surviving vase paintings. The
problem of facial expression is also illustrated by Euaenetus'
work at Catana, among which, with hair so luxuriant that it
almost hides the god's laurel crown, is a head of Apollo,
around which are disposed a crayfish, a bell, and the city's
name (108). The god's face is based on the standard models
of the Catanian coinage of the same period, its derivation be-
ing especially noticeable in the deep eye, set high in the head
and close against the line of the long nose. A very different
creation is Euaenetus' river god Amenanus (109), also made
for Catana, which, like the engraver's Apollo, has luxuriant
hair that grows low over his forehead and waves gently over
his neck like the eddies of his watery domain. Unlike the
Apollo head, however, open areas of the cheek and nose are
modeled to give a sense of relief by means of a subtle pattern
of shadow. The murky character of the face is created by three
chevronlike furrows on the forehead of the god, producing the
effect of a mask. It is significant that an artist of Euaenetus'
stature, deeply concerned with graphic art, could not bring
himself to change the conventional profile of the coin head.
Instead, reaching back to the devices of Archaic and Early
Classical art for representing subhuman creatures, he
adopted the wrinkled forehead of Archaic satyrs and of the
centaurs of the west pediment of the temple of Zeus at
Olympia (67, 69).

In the fifth century the Classical tradition was cast in the
form in which it has been known and imitated until the present
day. Periclean Athens having stated its ideals with such en-
during clarity and eloquence, Late Phidian art, a reaction
against the familiar and expected, was produced by men who
worked in the wake of the sophistic revolution and belonged
to a generation beset by doubt as well as stimulated by dis-
covery. Late Phidian art may be less noble and confident than
that of the Parthenon, but it is vastly more exciting. Only by
clinging to the noble but emotionless Classical head—thus de-
liberately perpetuating in some measure the ideal Archaic
sculptural form—did it hesitate to cast aside convention.[6]

●

6. That the perpetuation
of Archaic artistic
idealism was an active
purpose in the fifth cen-
tury is also made clear by
the references to art made
by Greek authors of the
period that are examined
in Appendix A.

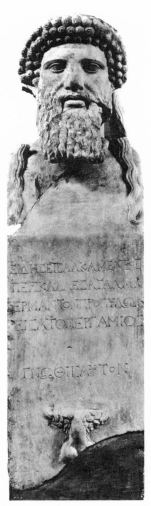

105. Herm by Alcamenes,
Roman copy

106. Silver coin of Catana struck from dies by Heraclides

107. Silver coin of Syracuse with obverse struck from die by Euaenetus

108. Silver coin of Catana struck from dies by Euaenetus

109. Silver coin of Catana struck from dies by Euaenetus

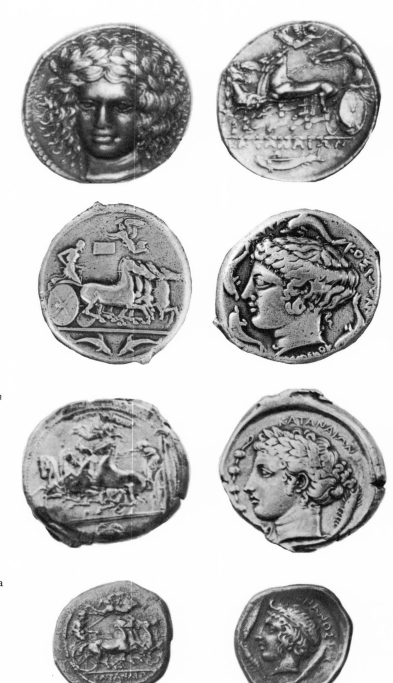

Athenian architects in the age of Pericles also sought to create unexpected effects and compositions of symbolic significance. On the Acropolis this expressionism is evident in the irregular plans of the Propylaea and the Erechtheum. In Arcadia it appears in the temple of Apollo at Bassae that was designed by Ictinus, the principal architect of the Parthenon.

Because the buildings are not axially symmetrical, architectural historians have refused to believe that the remains of the Propylaea and of the Erechtheum represent the original intentions of their designers. Mnesicles' Propylaea (110–12) is no more than a stage front to the Acropolis (82). It appears to be symmetrical when viewed from the approach to the Acropolis, but although the façades of the wings are symmetrical, the outer end of the façade of the south wing masks a shallow interior. Architectural historians, however, insist on reconstructing the south wing on the model of the north wing. They argue that this was the original design of Mnesicles, but that his plans were frustrated by three circumstances: a shortage of funds occasioned by the outbreak of the Peloponnesian War;[7] the objection of the priestess of Athena Victory to a design incorporating in the Propylaea part of her sanctuary; and piety, which made it impossible to dismantle one of the remnants of the Mycenaean defenses of the Acropolis, the Pelasgian wall that still cuts across the southeast corner of the Propylaea.

Proponents of an original symmetrical design can also point to material evidence drawn from the existing remains of the Propylaea. Work had been started on a large room at the northeast corner of the building, where the existing walls were made ready to receive the extension, and there are cuttings that have been interpreted as sockets for future ridgepoles for both the incomplete northeast hall and a matching hall on the south side of the building. However, the evidence of these ridgepole cuttings is not unequivocal because they were placed at different heights in the existing walls.

Nevertheless, there is a single insurmountable objection to the case for a symmetrical south wing of the Propylaea: the Pelasgian wall faces a rapidly rising mass of Acropolis bedrock that towers thirty feet above the base of the south wing of the Propylaea. Mnesicles would have had to be prepared to quarry away tons of bedrock to carry out any symmetrical

7. The "Decrees of Callias" (*Inscriptiones Graecae*, 2d ed., 1, nos. 91–92; George F. Hill, comp., *Sources for Greek History between the Persian and Peloponnesian Wars*, ed. Russell Meiggs and Antony Andrewes [Oxford, 1951], no. 67), generally dated to 434 B.C. and often cited to support this contention, provided for the continuation of the building program even though war was imminent, and not for termination of the work. For Greek cities, moreover, war was the normal state, and work on the Erechtheum was carried on during the darkest days of the Peloponnesian War. Later dates have also been proposed for this decree, most recently 418 B.C. by Charles W. Fornara in "The Date of the Callias Decrees," *Greek, Roman, and Byzantine Studies* 11 (1970):185–96.

110. Propylaea and neighboring buildings

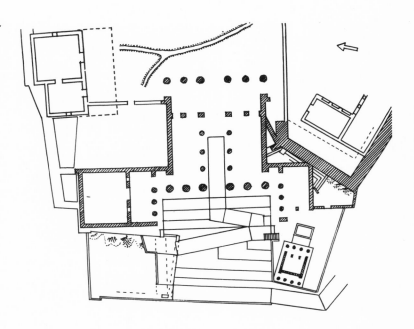

111. Propylaea, east elevation

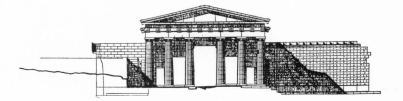

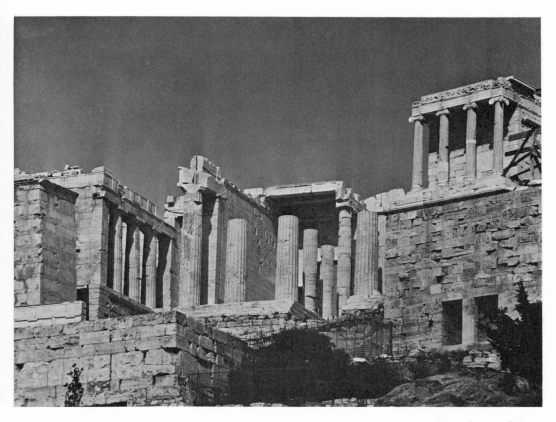

112. Propylaea and (at right) temple of Athena Victory

8. William B. Dinsmoor, "The Athenian Theater of the Fifth Century," *Studies Presented to David Moore Robinson on His Seventieth Birthday* (St. Louis, 1951), 1:309–30. In his *Pictorial Dictionary of Ancient Athens* (London and Tübingen, 1971), p. 537, John Travlos has preferred to restore the fifth-century theater without the parascenian stage-building.

9. The Larisa palace is a type of porticus dwelling. Such buildings are now known to have been widespread in the Mediterranean at an early date. Buildings related in form are found at Morgantina in Sicily (Erik Sjöqvist, "Excavations at Morgantina: 1959," *American Journal of Archaeology* 64 [1960]: 125–35, esp. pp. 133–34) and in Etruria (Carl-Erik Östenberg, "An Etruscan Archaic House-Type Not Described by Vitruvius," *Opuscula romana* 7 [1969]: 89–107). These are the direct forerunners of Roman and Late Antique porticus villas (Karl M. Swoboda, *Römische und romanische Paläste* [Vienna, 1918; 3d enlarged ed., Graz, 1960]). The building at Morgantina is probably the palace of the sixth-century tyrant.

plan for his building. Despite Greek readiness to lay deep foundations when required, like those on the south side of the Parthenon, it seems most improbable that such wasteful construction would have been contemplated by men who saved fragments of the unfinished Parthenon and used them in the Periclean temple, and who also carefully conserved and reused the blocks of the gatehouse they dismantled to make way for the Propylaea.

Why then did Mnesicles build the Propylaea with two projecting wings, one of them little more than a stage front? Certainly the effect was splendid, but the passage through the central unit of the Propylaea is majestic in itself, with Ionic columns on either side, their grace heightened by contrast with the Doric exterior. Moreover, this central unit alone would have repeated the plan of the gateway it replaced.

The plan of the Propylaea may be related to the same prototype that is reflected in the stage buildings of Greek theaters, which, at one phase of their development, were constructed with large wings projecting toward the audience. Parascenia, as these wings are called, have been attributed to the stage-building of the theater of Dionysus in Athens in the fifth century.[8] Since scenes set before the residence of a heroic ruler were frequent in Attic tragedy, the stage-building with parascenia must have been compatible with accepted ideas of palace architecture. Such a connection between royal symbolism and the parascenia plan is confirmed by the sixth-century palace of the local despot at Larisa on the Hermus in Asia Minor. Almost the only surviving example of palace architecture in the Classical Greek world, this palace has a parascenia façade like that of the restored fifth-century stage-building of the theater of Dionysus (113).[9] The similarity of Mnesicles' Propylaea to these buildings suggests that the Periclean entry to the Acropolis was intended to emphasize the heroic past of the sacred hill of Athens, where the palace of King Erechtheus had stood in the days when gods and heroes mingled on the Acropolis as they mingled in the decoration of its later monuments.

The Propylaea is not the only building to have been misunderstood because of the conviction of architectural historians that asymmetrical planning did not occur in Periclean architecture. The Erechtheum, that beautifully detailed Ionic

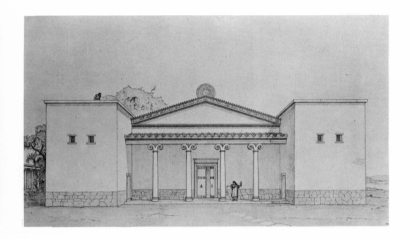

113. Larisa on the Hermus, palace

structure north of the Parthenon, has also been hypothetically restored in an "original" plan with axial symmetry (114, 115). The core of the Erechtheum is a simple building preceded on the east by a porch and with its interior subdivided into four rooms, but its north porch and the Porch of the Maidens on the south are asymmetrically placed and are very different from each other in size and appearance, although each functioned as a shelter for a cult place. This asymmetry in the Erechtheum must have delighted and surprised a world accustomed to blocklike regularity in its temples. Lacking the conscious symbolism of the Propylaea, the Erechtheum made a greater break with tradition. It is one of the most adventurous buildings in the history of Western architecture.

Many of the architectural features of the Parthenon and the temples of the Hephaesteum group had already appeared elsewhere. The Ionic columns of the Parthenon west chamber, for instance, had been preceded more than a half century earlier by the Ionic porch of the temple of Athena at Paestum. The Ionic details in the moldings of the Parthenon also had precedents in the western Greek world, and the Ionic friezes of the Parthenon, like those found over the porches of the Hephaesteum and the temple of Poseidon at Sunium, may echo the experiment made at Assos in the Troad, for the late Archaic temple there, built before 490 B.C., while the city was under Athenian influence, had not only sculptured metopes but also an exterior sculptured architrave.[10] However, the marriage

10. It has been suggested that the Pisistratid temple of Athena had an interior Ionic frieze similar to that of the Parthenon, as well as interior porches with Ionic columns. This hypothetical restoration is discussed by H. Riemann in "Der Peisistratidische Athenatempel auf der Akropolis zu Athen," *Mitteilungen des Deutschen Archäologischen Instituts* 4 (1950):7–39.

114. Erechtheum

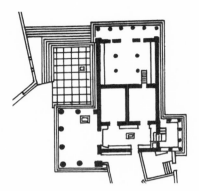

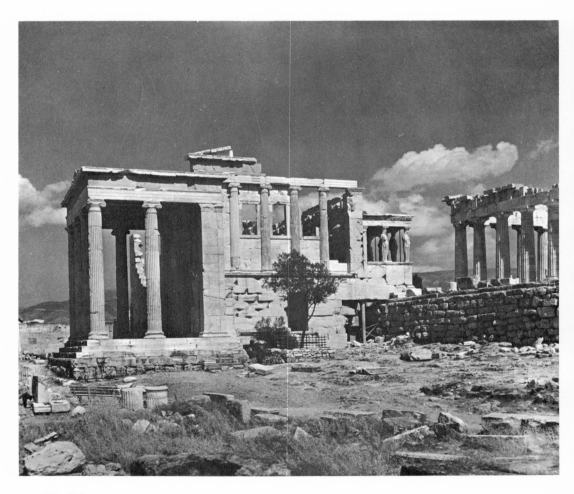

115. Erechtheum

of Doric and Ionic that first occurred in Periclean Athens prepared the stage for Ictinus' temple of Apollo at Bassae (116–19). This temple, which has guarded a lonely hillside in the mountains of Arcadia since the late fifth century, is of revolutionary importance. For although the cold gray stone of the area is uninviting to the mason, so that the exterior of the temple has an old-fashioned rigidity that has led many to date it before the Parthenon, the interior contained the earliest-known example of the Corinthian order. Tradition credits the invention of this last of the major ancient orders to the sculptor Callimachus, but Ictinus was responsible for the Bassae capitals, which combine a low ring of leaves and two tight spiral volutes in the center of the bell.

The Corinthian capitals of the temple of Apollo at Bassae stood on columns dividing the cella from an open chamber to the rear, and along the two long walls of the cella were engaged Ionic columns of a simple, individual form. Above the columns around the cella was a frieze with an Amazonomachy and a centauromachy. This interior Ionic frieze is one of the first of a long series of battle friezes that follow the patterns of spacing and of interlocked triangular composition seen also in the east Ionic frieze of the Hephaesteum.

No less significant than the Corinthian capitals at Bassae is the triumph of expressionism that Ictinus created in the open area where the cult statue was almost certainly placed, screened from the rest of the cella by columns. For the temple —with its long axis running from north to south and with a door in the east wall of the cella—was designed so that on Midsummer Day the rising sun would illuminate the cult statue.[11] The implications of the emphasis at Bassae on the interior and its lighting were fully realized in Western architecture only under the Roman Empire and its Byzantine successor, in the Pantheon and Hagia Sophia.

11. See Frederick A. Cooper's revealing study, "The Temple of Apollo at Bassae: New Observations on Its Plan and Orientation." *American Journal of Archaeology* 72 (1968):103–11.

116. Temple of Apollo at
Bassae

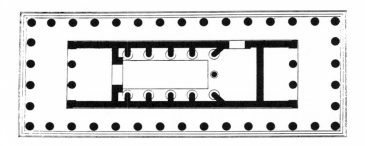

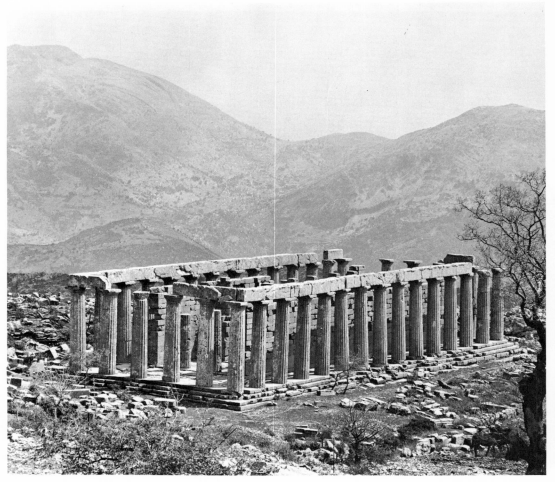

117. Temple of Apollo at
Bassae

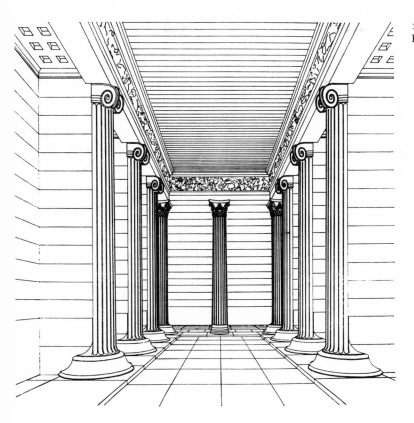

118. Temple of Apollo at Bassae, cella

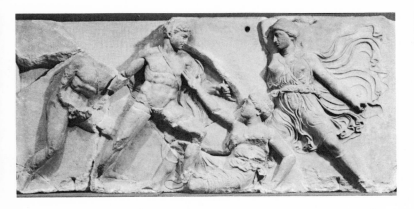

119. Temple of Apollo at Bassae, interior, Ionic frieze, detail

7. Change in the Fourth Century

1. Quintilian *Institutio oratoria* 12. 10. 3–9.

Even in antiquity the art of the fourth century had its detractors, who claimed that sculpture had reached perfection in Phidias' work and had declined thereafter.[1] The same canon of taste has had its vogue in modern times. As soon as the Apollo Belvedere fell from favor as the personification of beauty, a position it held well into the nineteenth century, the Elgin marbles were installed in its place. Post-Phidian sculpture, even Hellenistic statues like the Venus de Milo, could be admired, but the suspicion remained that the sensuality of their appeal was as decadent as the period to which they belonged. Yet the masters of the fourth century also had their supporters in the ancient world. The chapters on sculpture in Pliny the Elder's encyclopedia reflect a theory that art had reached perfection not in Phidias' work in the age of Pericles but in the work of Lysippus a century later.

•

Art is the child of patronage as well as of genius, and changes in the former bring changes in the latter. The first patrons to show new possibilities to the Greek artist were the Hellenized satraps of the Persian provinces in western Asia Minor. These Persian viceroys played a Machiavellian role in the closing stages of the Peloponnesian War, hoping by means of bribery and subsidies to keep both sides fighting to exhaustion. In 412 B.C. the Athenian renegade Alcibiades, then in the service of Sparta, made an arrangement with the satrap Tissaphernes, who, recognizing the international primacy of Athenian currency, undertook to provide money for the Spartan cause in the form of silver coin of the Attic standard. A unique coin (120), now in the British Museum, shows that the satrap could not resist the opportunity to include coins bearing his own portrait among the silver pieces destined for his allies. This coin was found at Labranda in Asia Minor, together with a number of ordinary Athenian coins of the tetradrachm denomination. The coin's reverse reproduces the Athenian types of an owl, an olive sprig, and a crescent. The inscription, however, has been changed from "ATHE," the abbreviation of "the Athenians' money," to "BAS," the abbreviation of "the king's money" (that is, the Great King of Persia).

120. Satrapal coin

2. For the importance of these coins in the history of Greek art, see Laura Breglia, "Correnti d'arte e riflessi di ambienti," *Critica d'arte* 5 (1940):58–71.
3. Preliminary notices are in *Archaeological Reports for 1959–60*, pp. 34–35.

The obverse of the coin shows a bearded head wearing the Persian tiara. It cannot be a portrait of the Great King because the peak of the tiara is folded, whereas the king's tiara was worn erect. The head, therefore, must be that of Tissaphernes, who is portrayed with a long face, emphasized by his beard, which is trimmed in an unusual fashion to sweep forward to a point. His nose is that of an Asiatic, and beneath his heavy brow his eye is at once serene and piercing. The line of the mustache emphasizes a decisive mouth.

The telling individuality of this portrait is even more apparent when it is compared with another satrapal coin (121), also in the British Museum, on the reverse of which there is also a familiar Greek type, the lyre, with the Great King's inscription. The portrait of the observe is another outstanding head. Some have seen it as a likeness of Tissaphernes grown old, but it may be a portrait of Pharnabazus, who ruled the area of the Asiatic Propontis for Persia until 392 B.C. Both men had opposed the Spartan invasion of Asia in the years after 398, and both had struck silver on the Greek standard to pay Greek mercenaries and subsidize Greek allies.[2]

The Hellenism of a Tissaphernes or a Pharnabazus went beyond an interest in providing, for Greek allies and Greek mercenaries, coins that looked and felt familiar. Long patrons of Greek art, at the end of the fifth century the princes of Lycia were commissioning structures like the Nereid Monument at Xanthus, now largely in the British Museum, for which Greek artists used experience gained in executing sculptural programs like that of the Parthenon to create allegorical intimations of immortality for their employers. At the same time, Lycian sanctuaries like that at Trysa (Gjölbaschi) boasted elaborate reliefs that reflected in linear perspective the achievements of the late fifth century. Those from Trysa are now in the Kunsthistorisches Museum in Vienna.

The satraps were philhellenes on an even greater scale, as is shown by the current excavations of the palace of Pharnabazus at Dascylium, which have revealed an exquisite structure of pure Greek architecture.[3] The collection of Greek art that adorned the palace can only be imagined. And at the end of the fifth century even the Great King residing in Oriental splendor beyond the Euphrates employed Greek sculptors, among them Telephanes of Phocaea. In the palace at Persepo-

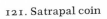

121. Satrapal coin

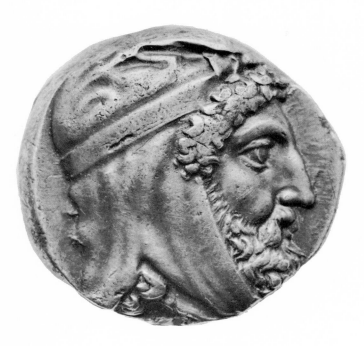

lis a seated figure of the "Penelope" type has been found, part of a collection of Greek sculpture. Although Greek subjects had lived within the boundaries of the empire since the middle of the sixth century, little influence on the taste of Persian rulers was to be expected from Greek workers in the Great King's forced labor battalions, even the sculptors who carved reliefs and columns for the palaces at Susa and Persepolis. However, many Greeks occupied influential positions, among them Democedes, who was both a royal physician and a diplomatic emissary; the physician Ctesias, who wrote the history of the Persian empire in Greek; Themistocles, who became governor of Magnesia on the Maeander; and Demaratus and Hippias, who became the intimates of Xerxes.

•

For the development of Greek art the crucial role in these relationships was played by the Greek artists called to execute portraits of the great satraps, for from the challenge of these commissions arose an art devoted to the expression of personality. The moment was propitious because the longstanding awe of the Greeks before the vastness of Persia and the power of the men who ruled that empire had developed into a feeling of respect for Persian traditions and in some cases for individual Persians. Xenophon knew the Persians well from his part in the adventure of the ten thousand Greek mercenary soldiers hired by the younger Cyrus to attempt the overthrow of his brother the Great King. Some of the most impressive pages of Xenophon's history describe the meeting of Agesilaus, king of Sparta, and Pharnabazus, the opposing commander, during the Greek invasion of Asia Minor in 395 B.C. The Sophists' attack on conventional, uncritical thinking in the Greek world also encouraged the late-fifth-century Greeks to look on other nations with greater sympathy than even Herodotus and Aeschylus had felt for the majesty of the Persians. Instead of kindred souls masquerading in sumptuous, outlandish costumes, foreigners became men whose inherently different characters could be appreciated and admired. Euripides, who at the end of his life accepted the patronage of the Macedonian Archelaus, a barely Hellenized prince of dubious ancestry, created as early as 431 B.C. in his

Medea a barbarian who by her intensity of spirit mocked the conventions of Greek society. And by the end of the century, in sculptural commissions for the satraps of western Anatolia, the Greek artist had been forced to put aside the convention of the generalized head and study individual character. From that study came the possibility of an art devoted to the exposition of emotion and personality.

Once launched on its new course, art was to find no support in the philosophy of the first half of the fourth century; and when Aristotle and Theophrastus began lecturing and writing, the direction of artistic development was already set. In the early fourth century both Antisthenes of Cyrene, the forerunner of Epicurus, and his opponents in the Cynic school were primarily moral philosophers. Plato, still fighting the epistemological battles begun in the fifth century, labeled visual art the practice of deception.[4] Rather than philosophers, the major stimulus of the artist was to be his patron.

Nor was aversion to portrait studies from life the only limitation inherent in the Greek artistic traditions that were placed at the service of Persian patrons. Another was the constitutional inability of Greek artists to make a flattering figure of a non-Greek. Many non-Greeks appear on Greek painted vases, but if the portrayal is flattering, the foreigner is represented as a Greek. And so the fifth-century vase painter Myson, wishing, on an amphora now in the Louvre, to confer an appropriate nobility on King Croesus of Lydia on his pyre, painted a figure labeled with Croesus' name that could have passed for a Hellenic Zeus. The Scythian archers and cavalrymen on late Archaic vases are also really Greeks in costume. And in the scene of the duel of Achilles and the Ethiopian prince Memnon, drawn by the master vase painter Exekias about 530 B.C. on an amphora in the British Museum, Memnon is a Greek hoplite, while his little slave, a Negro, has an unattractive, wrinkled face. When another master artist, the Berlin painter, illustrated the same story a half century later on the neck of a volute crater now in the British Museum, he omitted the Negro, leaving Achilles and Memnon to fight it out, both heroic and therefore both Greek warriors.

Comic foreigners continue to appear in scenes on painted vases—like the pig-faced Egyptians who battle Heracles on a jar (pelike) in Athens painted about 470 B.C. by the artist

4. Bernard Schweitzer discusses Platonic influence on later fourth-century art in *Platon und die bildende Kunst der Griechen* (Munich, 1963).

5. Kristian Jeppesen, *Paradeigmata,* Jutland Archaeological Society Publications, vol. 4 (Aarhus: Aarhus University Press, 1958), fig. 50. On the basis of recent excavations of the enclosure of the tomb, reported in *Acta archaeologica* 38 (1967): 29–58, he now feels that it is necessary to restore a larger tomb building. For convenience, the minimal restoration of Professor Jeppesen, which does not embody his most recent conclusions, is reproduced here as illustration 123.

known as the Pan painter (122). And vases in the form of Negro heads, wide-eyed like minstrel-troupe blackface, were always popular. But in major art there was almost no opportunity to treat barbarian subjects. An exception—if it is not the dedication of an Athenian adventurer returned from the Chersonesus—may be the headless Archaic statue of a horseman in Persian dress from the Athenian Acropolis. Another exception is the monumental painting of the battle of Marathon, in the Decorated Stoa at Athens, that was executed by Micon and Panaenus. In either case the manner in which the Persians were represented is unknown, but it may be assumed that their features, like those of the Athenian leaders represented in the painting, were made to conform to current prejudices.

If the forces necessary to overthrow the inhibiting power of convention over portraiture were building up in Greece as a result of the sophistic movement, Persian patronage at the end of the fifth century released them. Toward the end of the Peloponnesian War, two prominent Greeks had their portraits dedicated in the sanctuary of Hera at Samos. Neither of them, the Spartan admiral Lysander or the Athenian Alcibiades, was noted for his self-control or modesty; Lysander, indeed, was happy to accept divine honors from the Greek cities he liberated from Athenian control. But the time and place in which their portraits were executed are important—the coast of Asia Minor in the last decade of the fifth century, after the Tissaphernes coin portrait.

•

Satrapal patronage that was only beginning with Tissaphernes, Pharnabazus, and the Lycian prince Mithrapata (who struck a fine series of coin portraits) culminated with Mausolus, who ruled the satrapy of Caria almost independently between 377 and 353 B.C. His greatest legacy was his tomb, which ranked among the seven wonders of the world. The Mausoleum (123), of which there is a garbled description in Pliny the Elder's encyclopedia, was designed by the Greek architect Pythius. About 134 feet high, it had a podium, an Ionic colonnade, and a stepped pyramid, and rested on foundations 95 feet wide and 117 feet long.[5]

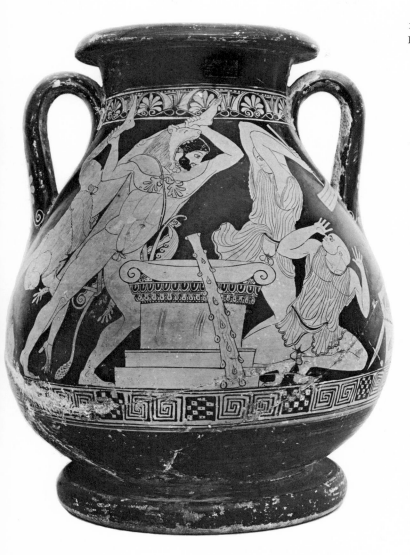

122. Attic red-figured
pelike

123. Mausoleum at Halicarnassus (restored elevation by K. Jeppesen not including results of his latest excavations)

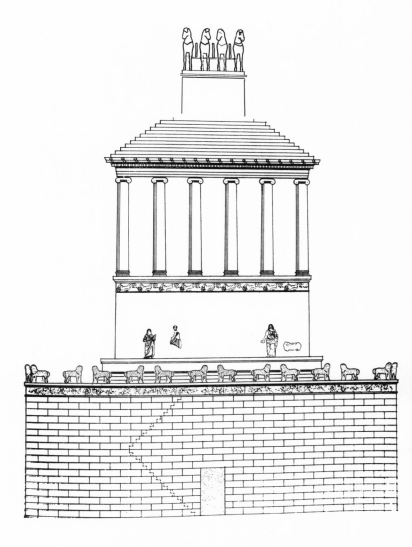

 The plan of the Mausoleum was not an innovation but was developed from a type of tomb that had already been built in Asia Minor, where the Nereid Monument at Xanthus in Lycia and the polyandrion of Triopion at Cnidos, the common tomb of those fallen in an unknown battle, have the elements of the Mausoleum in miniature. The opposed pairs of lions, which in the reconstructed Mausoleum are like a balustrade around the top of the lower podium, are traditional tomb guardians, and the frieze of chariots situated immediately below the Ionic colonnade also has Archaic antecedents. The famous

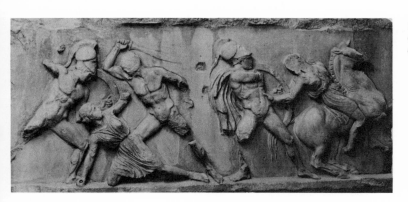

124. Mausoleum at Halicarnassus, Ionic frieze, detail

frieze of battling Greeks and Amazons (124), placed at the top of the lower podium of the reconstruction, has the triangular structure that had been worked out for battle friezes with great success in the fifth century, most notably in the interior Ionic friezes of the temple of Apollo at Bassae. But like all conscious efforts to prolong the usefulness of a good model, the Mausoleum Amazonomachy has lost something of the strength of its prototypes. The figures are too slim, too carefully arranged: they pose rather than fight.

The freestanding sculpture on the bench at the bottom of the second podium of the reconstruction shows the new sculpture of the fourth century at its most brilliant and powerful.[6] Two of the statues, a man and a woman, survive almost entire, except that the woman has lost her face. In handbooks of Greek sculpture the heroic figure of the man, which stands nine feet tall, has long been labeled a portrait of Mausolus (125). There is no evidence to justify this identification, but the force of character conveyed by his features unavoidably suggests portraiture to the modern critic. With his bold face, framed by an untamed aureole of hair and darkened by the heavy line of his mustache, he is no Greek. But what a man he is! And how well the sculptor's knowledge and understanding of his subject have been wedded to the tricks of Greek sculpture is shown by the emphasis given to the barbarian personality by the shadow effects produced by the undercutting of the restless folds of heavy drapery and the slight rotation of the body.

Mausolus could command the best talent of his day, and, according to Pliny and Vitruvius, four of the greatest con-

6. The sculpture is assigned to this position by Jeppesen, *Paradeigmata* fig. 50. Debatable are arguments for dating the figures to the second century B.C. originally put forward by Rhys Carpenter and recently—in *Hellenistic Art* (Greenwich, Conn., 1969), pp. 35–36—by Christine M. Havelock.

125. Mausoleum at Hali-
carnassus, male figure

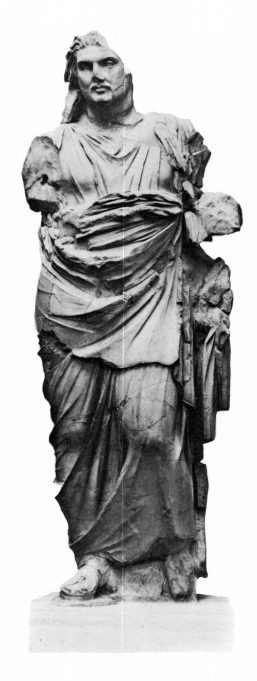

temporary sculptors—Scopas, Praxiteles, Bryaxis, and either Leochares or Timotheus—contributed to the frieze that surrounded the tomb, each working on a separate side. Much effort has been spent trying to restore the order of the plaques of the Amazonomachy and centauromachy that made up the frieze and to identify each sculptor's work. But too little is known about the five masters, and what survives of the frieze tends to be weak and unprogressive in comparison with its prototypes of the fifth century. Nevertheless, there is no reason to doubt that some or all of these sculptors worked for Mausolus or that they worked on the Mausoleum. The standing male barbarian may well be the work of one of them.

●

The careers of two of Mausolus' five sculptors, Scopas and Praxiteles, are known in some detail. After working in Caria, Scopas assumed the direction of the architectural and sculptural work for the temple of Athena Alea then being built at Tegea in the central Peloponnesus. It is unlikely, however, that he was responsible for the entire rebuilding, for the old shrine had burned in 396 B.C., and the reconstruction should have been under way before he arrived in the 340s. Nevertheless, the ornament and finishing of the building must all have been his work.

At the temple at Tegea there is the same combination of a weakening tradition and vigorous progress as in the Mausoleum sculpture. In the restored elevation the exterior Doric order is emaciated and lifeless in comparison with Doric temples of the fifth century (126). Like their predecessors, the architects of the fourth century sought to make the order more graceful by making it more slender. But they went too far, losing the exquisite architectural refinement that gave such majesty to fifth-century Doric.

The interior of the temple at Tegea is another matter, for in its finishing and detail Scopas' work stands out, especially in the cella, one of the richest known expositions of the syntax of Greek architectural moldings. Scopas' handling of the Corinthian order shows how much it was a sculptor's order (127). His low, engaged capitals have great personality, and by replacing the spirals originally found at the center of each

126. Temple of Athena
Alea at Tegea

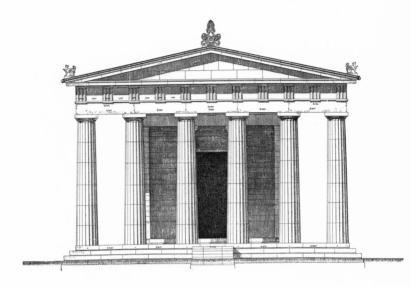

127. Temple of Athena
Alea at Tegea, Corinthian
capital

128. Temple of Athena
Alea at Tegea, *sima*

face of the capital with leaves, he made a permanent contribution to the development of the order. And the same joyous, living, expanding foliage is found on the ornamental gutter (*sima*), proceeding along the edges of the slightly projecting roof on the flanks of the temple and up the triangle formed by the roof over the pedimental opening at either end of the building (128). Like the finishing of the interior, this was one of the last elements to be added to the temple, so that it was almost certainly designed by Scopas. As on the capitals, the pattern is based on the growing plant world, with the stems gathered into a spiral form. Its vigor contrasts with the tired geometry of the Doric columns below.

What little remains of the sculptured metopes and the sculpture of the west pediment is now in the National Museum in Athens. There are more fragments from the east pediment, which depicted the hunting of the Calydonian boar. Rudely carved, with deep-set eyes that look brutally at the world, the surviving heads are astonishing (129). Pausanias names Scopas as the architect of the temple and mentions statues by him, an Asclepius and Hygieia, in the cella but says nothing about Scopas in connection with the pediments. The acceptance by some scholars of the pedimental heads as typically Scopasian has given rise to the myth that the deep-set eye is a hallmark of Scopas' sculpture. But other scholars have rejected these pediments out of hand as too coarse for the master.

The Tegea pediments must be considered in the light of the importance of painting in fourth-century Greece, for the an-

129. Temple of Athena Alea at Tegea, east pediment, head

7. M. Napoli, *La Tomba del Tuffatore* (Bari, 1971); Machteld J. Mellink, "The Painted Tomb near Elmali," *American Journal of Archaeology* 74 (1970):251–53.

cient testimonia are full of praise for such painters as Apelles, Zeuxis, and Euphranor, about whose work almost nothing is known. The development of painting in the sixth and fifth centuries can be followed through painted vases and the recently discovered frescoed tombs at Paestum in Italy and at Elmali in Asia Minor.[7] But after the mid–fifth century painters began experiments with perspective (reflected in the designs of the engraver Euaenetus) and with coloristic techniques that could not be imitated successfully by vase painters. The precise effect obtained by fourth-century painting is therefore largely a matter of conjecture: a faded woman's head on a ceiling coffer of the Nereid Monument at Xanthus is the only survivor from this period of major painting. However, the famous Alexander Mosaic from Pompeii, now at Naples, which depicts the conqueror pressing the Persian king in battle, reproduces a late-fourth- or third-century painting, possibly *The Battle of Alexander against Darius* by Philoxenus of Eretria. And fourth-century pebble mosaics, the

best of which are from Pella in Macedonia, also reflect the coloristic effects of the period. Other reflections are found in the elaborately painted tombs at Leucadiae in Macedonia and at Kazanlak in Bulgaria, as well as in later Etruscan tomb paintings.[8] There are a few painted gravestones of the period in Greece, notably those from Demetrias-Pagasae in Thessaly.

Even in the fifth century, Greek painters had unquestionably developed certain chiaroscuro techniques. From them, with startling rapidity in the 430s, sculptors learned to compose in terms of light and shadow. This technique, already well developed in the Parthenon sculpture, led to the dramatic transparent drapery of subsequent fifth-century sculpture, drapery that to a large extent made it possible to suggest violent emotion and activity while retaining impassive facial features. Once the convention of the idealized expression had been broken, their medium allowed painters to respond more easily than sculptors to the impetus toward the expression of character. Xenophon's anecdote of a conversation between Socrates and the young painter Parrhasius is evidence of such a response before 399 B.C.; and if Pliny can be believed, Parrhasius' *The Body Politic*, painted before 399 B.C., was an adroit study in characterization.[9]

The projection of violent emotion through dramatic shadows in the pedimental sculptures from Tegea testifies to the use of painterly effects by sculptors. But like the men who worked on the pediments of the temple of Zeus at Olympia in the fifth century, their colleagues at Tegea understood the unimportance of detail in sculpture meant to be displayed well above the ground. Therefore, although there is no reason to doubt that Scopas was associated with the Tegea pediments, they cannot be used as a touchstone in identifying works by him meant to be seen at close range.

The changing attitude of the fourth century toward the portrayal of the mythical or divine female subject is shown by a fourth-century female head found in the cella of the temple at Tegea by French excavators. This head (130), which is probably the Hygieia of Scopas mentioned by Pausanias, has an attractive girlish sweetness. Her expression is less forceful than that of a comparable fifth-century head—for example, the Polycletan Amazon (97)—but it conveys an im-

8. Photias M. Petsas, Ὁ Τάφος τῶν Λευκαδίων [The tomb of Leucadiae], (Athens, 1966); V. Mikoff, *Le tombeau antique près de Kasanlak* (Sophia, 1955).

9. *Memorabilia* 3. 10. 1.

130. Temple of Athena
Alea at Tegea, head

10. On the Piraeus find,
see *Archaeological Reports
for 1958*, pp. 23–24; *Bul-
letin de correspondance
hellénique* 84 (1960):
647–54; *American Journal
of Archaeology* 64
(1963):212; Karl Shefold,
"Die Athene des Piräus,"
Antike Kunst 14 (1971):
114–22.

pression of personality that would have been foreign to the fifth century.

That the majesty of many fourth-century sculptures is diminished by this infusion of personality into facial expression is evident in the majority of the sculptures executed under the supervision of Timotheus for the temple of Asclepius at Epidaurus, as well as in the fourth-century bronze statues discovered by accident in the Piraeus in 1959.[10] The latter—an Athena Archegetis (131), an Artemis, and a Muse—exemplify the grace and femininity that the fourth century brought to the treatment of such subjects. But the effect is more of prettiness than of dignity, and that this prettiness affected male figures, too, is demonstrated by such designs as the Apollo heads on coins that were struck at Olynthus for the Chalcidian League before the city was taken by Philip

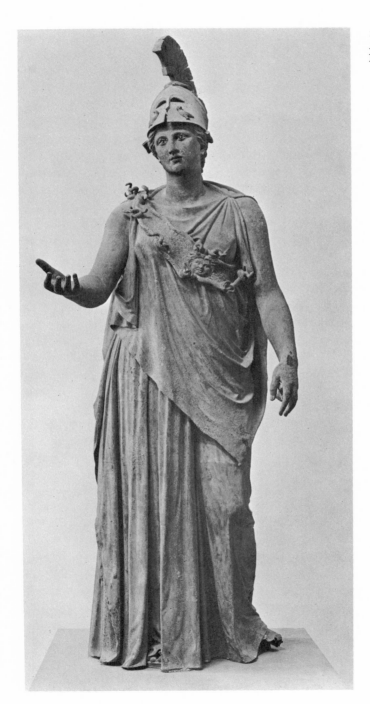

131. Bronze Athena Archegetis from the Piraeus

11. Brunilde S. Ridgway, "The Lady from the Sea: A Greek Bronze in Turkey," *American Journal of Archaeology* 71 (1967):329–34.
12. Illustrated in *Polemon,* vol. 4 (1949), supp. fig. 1, and *Journal of Roman Studies,* vol. 48 (1958), pl. 3.2.
13. Fr. 24.

of Macedon in 348 B.C. (132). However, the border between spiritless and passionate beauty is narrow. There is great matronly sympathy in the seated female figure in the British Museum called the Demeter of Cnidos, and even more in the bronze head of a similar statue fished from the sea off the Turkish coast in 1952.[11] And only the fourth century (or a later period directly influenced by the fourth century) would have been capable of the frank and sympathetic treatment of the Macedonian warhorse and his Negro groom in the monumental relief in the National Museum at Athens.[12]

Callistratus' lengthy description of a maenad by Scopas suggests that the sculptor was interested in representing strong emotion as well as personality. All phases of Scopas' work, indeed, reflect the interest in character and psychic constitution that, as a result of Greek experience with Asiatic patrons, set the work of the fourth century apart from its past. Although sculpture was humanized in the fifth century and although the exposition of such emotional states as the Bacchic frenzy had always been part of Greek art, still the study of individual character and personality was not the dominating motivation of fifth-century art as it was of the art of the succeeding age. The study of character in the fourth century, moreover, is not a matter of physiognomy alone but of the entire body. Scopas' pedimental figures at Tegea are menacing studies in the psychology of struggle. So, too, the conventional is vitalized in the Hygieia head, which brings the personality of a girl to a goddess, and in architectural ornament that exploits the inner thrust of blossoming life.

•

132. Silver coin of Chalcidian League

A precious fragment of Hellenistic art criticism, preserved by the Augustan historian Diodorus the Sicilian, makes the same judgment on the work of Scopas' contemporary, Praxiteles, who is said to have "united completely the passions of the soul with his works in stone."[13] The accuracy of this assessment is borne out by Praxiteles' works, among them his celebrated Apollo about to Kill a Lizard, of which several Roman copies can almost certainly be identified (133). The subject of the statue—an effeminate youth carefully watching a lizard he is about to kill as it crawls up the trunk of a small tree

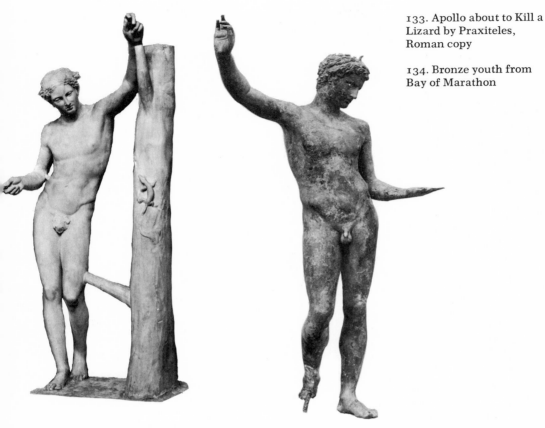

133. Apollo about to Kill a Lizard by Praxiteles, Roman copy

134. Bronze youth from Bay of Marathon

—is distastefully sadistic, a sardonic comment on the god's personality. Moreover, the name *Apollo* is a short morphological step from the Greek verb *apollumi* ("to destroy"); and Apollo the healer and prophet was also Apollo the killer of Niobe's children and destroyer of heroes. Praxiteles' soft boy is thus a study of the morbid personality. Although the quality of the existing copies of Apollo about to Kill a Lizard is mediocre, a bronze figure of another youth (134) that was recovered from an ancient shipwreck in the Bay of Marathon in 1925 is, if not by Praxiteles, at least by a successful contemporary imitator of his style and conveys to the modern world something of the luster and fascination of the surface of Praxitelean bronzes.

In antiquity the most famous of Praxiteles' works was the nude Aphrodite he created for the shrine of Cnidos.[14] This statue was, Pliny says, "superior to all the works, not only of

14. The identification of a fragmentary head in the British Museum as part of the original Aphrodite of Cnidos was announced in the *New York Times*, 8 Nov. 1970, by Iris C. Love, who is conducting excavations at the ancient site.

135. Aphrodite of Cnidos
by Praxiteles, Roman
copy

136. Aphrodite of Cyrene

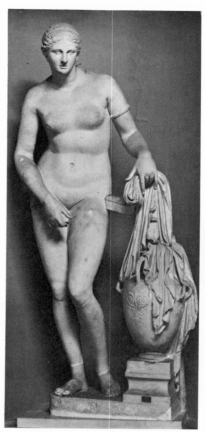

Praxiteles, but certainly in the whole world, which many peo-
ple have sailed to Cnidos in order to see." The closest replicas,
in marble, of this first nude statue of a Greek goddess are in
the Vatican Museum (135), where the head and body are
from different replicas, and in the Munich Glyptothek. In
comparison with such Hellenistic variations of the nude
Aphrodite as the milky-skinned Aphrodite from Cyrene in the
National Museum in Rome (136), the Praxitelean goddess
has marvelous dignity. Unaware of the worshiper, she stands,
robe in hand, as if about to bathe. Once more Praxiteles is
both frank and disconcerting, telling his world that the celes-
tial and cosmic Aphrodite was perhaps not as important as the
goddess of physical passion, who is most appropriately seen
naked. Previously, except when the dramatic situation per-
mitted a serious disarray of dress, female nudity in art had

been reserved for slave girls, entertainers, and prostitutes. In the psychological art of Praxiteles, the Aphrodite who excites the passions predominates, which, according to the poem on the statue, was "just the way Ares would have wanted her."[15]

15. Greek Anthology 1, 104. 9.

•

While Praxiteles was an Athenian and Scopas a Parian from the islands, the third great master sculptor of the fourth century was a Peloponnesian. In many ways the most conservative of the three, Lysippus grew up in Sicyon, just west of Corinth, where he was trained in the tradition of Polycletan sculpture. He accepted the patronage of the great leaders of Boeotia, Thessaly, and Macedonia, finally becoming the portrait sculptor of Alexander the Great. Lysippus' activity can be documented from 370 B.C., when he carved a statue of the Theban general Pelopidas at Delphi, to after 304 B.C., when he executed a similar commission for Alexander's former general, King Seleucus of Syria.

Three or four years before 336 B.C., when Alexander succeeded his father Philip as ruler of Greece, Lysippus made a posthumous portrait of a Thessalian prince named Agias for Pharsalus, Agias' native city. The statue's inscribed base has survived there into modern times, and by a singular coincidence the French excavators discovered a statue of Agias at Delphi (137), on whose base was an inscription identical to that at Pharsalus, except that Lysippus' name was omitted and fewer victories were claimed for him in the Delphic games. Along with the statue of Agias at Delphi were statues of eight of his ancestors and descendants, among them Daochus, a contemporary of Lysippus who had evidently commissioned the group. Apparently the Pharsalus Agias was part of an original group by Lysippus, and the Delphi group must have been reproduced in his workshop. Although the finish of the Delphi pieces is not wholly satisfactory, they are the most important surviving examples of Lysippus' art before the accession of Alexander.

The Daochus group testifies to Lysippus' command of the traditions of Greek sculpture. The body of Daochus' ancestor Sisyphus the Elder, for example, is that of a Polycletan athlete in a tunic, while that of Agias is derived from the

137. Posthumous portrait of Agias from Delphi by Lysippus, contemporary copy

16. Charles Hill Morgan has pointed out the very close resemblance of a torso from the Hephaesteum to the Agias torso in "The Sculptures of the Hephaisteion, III," *Hesperia* 32 (1963): 91–108.
17. *De Alexandri fortuna aut virtute* 2. 2. 3.

style of Phidias.[16] Agias' head, however, has little to do with the fifth century, for its deep-set eyes and brooding expression give it the concentration of personality demanded by the fourth century. With a similar expression, the typical tall, angry-eyed Lysippan athlete left a lasting impression on ancient art. And among Lysippus' athletes was the greatest of them all, the deified Heracles, who must have fascinated Lysippus, for he portrayed Heracles in many works. They range from a gigantic figure at Sicyon, which may have inspired the Heracles Farnese in the National Museum in Naples, to life-sized and possibly miniature statues.

Lysippus had portrayed Alexander since the Macedonian's childhood and had seen his subject as a boy in the luxurious surroundings of Philip's capital at Pela, where, although they may date from the end of the fourth century, the opulent pebble mosaics of the houses now being excavated by Greek archaeologists reflect the culture that Philip brought to Macedonia. "Only Lysippus," Plutarch said of the sculptor as Alexander's portraitist, "brought out his real character in the bronze and gave form to his essential excellence. For others, in their eagerness to imitate the turn of his neck and the expressive, liquid glance of his eyes, failed to preserve his manly and leonine quality."[17] Lysippus, then, was able to express character without making his subject seem morbid, weak, or distraught, dangers inherent in the psychological portraiture of the fourth century. In his portrait of Alexander, Lysippus the sculptor of athletes kept the vigorous youth of the prince, while Lysippus the sculptor of Heracles as the hero of the lion's skin gave Alexander a touch of the sublime.

•

According to ancient tradition, Alexander, having made Lysippus portrait sculptor at his court, gave Apelles a similar position as painter and appointed Pyrgoteles to carve his image in gem stones. This is no doubt an oversimplification, but the tradition may well reflect the fact that Lysippus, Apelles, and Pyrgoteles had the greatest influence on the representations of the conqueror. Although no reproduction of a statue of Alexander by Lysippus can be identified with certainty, on the reverse of the splendid decadrachm struck

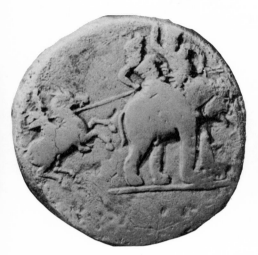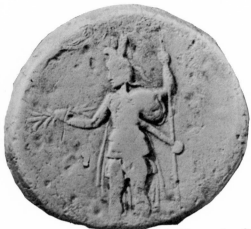

138. Silver coin of Alexander the Great

at Babylon in 323 B.C. there is a reproduction, lamentably small in scale, of a portrait by Apelles of the Macedonian holding the thunderbolt of Zeus (138). (On the obverse is a view of Alexander in battle, attacking the elephant of King Porus of India.) Pyrgoteles' gems, too, have perished, but his work must have influenced the powerful head of Alexander as Heracles on the obverse of Alexander's silver coins (139); this head can be identified as Alexander because, soon after the Macedonian's death, Ptolemy I struck a similar coin (140), on which the same head is adorned with the elephant headdress, symbolizing the conquest of India. Another deified version of this head, showing almost mystical rapture, appears on the coins of King Lysimachus of Thrace after 297 B.C. (141); its identification is certain because the head bears the horns of Ammon, who had prudently recognized Alexander as his son when the conqueror appeared at the the god's shrine at the Egyptian oasis of Siwa.

The head of Ptolemy's coin is that of the deified Alexander. Whether or not the conqueror actually aspired to deification during his lifetime, the concept of deification was already implicit in the gold and ivory portraits of the boy Alexander with his parents that were executed by the sculptor Leochares and dedicated in the *heroon* at Olympia called the Philippeion. The assimilation of Alexander's ancestor Heracles to Alexander's own features is decisive evidence of such aspirations.

139. Silver coin of Alexander the Great

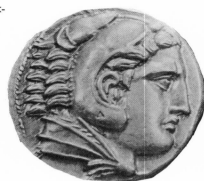
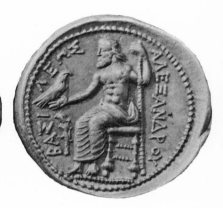

140. Silver coin of Ptolemy I of Egypt with posthumous portrait of Alexander the Great

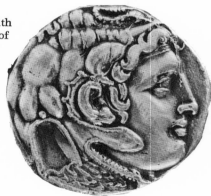
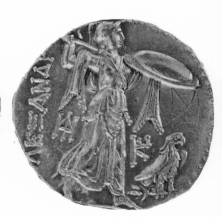

141. Silver coin of Lysimachus of Thrace with deified portrait of Alexander the Great

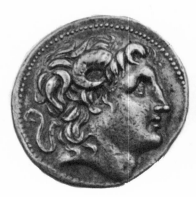
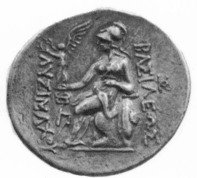

The form in which these features are cast is derived not from the Phidian and Polycletan traditions but from the work of fourth-century portraitists patronized by satraps and kings. The conscious geometry by which the fifth century gave an appearance of enduring perfection to the human expression has given way to an art adapted to an age that believed in the power of the human personality to break through the barrier between the human and the divine.

8. The Hellenistic Epilogue

The Hellenistic world, which occupied the three centuries between the death of Alexander the Great and the empire of Augustus Caesar, was no longer contained within the physical or spiritual limits of Classical Greece. Its frontiers were extended to the Indus and the borders of the Sudan. Yet the capitals of this powerful new Greek world are almost wholly unknown archaeologically. The public monuments of Antioch in Syria, Alexandria, Bactra in Afghanistan, and even Macedonian Pella are still undiscovered, unexcavated, or permanently hidden beneath flood plains or modern cities. Save for a few copies and fewer originals, the portraits and monumental statuary of those centuries have perished. Only one Hellenistic capital has been exposed by excavation, the fortress city of Pergamum, from which the Attalid dynasty ruled western Asia Minor in the third and second centuries.

The work of the Hellenistic architect, whose buildings were an academic continuation of the Classical style without its elegance, reflected the needs and aspirations of his age. His interest was less in the individual structures than in urban design, for which his major tool was the colonnaded stoa, lengthened, divided, and combined to form backgrounds, connections, and enclosures. In the cities and major sanctuaries of the old Greek world, royal patronage was largely manifested in the construction of public colonnades, of which the markets of Miletus are an outstanding example (142). Even more ingenious were the efforts of the city planners of Athens under the patronage of the Attalids and the Ptolemies of Egypt to make the ancient market place into a formal enclosure surrounded by colonnades. And the Hellenistic sanctuaries were similarly treated, so that their temples, though often stunted and coarsely finished by Classical standards, were made impressive by their setting on the axis of an enclosing colonnade. The effect was often enhanced by an elevated prospect over a terrace, as at the sanctuary of Asclepius at Cos (143).

The colonnaded unity of these cities and sanctuaries was the architectural expression of an age that built a Hellenic world among the patchwork of races of the old Persian empire and bound the East to old Greece. Besides being used to symbolize unity, the axial symmetry of Hellenistic architecture was also employed to focus attention on the shrine or image of the royal personage, who became independent of tra-

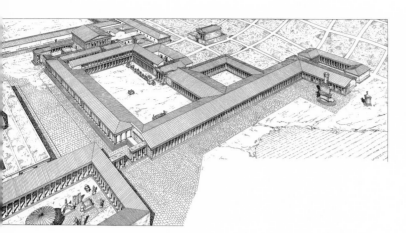

142. North market of
Miletus

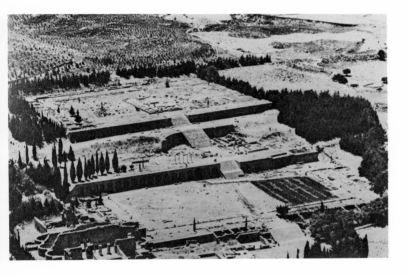

143. Sanctuary of As-
clepius at Cos

ditional political divisions by assuming divine honors. Axially planned complexes began to be employed in connection with royal cults as early as the foundation of the Hellenistic kingdoms in the generation after Alexander's death. In 304 B.C. the people of Rhodes were already honoring Ptolemy I of Egypt with a *heroon* enclosed by colonnades.[1]

This architecture of controlled space and controlled effect is closely related to the best of Hellenistic monumental art, like the Victory of Samothrace (144). This majestic statue, commemorating an unknown naval victory, still stands (in the Louvre) on its stone base resembling the prow of a warship. Its original setting was at the edge of a fountain basin that created an artificial sea before it. The Victory was thus a monument in an encompassing and dramatic setting. Like every Hellenistic statue, it is a recomposition of Classical prototypes—the "Iris" of the Parthenon west pediment as well as the Victories of the fifth century, among them the famous surviving original by Paeonius from Olympia. But the artist of the Victory of Samothrace was not the slave of his fifth-century models. The body of his Victory has the graceful inclination of a banking airfoil to which the movement of the drapery is harmonized.

The creations of Hellenistic art were not all proud statues like the Victory of Samothrace, for there were other uses for the art of consciously assumed effects. The figures created by an earlier age might become the means of disguise, with the Hellenistic ruler assuming the postures of the heroes and statesmen of the past as they suited his tastes and needs. Especially on his portrait coins, he might become an inspired imitator of Alexander the Great (145), affect a profile of Phidian purity (146), or assume an expression of concerned reflection worthy of a philosopher (147).

With the art of affected and assumed disguise there arose an art of heightened effect and distortion, for the grotesque is not absent from Hellenistic portraiture. Indeed, the portraits of Ptolemy I of Egypt verge on caricature, though they were intended to project the ruler's inspired vigor (145). In this age of the grotesque statuette, figures of athletes frankly displayed deformed brutality, like the bronze boxer now preserved in the National Museum in Rome (148), which may represent King Amycus, the mythical opponent of Polydeuces.

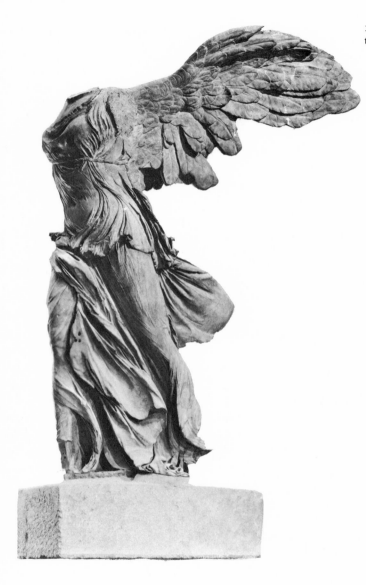

144. Victory of Samo-
thrace

145. Silver coin of
Ptolemy II of Egypt with
portrait of Ptolemy I

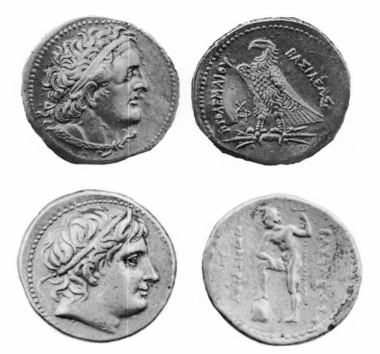

146. Silver coin of
Demetrius I of Macedonia

There is no better example of the sensuous art that accompanied extremes of deformity than the milky white Aphrodite of Cyrene (136) that is the neighbor of the seated boxer in the galleries of the National Museum in Rome. The Hellenistic Age delighted in learned, complex allegories, which are known today mostly in small-scale art, and in personifications that, like the famous Fortune of Antioch, resemble a costumed tableau vivant.

●

Under the Attalids in the third and second centuries the acropolis of Pergamum was transformed into an architectural expression of the Greek voice in the ancient world. The work there is vast, but often pedantic and dull. Temples are carefully set off-axis in the ancient style, within colonnades that demand Hellenistic axial planning. The terraces that mimic cities and sanctuaries built centuries before bear the mark of mass-produced haste, and the famous statues on the colonnades are restrained versions of famous originals.

147. Portrait of Anti-
ochus III of Syria, Roman
copy

148. Bronze boxer

149. Great Altar of Zeus
from Pergamum

Within this city of reproductions and adaptations, however, works of genius were created. Among them are the dedications composed of figures of defeated Celts, of which the ancient copy called the Dying Gaul is the best known. But the foremost Pergamene creation is the Great Altar of Zeus (149), the remains of which now grace the National Museum in Berlin. The altar, which stood in a courtyard, rests on a platform reached by a wide stairway that rose between two projecting arms. Within a slender Ionic colonnade that enclosed the altar was a frieze, important in the history of art for its illusionistic and landscape elements, that depicts the story of Telephus, the mythical founder of Pergamum. The major frieze, however, is on the base of the platform on which the altar and its sheltering colonnade stand. Intricate in design and overwhelming in scale, its subject is a battle of gods and giants in which almost a hundred figures in high relief, 7.5 feet tall, are locked in savage combat over 390 feet of the altar platform. An inscribed label accompanies each figure, providing precise identification in the learned tradition of such early gigantomachies as that of the Siphnian treasury at Del-

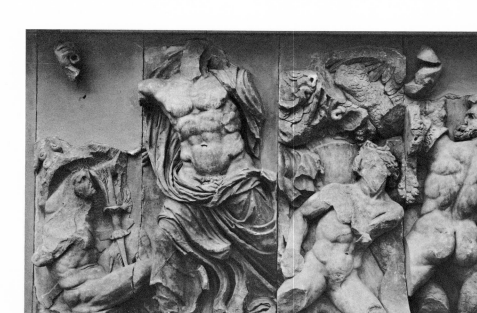

150. Great Altar of Zeus
from Pergamum, exterior
frieze, detail

phi. The Pergamene frieze is also a sophisticated recomposi-
tion of prototypes of the Phidian age, for the Zeus and Athena
(150) are borrowed directly from the Poseidon and Athena of
the west pediment of the Parthenon.

More important than the awe-inspiring size of the building
and the bravura of its sculpture is the conscious association
of sculpture and architecture for allegorical expression. The
physical relation between the building and the platform frieze
is impressed on the visitor as he ascends the stairway to the
colonnade and altar, for the combatants on the frieze brace
themselves on the stairs, so that the battle of gods and giants
seems to spill over into the human world. The victory of the
gods in this battle, which made possible the divine Olympian
kingdom, was used by the Attalid dynasty as a type of their
own victory over the Celtic invaders of Asia Minor in the third
century. Resting on the platform is the colonnade, within
which is the Telephus frieze, representing, by association,
his successors the Attalids. Thus the never-ceasing struggle
in the human world to repel invaders mirrors the never-
ceasing struggle in the divine world to repress the monsters

imprisoned by Zeus beneath the volcanoes of the Mediterranean.

•

In the Great Altar, architecture and sculpture achieve a symbolic expression unique in the Greek world. This very achievement, however, is accompanied by an unconscious intimation of the weakening of the culture that the Attalids were so eager to proclaim. It is the violence and pathos of the frieze, not the placid security of the colonnade above, that is memorable. A similar feeling of horror dominates much of the dramatic sculpture of the late Hellenistic world—not only such figures of despair as the great Laocoön of the Vatican but even heroes shown in the moment of victory.

In 1959 at Sperlonga in Italy, a Roman seaside grotto was discovered in which were the remains of a collection of superb Hellenistic sculpture.[2] Surviving from a group representing Polyphemus attacked by Odysseus and his men are two of the latter (151), their fear and apprehension portrayed with the highest virtuosity of late Hellenistic art. These are the same heroes who attacked Polyphemus on the seventh-century funeral vase from Eleusis (4). The silhouettes of the Eleusis vase stand at the beginning of Greek Archaic art, full of the confidence of a different and distant age. The drama of late Hellenistic art is a tremulous descendant of the humanity of both the Olympian sculptures and of Phidian Athens. Yet it responded to the questions put by the human soul to the human intellect in each epoch of Greek history: What is it to be a hero? What is it to be a god? It is perhaps because each generation of her spiritual descendants has felt the need to ask the same questions that the continuity of our artistic tradition is founded on the monumental art of ancient Greece.

2. It was first described by Giulio Iacopi in *L'antro di Tiberio a Sperlonga* (Rome, 1963) and Gösta Säflund in *Fynden i Tiberiusgrottan* (Stockholm, 1966). A definitive treatment of the grotto and the many problems posed by its monuments is expected shortly from Baldo Conticello. Recent studies include Conticello, "Restoring the Polyphemus from Sperlonga," *Archaeology* 22 (1969): 204–7, and L. Gösta Säflund, "Sulla ricostruzione dei gruppi di Polifemo e di Scilla a Sperlonga," *Opuscula romana* 7 (1969): 25–52.

151. Companion of Odysseus from Cave Triclinium, Sperlonga

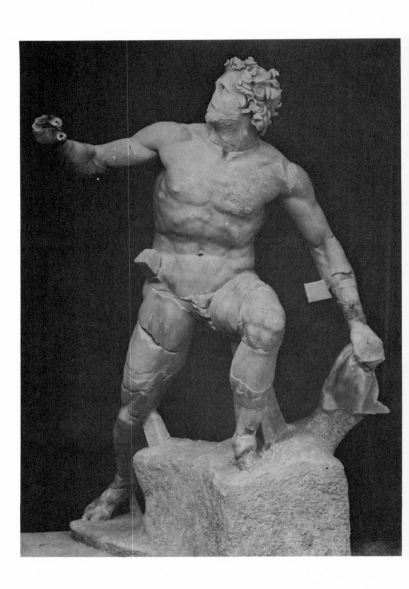

Appendixes

Bibliographical Note

Appendix A. Greek Authors of the Fifth Century on Art

There was no critical writing on art in fifth-century Greece. The architects' writings mentioned by Vitruvius were probably detailed building contracts rather than aesthetic treatises, and artists' writings, like Polycletus' *Canon*, seem to have been practical craft manuals. But the poets and philosophers were not completely silent on the subject of the visual arts. Euripides gave vivid expression to the joys of a sight-seeing Greek before the statuary of the temple at Delphi in the lines of the slave girls in *Ion* and both Aeschylus and Gorgias wrote of the pleasure of visual art.[1] Although the dramatists and other poets of the fifth century may seem to be insensitive to the image of man and of anthropomorphic divinity in statuary and painting, the passages that follow show that they instinctively associated men and gods in visual art with divine and heroic immutability. This attitude toward the visual image limited its function in poetic imagery.

1. *Ion* 184–87, *Agamemnon* 416–17, *Encomium of Helen* Fr. 11. 18.
2. Plutarch's paraphrase is in *De quaestionibus convivialibus* 9. 15. 2:

> καὶ ὅλως ἔφη μεταθήσειν τὸ Σιμωνιδεῖον ἀπὸ τῆς ζωγραφίας ἐπὶ τὴν ὄρχησιν, τὴν γὰρ ὄρχησιν εἶναι ποίησιν σιωπῶσαν, καὶ φθεγγομένην ὄρχησιν πάλιν τὴν ποίησιν.

[And so, he said, we must transfer Simonides' remark from painting to dancing and say that dancing is silent poetry and call poetry a speaking dance.]
3. Fr. 62, 72, 74, 73.

•

According to Plutarch, Simonides compared the arts of painting and poetry.[2] But although it is uncertain whether Simonides found painting like poetry for its suggested movement or for its color, the latter interpretation is preferable. For Simonides repeatedly used coloristic epithets in the tradition that began with the seduction of Zeus in the fourteenth book of the *Iliad:* a sail is red (φοινίκεον), a girl's lips crimson (πορφύρεον), a swallow deep blue (κυανέα), and nightingales green-necked (χλωραύχενες).[3]

As the leading fifth-century writer of epitaphs, many of them for the bases of sculptured monuments, Simonides was heir to the Archaic convention of the "speaking" epitaph. However, this convention of first-person address by grave monuments (both representational and aniconic) should not be taken as proof of a different and consciously animating attitude inherited from the Archaic past—not even in the rare cases in which an effigy assumes the role of speaker. An example of the latter is the memorable epitaph of Midas quoted by Plato:

Χαλκῆ παρθένος εἰμί, Μίδα δ' ἐπὶ σήματι κεῖμαι.
ὄφρ' ἂν ὕδωρ τε νάῃ καὶ δένδρεα μακρὰ τεθήλῃ,

4. *Phaedros* p. 264d, Greek
Anthology 153.
5. *Nemean Odes* 5. 1–5.

αὐτοῦ τῇδε μένουσα πολυκλαύτου ἐπὶ τύμβου,

ἀγγελέω παριοῦσι Μίδας ὅτι τῇδε τέθαπται.[4]

[A bronze maiden I, I lie on Midas' tomb,
while water flows and the tall trees bloom;
resting on this tear-stained bier,
I tell the passer, "King Midas lies here."]

The speaking convention is an extension of the Greek verbal
formula used to identify almost any object (for example, "I
am the cup of ———"). In the forty-three epitaphs surviving
in the Simonidean corpus, it is used only twice, indicating
that Simonides avoided a usage that he could have exploited
had he wished to emphasize the animation of funeral images.

Pindar's imagery also emphasizes the static quality of art
and architecture. In the fifth Nemean ode Pindar seizes upon
the motionlessness of the statue as a contrast to the move-
ment of his ode:

Οὐκ ἀνδριαντοποιός εἰμ᾽, ὥστ᾽ ἐλινύσοντα ἐργά-
 ζεσθαι ἀγάλματ᾽ ἐπ᾽ αὐτᾶς βαθμίδος
ἑσταότ᾽ ἀλλ᾽ ἐπὶ πάσας
 ὁλκάδος ἔν τ᾽ ἀκάτῳ, γλυκεῖ᾽ ἀοιδά,
στεῖχ᾽ ἀπ᾽ Αἰγίνας, διαγγέλλοισ᾽ ὅτι
Λάμπωνος υἱὸς Πυθέας εὐρυσθενὴς
νίκη Νεμείοις παγκρατίου στέφανον.[5]

[I am no maker of statues or one to fashion
figures standing quietly on their pedestals
But with any ship or freighter go, sweet song,
from Aegina to spread the news that mighty
Pytheas the son of Lampon has been crowned victor
of the pancratium at Nemea.]

There is a kinship between this viewpoint and Simonides'
interest in art, for if the preceding interpretation of Simon-
ides is correct, the static element of color more than anima-
tion of form excited his imagination. Pindar shared this de-
light in the coloristic sensations of art and expressed it by
comparing the work of the poet and architect:

Χρυσέας ὑποστάσαντες εὐτειχεῖ προθύρῳ θαλάμου
κίονας ὡς ὅτε θαητὸν μέγαρον
πάξομεν, ἀρχομένου δ' ἔργου πρόσωπον
χρὴ θέμεν τηλαυγές. [6]

6. *Olympian Odes* 6. 1–4.
7. *Eumenides* 55–56.
8. *Agamemnon* 238–43.

[As if on the handsome porch of a hall we raised golden
columns like a towering megaron,
we shall construct (this ode). One must illuminate
the façade of every work at the beginning.]

The normal Greek word for statue, and the word Pindar
used in the fifth Nemean ode and elsewhere, is ἄγαλμα, which
means "delight" and "honor" as well as "decoration" or
"statue." The statue, therefore, is a decoration and an honor
for a god or a tomb. Some of these meanings appear in a pas-
sage from Aeschylus in which the Pythia, approaching the
temple at Delphi, is greeted by the horrid sight of the sleep-
ing Furies. She cries out:

καὶ κόσμος οὔτε πρὸς θεῶν ἀγάλματα
φέρειν δίκαιος οὔτ' ἐς ἀνθρώπων στέγας. [7]

[It is not right to bring them
into the presence of the *agalmata*
of the gods or into the homes of men.]

Ἀγάλματα here includes everything that creates the proper
setting for the god—temple, offerings, and statuary—things
proper to eternity rather than to mortality.

Another passage from Aeschylus, the famous lines describ-
ing Iphigenia at the moment of her sacrifice at Aulis, shows
that this is the way he thinks of art:

κρόκου βαφὰς δ' ἐς πέδον χέουσα
ἔβαλλ' ἕκαστον θυτή-
ρων ἀπ' ὄμματος βέλει φιλοίκτῳ,
πρέπουσα τὼς ἐν γραφαῖς, προσεννέπειν
θέλουσ'. [8]

[Letting slip the saffron dyed stuff to her foot,
from her eyes she struck each of the sacrificial officers

9. Fr. 490, Nauck; *The Phoenician Women* 128; *The Acharnians* 992.
10. Fr. 124, Nauck.

with a shaft seeking pity,
standing out as if in a picture, wishing to speak.]

But of course she cannot speak. The poet clearly intended to emphasize the silence of the painting. Because it is silent and motionless, it is suited to the world of the ἀγάλματα, and not to the world in which human beings live, move, and speak.

These few passages from Simonides, Pindar, and Aeschylus—almost their only existing comments, however oblique, on art—suggest that they agreed that sculptured or painted forms have a permanency not to be confused with transient humanity. Because of this feeling that the forms of art are more properly devoted to the permanent realm of gods and heroes, Greek dramatization of the divine and heroic world on stage was not a portrayal of simulated humanity: the audience looking at a Greek actor saw a sculptural mask. And just as the epinician poet avoided mention of statues when seeking images for movement and passion, so the dramatic poet avoided images drawn from immobile art when dramatizing the deeds and passions of gods and heroes.

●

The literature of the whole fifth century perpetuated the Archaic solemnity and immutability of major representational art. Statues and paintings were seldom referred to. Sophocles mentioned a statue only to evoke a particular image of Hecate, Euripides suggested the appearance of Hippomedon by comparing him to a painting of a giant, and Aristophanes used the same device to suggest the appearance of Eros.[9]

Euripides also turned to sculpture when he wished to describe Andromeda chained motionless against the cliff:

> ἔα, τίνα ὄχθον τόνδ' ὁρῶ περίρρυτον
> ἀφρῷ θαλάσσης; παρθένου τ' εἰκώ τινα
> ἐξ αὐτομόρφων λαΐνων τυκισμάτων
> σοφῆς ἄγαλμα χειρός.[10]

[What mass is this I look upon
washed round by the foam of the sea?

I liken it to a girl made of weathered stones,
a statue fashioned by a skillful hand.]

11. *Electra* 386–87
12. Fr. 195.
13. *Hecuba* 560–61.

And Euripides' Orestes says in a moment of bitterness:

αἱ δὲ σάρκες αἱ κεναὶ φρενῶν
ἀγάλματ᾽ ἀγορᾶς εἰσιν.[11]

[Skins without brains are statues of the market place.]

His lines echo the less specific words of Democritus:

εἴδωλα ἐσθῆτι καὶ κόσμῳ διαπρεπέα πρὸς
θεωρίην ἀλλὰ καρδίης κενεά.[12]

[Images conspicuous for their dress and ornament, but empty of heart.]

But of Polyxena at the moment of her death Euripides could write:

μαστούς τ᾽ ἔδειξε στέρνα θ᾽ ὡς ἀγάλματος
κάλλιστα,[13]

[She displayed breasts and shoulders
with beauty like a statue.]

These lines are in the Aeschylean tradition, for Polyxena and Iphigenia share their motionlessness with the figures of sculpture and painting.

●

These passages should dispel the notion that the Greeks appreciated representational art only for its simulated naturalism—a notion that modern art historians have taken over, largely from the evolutionistic schemes of art critics in the Hellenistic and Roman periods. It is not by chance that art has so small a part in the work of the poets, particularly the tragic poets of the fifth century. Major art, as it was transmitted to these poets from the Archaic past, was dedicated to the permanent and immutable qualities of the gods and heroes, whom it was the duty of the poets to recall to the dramatic stage not as men but nonetheless through the medium of living actors.

Appendix B. Chronological Chart

Age or Period	Approximate Dates (B.C.)
MIDDLE AND LATE BRONZE (Minoan and Mycenaean civilizations)	2000–1000
GEOMETRIC	1100–700
ORIENTALIZING	700–600
ARCHAIC	600–480
EARLY CLASSICAL	480–450
PERICLEAN	450–430
LATE PHIDIAN	430–400
LATE CLASSICAL	400–300
HELLENISTIC	300–30

Bibliographical Note

Greek art in general has been treated in recently published works by Gisela M. A. Richter, *A Handbook of Greek Art*, 3d ed. (New York and London, 1963); John Boardman, José Dörig, and Werner Fuchs, *The Art and Architecture of Ancient Greece* (London, 1967); and Giovanni Becatti, *The Art of Ancient Greece and Rome* (New York and London 1968). A mine of information is contained in the articles of the *Enciclopedia dell'arte antica* (Rome, 1958–66) and the *Encyclopedia of World Art* (New York and London 1958–68).

Specialized handbooks of sculpture are Gisela M. A. Richter, *The Sculpture and Sculptors of the Greeks*, 3d ed. (New Haven and London, 1970); Charles Picard, *Manuel d'archéologie grecque, la sculpture* (Paris, 1935–66); Georg Lippold, *Die griechische Plastik*, Handbuch der Archäologie (Munich, 1950). Specialized handbooks of architecture are D. S. Robertson, *A Handbook of Greek and Roman Architecture*, 2d ed., corr. (Cambridge, 1945); William B. Dinsmoor, *The Architecture of Ancient Greece* (New York and London, 1950); Arnold W. Lawrence, *Greek Architecture*, rev. ed. (Harmondsworth and Baltimore, 1962); Roland Martin, *Manuel d'architecture grecque* (Paris, 1965–). Specialized handbooks of painting and vase painting are Andreas Rumpf, *Malerei und Zeichnung*, Handbuch der Archäologie (Munich, 1953), and R. M. Cook, *Greek Painted Pottery* (London, 1960).

Index

Index

A View of Greek Art

R. Ross Holloway

This original and thought-provoking discussion of Greek art and architecture ranges from the Geometric vases of the eighth century B.C. to the Hellenistic Great Altar of Zeus at Pergamum of the second century B.C. and considers such diverse examples as the Sunium kouros, the temples of the western Greek colonies, and the great monuments of the Athenian Acropolis.

Ross Holloway explains why the various traditions that led up to the great art of the Periclean Age developed as they did. He shows how conservative and progressive stylistic elements combined, from the Archaic through the Periclean Age, to produce architectural and sculptural forms that expressed not only the heroic aspirations of a not-too-distant past but also— as in the sculptures of the Parthenon— pride in such contemporary achievements as the decisive victory over the Persians at Plataea. So, too, the expressionistic sculptures of the Late Phidian period that followed are shown to reflect the intellectual innovations of the fifth century B.C., and works of the Late Classical and Hellenistic periods to reflect increasing freedom from convention. Fully integrated with the text, 151 illustrations make it easy to compare works from different styles and periods.

General readers and specialists alike will find much to interest them in Ross Holloway's creative interpretations of familiar works, in his illuminating studies those that are important but not so well known, and in his ingenious and well-argued stands on controversial issues. *A View of Greek Art* will be ranked among such distinguished works as Gisela M. A. Richter's *The Sculpture and Sculptors of the Greeks* and Rhys Carpenter's *Greek Art.*

As professor of central Mediterranean archaeology at Brown University, R. Ross Holloway is able to bring to bear on Greek art the special insight of an experienced excavator. Among his books is *Satrianum* (Brown University Press, 1970), a record and an interpretation of the Brown University excavations he directed in 1966 and 1967.